PHOTOGRAPHING
Plants and Flowers

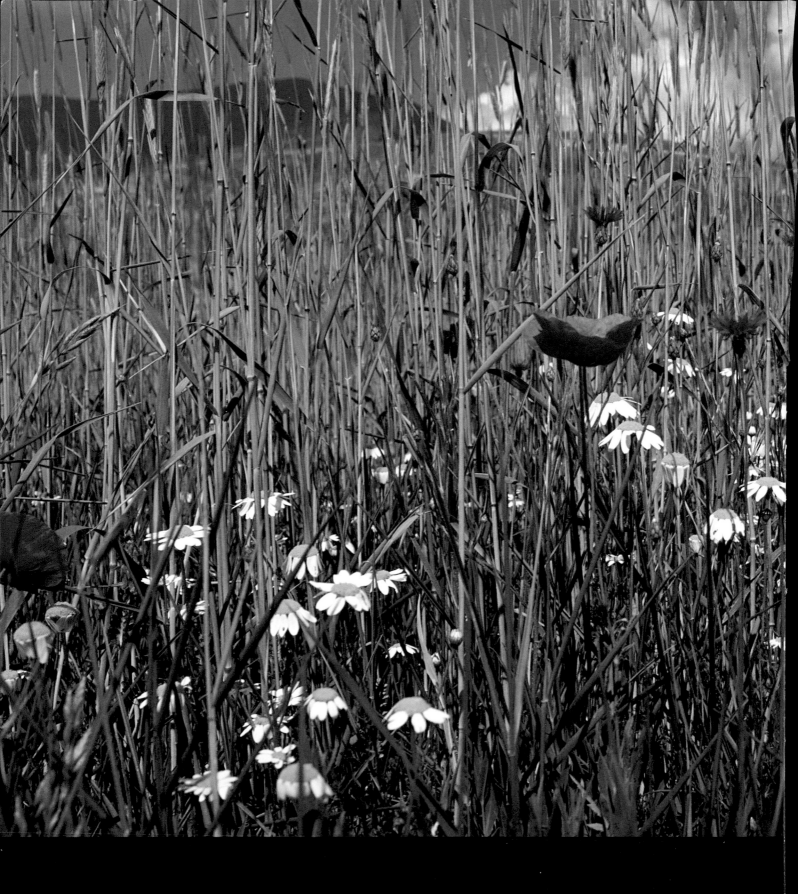

AMPHOTO BOOKS
An imprint of Watson-Guptill Publications
New York

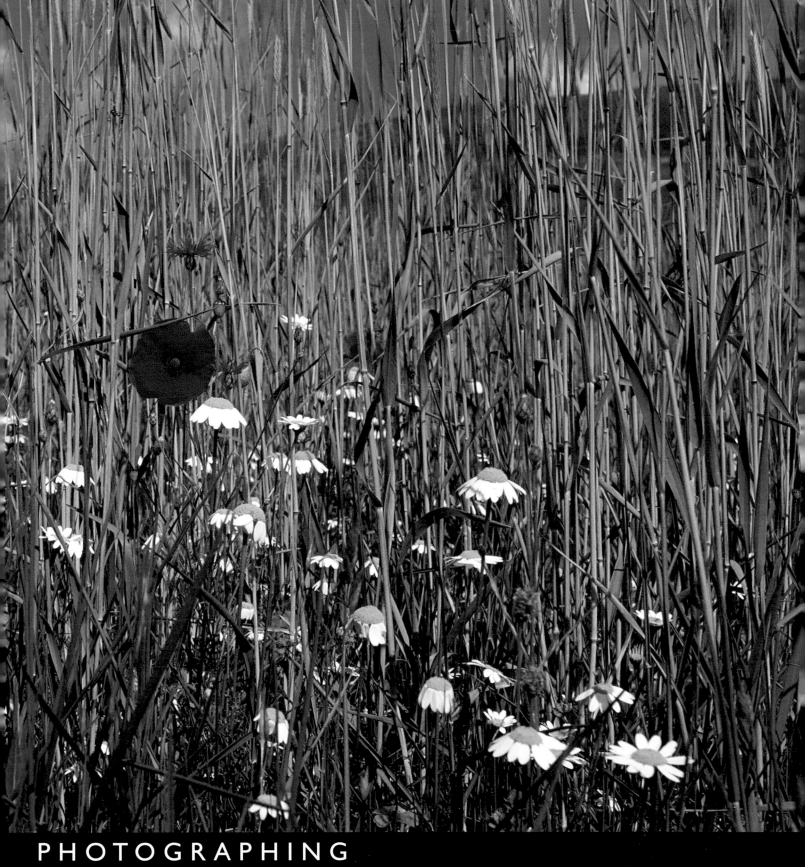

PHOTOGRAPHING
Plants and Flowers

This work is dedicated to Joanne Mary Davies (née Rees), whose belief in what her sometimes errant son could do has never waivered—even when I did not make it easy.

First published in the USA in 2002 by Amphoto Books
An imprint of Watson-Guptill Publications, 770 Broadway, New York, NY 10003
www.watsonguptill.com

First published in the UK in 2002 by Collins and Brown Limited, 64 Brewery Road, London N7 9NT

A member of the Chrysalis Group plc

1 3 5 7 9 8 6 4 2

Library of Congress Control Number: 2001094986

ISBN 0-8174-5502-7

Publisher: Roger Bristow
Photography by Paul Harcourt Davies
Commissioned by Sarah Hoggett
Project managed by Emma Baxter
Art direction by Anne-Marie Bulat
Designed by Roger Daniels
Copy-edited by Beverley Jollands

Manufactured in Hong Kong

p. I **Alpine Snowbell (*Soldanella alpina*), Dolomites Italy; pp. 2–3 Cereal field flowers, Mte Sibillini, Italy; pp. 4–5, clockwise from top left, Cornfield "weeds," Piano Grande, Mte Sibillini, Italy; Sunflowers (*Helianthus annuus*), Provence, France; Scarlet Horned Poppy (*Glaucium corniculatum*), nr Droushia, Cyprus; Crown Daisies (*Chrysanthemum coronarium*); Marginal Plants, Royal Horicultural Society Garden, Wisley, England**

Contents

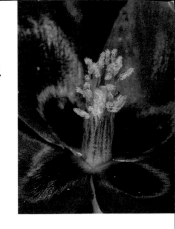

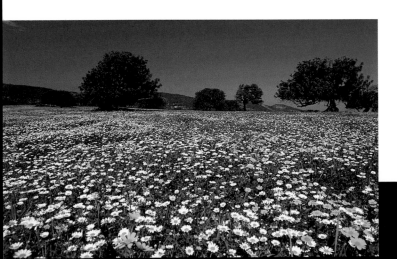

Introduction

FLOWERS have an extraordinary capacity for generating a "feel-good" factor. As gifts, they can convey feelings with a depth that words cannot match. No one who appreciates the countryside can fail to have their enjoyment enhanced by the scarlet sweep of a field of poppies, and spirits will always be lifted by the scent of wild roses on the breeze. Smiling sunflower faces seem to capture the sun itself, and mountain turf studded with alpine blooms puts an extra spring in your walking boots.

Whether you are studying, growing, or receiving them, flowers bring joy and celebration into your life. As this book evolved, that spirit of celebration was always in the background. It influenced the selection of pictures. It also inspired the desire to demonstrate easily mastered techniques that would allow readers to do photographic justice to this rewarding subject, and be pleased with the results. I have always had a deep interest in trying to preserve what is left of our natural environment. I dare to hope that if I can help people to find enjoyment in flowers and communicate it to others through photographs, some good is being done.

There is no single technique for photographing flowers and plants, and no single shot that is correct. In fact, you will find that the whole gamut of photographic skills—from close-up, through landscape, to portraiture and studio work—can be brought into play. Each plant has a definite "character," and to bring that out on film you have to look closely at it. You may then choose to isolate a detail with a macro lens, or set the whole plant in the context of its habitat using a wide-angle lens.

Sophisticated equipment is not the key to great photography, although having the best tools for the job is never a handicap. Many people take excellent photographs using compact cameras with built-in zoom and close-up facilities. Far more important is the ability to "see" a potential picture. This book aims to show you ways of getting impact into your photographs. It encourages you to look at the way an image is framed, raising questions of viewpoint, lighting, and backgrounds. An eye for design may be an innate quality, but we can all make much better use of the gifts we have if we understand all the possibilities.

People come to flower photography in various ways. In my case there was certainly an early appreciation of flowers, but when I was growing up in a Welsh mining valley, a love of flowers might have been regarded as "sissy" by my young friends. However, I saw many miners lavishing attention on sweet peas, dahlias, and roses grown for competitions, perhaps as an antidote to their working lives.

Through an early interest in butterflies, I became familiar with food plants for caterpillars and found my first bee orchid in the sand dunes of Kenfig, South Wales. Then I met a very able plant photographer—of the bizarre forms of orchids, in particular—and I was hooked. The purchase of a single-lens-reflex camera brought me to a passion for capturing plants and many other subjects on film. The first books I wrote were on orchids, and through an interest in plants and the natural world I have met an astonishing diversity of people—including an extraordinary number of lovable eccentrics—and have witnessed some of the loveliest scenery enhanced by floral color.

Your subjects may be the exotic blooms of far-off lands and high mountains, or the flowers in your backyard or window box. Whatever you choose, there is always great pleasure to be found in trying to capture plants on film in a way that brings back the feel of the heat on your skin or the scents of an herb-filled hillside—let's hear it for pure, unashamed escapism.

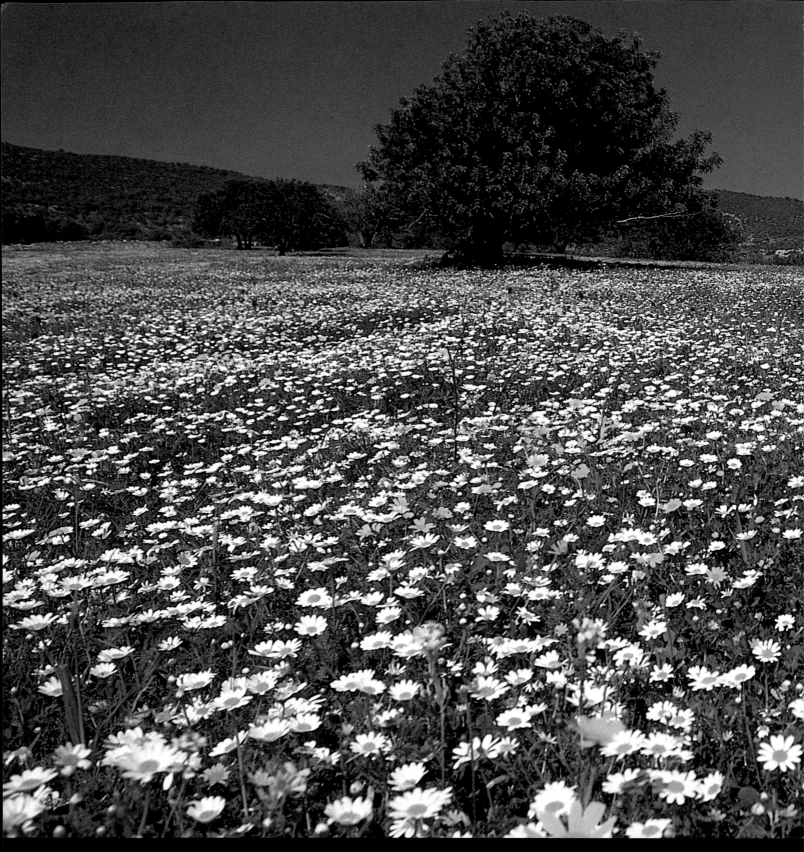

▲ **Crown Daisies (*Chrysanthemum coronarium*),
Akamas, Cyprus**
Pressure from tourism and the introduction of intensive
farming means that sights such as this are rare. Fields of
wildflowers are most often seen in the Mediterranean region,

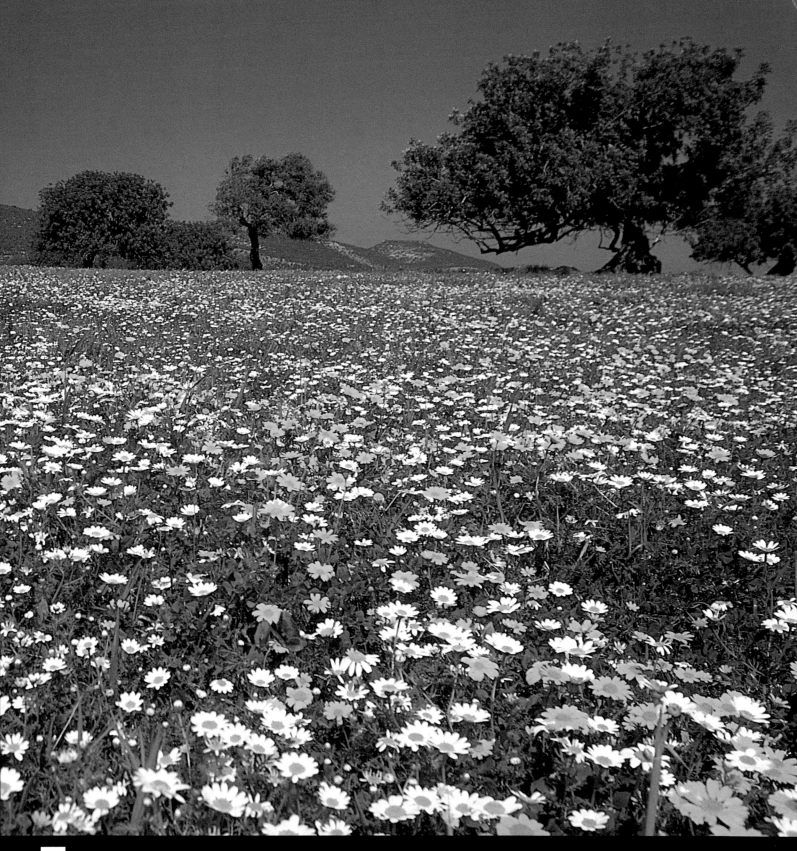

Exposure

Metering

How_ever well-developed your "eye" for a good photograph, it will be to no avail if the exposure of the film is incorrect.

An exposure meter can either be integral to a camera's design or a separate handheld unit. Although many professionals prefer handheld meters in the studio and for formats larger than 35mm, I tend to rely on camera meter readings in both my Nikon and Mamiya 645 outfits. At the same time, I aim to recognize those situations where the meter might be fooled and then bracket exposures (taking a range of shots from under- to overexposure).

Incident and reflected light

All light meters are calibrated to deal with "mid-tones" such as the blue of the sky in the opposite direction from the sun, green grass, red flowers, and the gray of a Kodak gray card with its 17 percent reflectance.

Incident light meters measure the light falling directly on a subject. Particularly under studio lighting—whether flash or continuous light—they give extremely accurate readings. Reflected light meters measure the light reflected from the

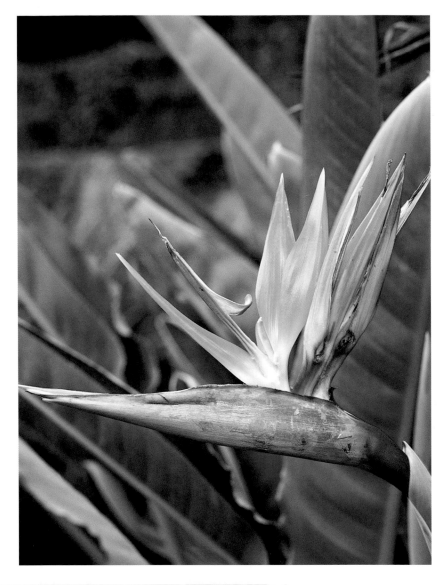

▷ **Daisies (Bellis perennis), Bath, England**
The spot-metering mode on the camera's metering head allowed the reading to be taken from the grass only—inclusion of the white daisies would have resulted in underexposure.

CAMERA Mamiya 645 super pro TL

LENS 45mm f2.8 wide-angle

FILM Fujichrome Velvia

SHUTTER SPEED 1/30 sec

APERTURE f/11

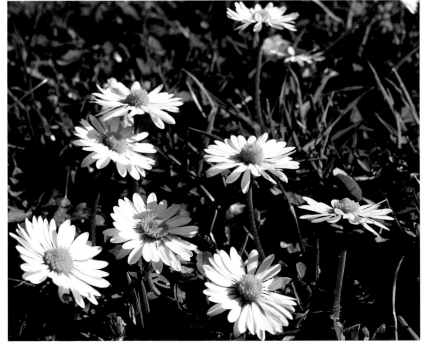

▲ **Bird of paradise flower (Strelitzia reginae), Funchal, Madeira**
The center-weighted mode of the camera meter provided the meter reading. I had felt that the orange flower might influence the meter slightly, but made no adjustment because a slight underexposure produces the kind of saturation I like in transparencies.

CAMERA Mamiya 645 super pro TL

LENS 45mm f/2.8 wide-angle

FILM Fujichrome Velvia

SHUTTER SPEED 1/125 sec

APERTURE f/8

FILTER polarizer

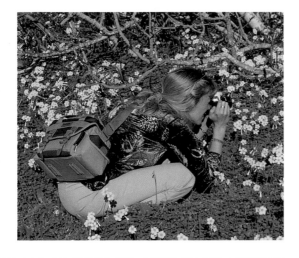

▷ **Bermuda buttercups (*Oxalis pes-caprae*), Algarve, Portugal**

On a bright January day in the Algarve, I experimented by exposing according to the sunny f/16 rule instead of the camera meter reading, and it provided an exposure that was "spot-on."

CAMERA Nikon F4
LENS 24mm AF f/2.8 wide-angle
FILM Fujichrome Provia
SHUTTER SPEED ¹/₁₂₅ sec
APERTURE f/16

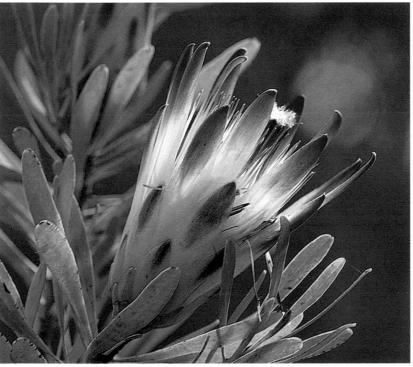

▲ **King protea (*Protea cynaroides*), Funchal, Madeira**

If back-lit subjects are metered directly, they will be reduced to a neutral tone and appear dull on film. In this case, a spot reading was taken from the protea leaves.

CAMERA Nikon F4
LENS 70–210mm f/2.8 zoom
FILM Fujichrome Velvia
SHUTTER SPEED ¹/₃₀ sec
APERTURE f/11

subject. The reading depends on the subject's color and surface reflectivity, but in modern cameras, through-the-lens (TTL) meters are extremely versatile and accurate.

Handheld meters can provide you with both readings of reflected light and, by taking a reading next to the subject, of incident light. For those who work in larger formats, a handheld spot meter is an essential tool, typically giving a 1-degree cone of light. You soon become very proficient at taking a number of readings and mentally averaging them.

The sunny f/16 rule

Any competent photographer eventually gets a "feel" for correct exposure—or rather, knows when a meter might be playing up.

A useful check relies on the "sunny f/16 rule." Film speeds indicate sensitivity of films on the International Standards Organization (ISO) scale. Each film is designed to give correct exposure when, on a sunny day in temperate regions, the aperture is set at f/16 and the shutter speed is ¹/film speed. For ISO 25, for example, this should be ¹/₂₅ sec. In practice there is sometimes about ¹/₃-stop difference, because for a film of ISO 50 the nearest shutter speed is ¹/₆₀ sec (there is no ¹/₅₀ sec speed). The "sunny f/16 rule" works very well— the table that is packaged with non-pro color negative films shows weather symbols and exposures based on it.

METERING PATTERNS

Many camera meters are equipped with switchable metering patterns:

Spot metering defines a narrow angle of view of a few degrees—a small spot at the center of the viewfinder and an exposure "lock" enable you to take a reading from a mid-tone in one area of the composition and use it for the whole exposure.

Center-weighted metering takes a reading over the whole viewfinder area but is biased toward the central portion.

Matrix metering divides the viewfinder into a number of areas—from five upward—and compares their relative light intensities with up to 30,000 patterns held in the meter's memory. Nikon includes distance measurements obtained from the autofocus rangefinder in its "D" range lenses. In theory, knowing the distance of a subject and the amount of light reflected enables the camera to account for reflectivity and get the exposure spot-on. In the Nikon F5, three separate sensors deal with color for extra accuracy.

Controlling Tonality

ADVANCES IN CAMERA ELECTRONICS mean that exposure can be taken care of automatically, freeing you to use your creativity in choosing and framing a subject. The downside is that you risk becoming dependent upon the electronics and reluctant to override what the camera dictates.

Exposure meters deal with mid-tones. Taking an exposure from a red or green object gives a reading for a mid-red or mid-green respectively. If you try the same thing with a yellow object it will be rendered as a mid-yellow and will appear dull and underexposed on film.

Once you realize this, there is a surefire way of getting colors to appear exactly the way you choose. By taking a meter reading of a particular color you can control how it will be rendered as a tone, from white through light tones, mid-tones, and very dark shades to black. This covers a spread of about 5 stops—2½ either side of the mid-tone —which is the typical range a film can handle. Tones from deepest black to featureless white have to be accommodated. Printers' inks have a much narrower tonal range, as do the phosphors used on computer screens, so a great deal of matching and compromise is needed when photographs are reproduced in any way.

In practice, to lighten a tone, you either open up the aperture using manual control or, in the case of autoexposure, increase exposure via the compensation dial. Conversely, closing the aperture or reducing exposure via the compensation dial darkens the tone.

It takes only a short time to gain confidence in this process. Once you have mastered the technique, lifeless color in your photographs becomes a thing of the past.

▲ **Plum tomatoes on market stall, Vieste, southern Italy**
The rich red of Italian plum tomatoes is an example of a mid-tone. A polarizer was used to cut down the surface reflections, but the highlights were still retained.

CAMERA Mamiya 645 pro TL	**SHUTTER SPEED** ¹/₃₀ sec
LENS 80mm AF f/4 macro	**APERTURE** f/8
FILM Fujichrome Velvia	**FILTER** polarizer

▶ **Bamboo, Ninfa, Italy**
For plant photographers, a film must be able to register every shade of green realistically and subtly. Using slower transparency films, you can fully exploit the contrast range of a subject.

CAMERA Mamiya 645 pro TL
LENS 45mm f/2.8 wide-angle
FILM Fujichrome Velvia
SHUTTER SPEED ¹/₃₀ sec
APERTURE f/8

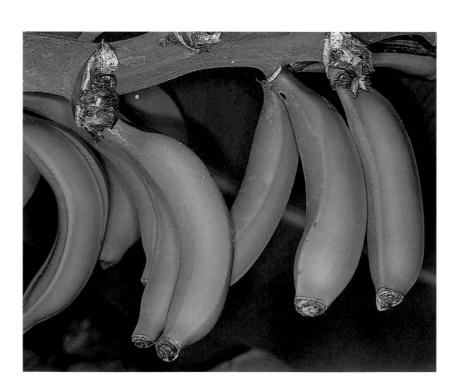

▶ **Green bananas (*Musa* sp), Funchal, Madeira**
Bananas growing in the shade of the plant had to be photographed with flash—the camera's TTL system coped perfectly with the green subject, with no need for correction.

CAMERA Nikon F4	**SHUTTER SPEED** ¹/₁₂₅ sec
LENS 60mm f/2.8 macro	**APERTURE** f/16
FILM Fujichrome Velvia	**LIGHTING** Nikon SB25 flash

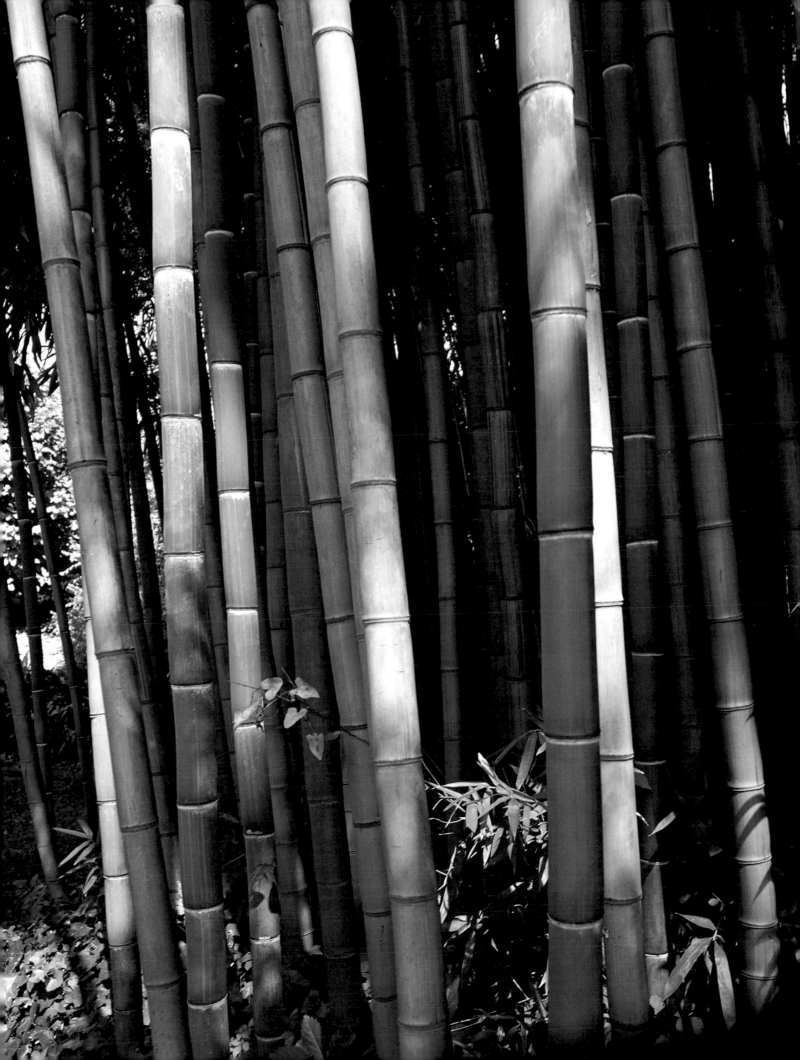

Extremes of Lighting

Although it is easier not to force a film to cope with a wider tonal range than it was designed to handle, spectacular images can be created using sharp contrasts.

Silhouettes (see pages 92–93) are created by exposing for a bright background: if foreground subjects are sufficiently underexposed they will appear black. Conversely, to create a "natural" white background (see pages 136–137) you should expose for the subject—perhaps flowers on a branch, with a lightly cloudy sky behind. Hand-held reflectors are useful for throwing light into a flower's interior when the background is bright.

Low light is not ideal for flowers, since colors can appear muted and lack any "bite." Slower films can handle low light, but exposures tend to be long and some films will suffer from reciprocity failure, where the relationship between aperture and shutter speed breaks down.

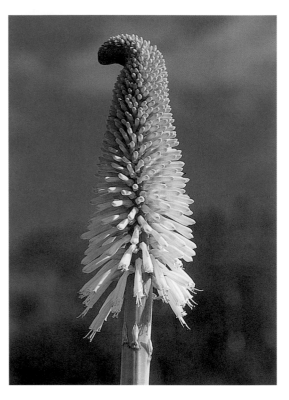

▲ Kniphofia hybrid, National Botanic Garden of Wales
The camera's internal exposure meter coped perfectly with this bright, highly reflective flower set against blue sky.

CAMERA Nikon F4
LENS 28mm f/2.8 wide-angle
FILM Fujichrome Velvia
SHUTTER SPEED 1/30 sec
APERTURE f/11
FILTER circular polarizer

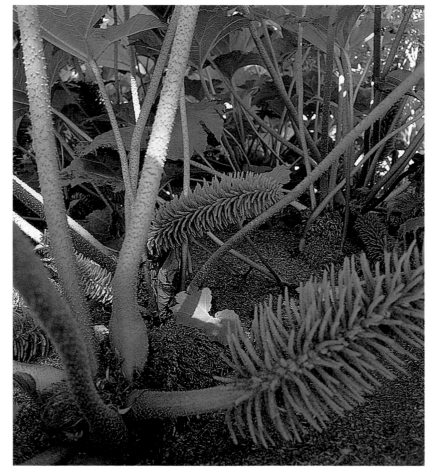

◀ Gunnera (*Gunnera tinctoria*), Terceira, Azores
Little light penetrates below the huge leaves of gunnera, but occasional shafts can pick out stems in the shade. The camera was mounted on a tripod to allow a slow shutter speed to be used.

CAMERA Nikon F4
LENS 24mm f/2.8 AF wide-angle
FILM Fujichrome Provia
SHUTTER SPEED 1/4 sec
APERTURE f/11

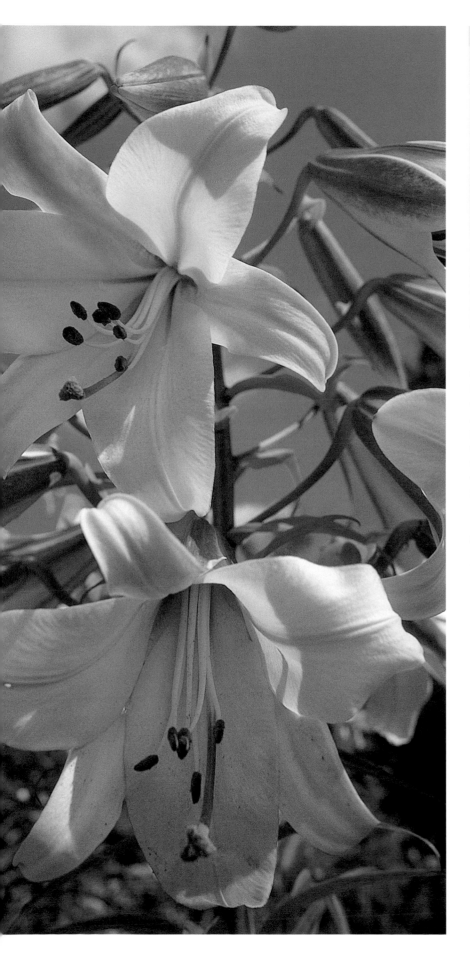

RECIPROCITY FAILURE

We take it for granted that an exposure of 1/60 sec at f/8 is equivalent to 1/30 sec at f/11 or to 1/125 sec at f/5.6—moving from one stop to the next on the aperture ring either halves or doubles the light entering the lens. However, at exposure times of 1 sec or longer, a film may not behave in this predictable way. There is no problem with Fujichrome Sensia, Provia, or Astia, the Kodak Elite Chromes (100/200/400), or with Ektachrome E100S and E100W, where no correction is needed up to 10 sec. Velvia requires an extra 2/3 stop at exposures between 1 sec and 10 sec. Ektachrome 100 and Kodachromes 25 and 64 need, in my experience, between 1/2–1 stop extra at these speeds, and you need to bracket exposures.

◄ **Hybrid lilies "Golden Clarion," Royal Horticultural Society Garden, Wisley, England**
A Lumiquest reflector was used to throw light into the trumpets of these hybrid lilies and so reduce the tonal range the film had to handle. A polarizer cut out reflection from the petals, intensifying their color, and also gave a boost to the blue of the sky.

CAMERA Mamiya 645 pro TL
LENS 45mm f/2.8 wide-angle
FILM Fujichrome Velvia
SHUTTER SPEED 1/30 sec
APERTURE f/11
FILTER linear polarizer

Yellows

THE ACCURATE RENDITION of yellow flowers, or more particularly the details on yellow petals, can be quite a problem. Modern film emulsions are excellent with neutral greens, reds, and blues, and for highlight and shadow detail. Yet yellow can often appear burnt out, and careful exposure control is needed.

The problem is that yellow flowers are highly reflective and can delude an exposure meter: you need to be aware of how tones are rendered (see pages 12–13) and make adjustments. Using a spot meter, I find ²⁄₃–1 stop overexposure gives bright but saturated yellows, but the amount can vary from camera to camera, and other meter modes may take too much of the background into consideration unless your subject virtually fills the viewfinder.

Retaining detail

Springtime floral displays in the Mediterranean, southern Africa, and many parts of the USA often feature yellow daisies and their close relatives. These can be captured spectacularly using a wide-angle lens, especially on fine-grain films such as

Yellow tulip (*Tulipa australis*), Monte Sibillini, Italy
Flash was used to bring out the richness of the tones in the tulip. The camera's matrix meter needed no correction, balancing all the elements in the picture. If yellow had occupied more of the frame, then a slight overexposure might have been needed.

CAMERA Nikon F4	**SHUTTER SPEED** ¹⁄₆₀ sec
LENS 105mm f/2.8 AF macro	**APERTURE** f/16
FILM Fujichrome Provia	**LIGHTING** SB21B twin flash

Crack willow (*Salix fragilis*), near River Thames, Oxford, England
The white silken hairs and yellow stamens of the catkin are highly reflective, and an exposure increase of ²⁄₃ stop was used to record the yellow as a bright tone.

CAMERA Nikon F4

LENS Sigma 180mm f/3.5 AF apo macro

FILM Fujichrome Velvia

SHUTTER SPEED ¹⁄₆₀ sec

APERTURE f/22

LIGHTING homemade twin flash

Fujichrome Velvia or Provia 100F and Koda-chrome 25. However, when you make large prints from successful 35mm transparencies—either from Cibachrome or on your ink-jet system—the individual flowers tend to become burnt-out blobs of yellow. Repeated disappointment with rendition of yellows provided the incentive for me to begin using roll film again for flowers in the landscape. The larger film area utilized when you photograph the same scene on roll film as you see through your 35mm viewfinder means that more grains of emulsion go into making up the image of each flower. This allows better rendition of fine detail.

Surface reflection

When photographing sunflowers in daylight I always use a polarizer, not only to achieve an amazing blue sky as a backdrop but because the filter cuts surface reflection from the yellow flower parts, and this has the direct effect of intensifying the yellow. The degree of polarization you use is a matter of personal taste, but if it is overdone it can produce an almost black sky when the sun is at a low angle.

The same caveats about exposure apply when you are taking close-up shots with flash. With any new camera or TTL flash, you can just expose a few frames of your favorite film on a yellow chrysanthemum, for example. Bracket exposures with $+\frac{1}{3}$, $+\frac{2}{3}$, and even 1 stop, then keep the resulting shots in your "test file" for reference. The exposure correction that gives yellows the "zing" you want and still preserves the finer details, such as the veins in flower petals, is the one to choose.

▲ **Crown daisy (Chrysanthemum coronarium), Chania, Crete, Greece**
Detail on a yellow subject is rendered more faithfully on roll film, where more of the emulsion is used to record each part than is the case with 35mm. The danger of using the latter is that yellow flowers simply become burnt out on enlargement.

CAMERA Mamiya 645 pro TL
LENS 45mm f/2.8 wide-angle
FILM Fujichrome Provia 100F
SHUTTER SPEED 1/60 sec
APERTURE f/16
FILTER polarizer

Problem Blues

Emulsion layers in films are sensitive to "hidden" wavelengths in the near infrared and ultraviolet regions of the spectrum, which the human eye cannot register. The pigments (anthocyans) in some apparently blue flowers reflect this invisible radiation, which then affects the film and produces false colors.

An overhead canopy may affect the light transmitted in a way that can result in peculiar colors. In a wood in spring, for example, the intense bright green of new beech leaves creates a color cast on bluebells flowering beneath.

One solution is to employ flash subtly, using it to illuminate the subject in the foreground while mixing it with natural light from the background (see page 35). Color correction filters can also be helpful. A 20cc blue filter gives a more accurate blue, but the drawback is that the surrounding leaves can take on a blue-green hue.

The slower the emulsion, the more faithfully it seems to record blues: Kodachrome 25 was long the film of choice for many flower photographers, although other slow emulsions also work well. Weather and light conditions can make a great difference. Diffuse light on a bright day with light cloud cover can be effective. The best weather, however, is dull or even rainy. In such conditions there is little scattered infrared or ultraviolet radiation to react with the emulsion layers in films and produce unpredictable results. Other colors also take on a surprising vibrancy in dull weather, and this approach has proved successful using standard film stock of Velvia and Provia.

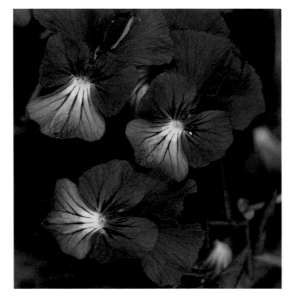

▷ **Trumpet gentians (*Gentiana acaulis*) with other alpine flowers, Umbria, Italy**
Light cloud on a rather dull day provided a diffuse light that rendered the blue of these gentians more accurately than direct sun.

CAMERA Nikon F4
LENS 24mm f/2.8 AF wide-angle
FILM Fujichrome Velvia
SHUTTER SPEED ⅛ sec
APERTURE f/16
FILTERS circular polarizer, UV

◁ **Bertoloni's pansies (*Viola bertolonii*), Umbria, Italy**
Here, the slight purplish hue of the pansies reproduced accurately with flash but not with direct sunlight.

CAMERA Nikon F4
LENS Tamron 90mm f/2.8 macro
FILM Fujichrome Velvia
SHUTTER SPEED 1/60 sec
APERTURE f/16
LIGHTING SB21B microflash

▷ **Spring gentians (*Gentiana verna*), Umbria, Italy**
At first sight these gentians would appear to be colored a "difficult" blue, but unlike their trumpet relatives they seem to reproduce accurately on film even in bright sunlight. If possible, photograph blue flowers both in sunlight—diffused or direct—and in duller conditions.

CAMERA Mamiya 645 super
LENS 80mm f/4 macro
FILM Fujichrome Provia
SHUTTER SPEED 1/60 sec
APERTURE f/16
FILTER linear polarizer

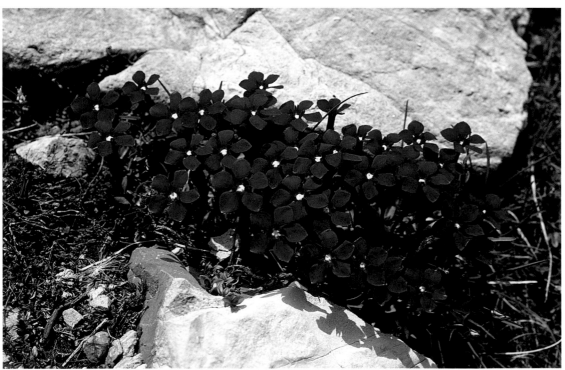

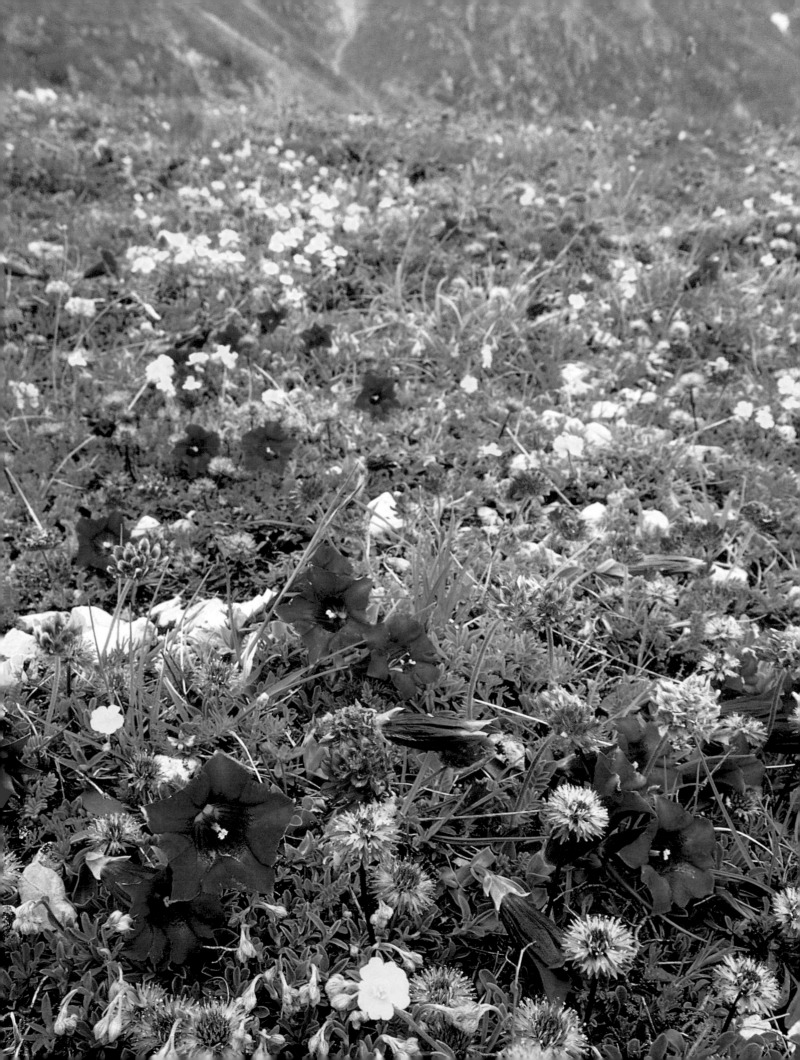

Plants in Snow

THE SIGHT OF THE FIRST CROCUS flowers in early spring, or of winter aconites pushing their buds through snow, always brings joy to the heart. The combination of fresh flower colors, green leaves, and crisp white snow is always an electric mix for the photographer.

The whiteness of the snow in the viewfinder will affect exposure readings unless you take a spot reading from the flowers or leaves, or use an incident light meter. Snow makes a meter believe that the available light is much brighter than it is, and this leads to an underexposure of around 1–1⅓ stops. The tried-and-tested advice for vacationers taking photographs in winter resorts is to take a reading for exposure from something that is mid-toned, such as the back of their hand, colored clothes, house roofs cleared of snow, or log cabin walls.

Although I always correct the exposure for subjects in snow, I also take a few shots based on the camera's own reading of the light intensity. This can produce spectacular effects by darkening icicles or revealing long shadows late in the day as the light falls across snow-covered fields.

When you are working in snow conditons, cold can affect the camera's performance.

▼ **Bramble leaf (*Rubus* sp), Cowbridge, Wales**
For the highly reflective ice crystals delineating the veins, I bracketed exposures, choosing the one that had just +⅓-stop correction. In fact, the matrix meter was so accurate it could have been trusted without correction.

CAMERA Nikon F4
LENS 60mm f/2.8 AF macro
FILM Fujichrome Velvia
SHUTTER SPEED 1/125 sec
APERTURE f/16
LIGHTING SB21B macroflash

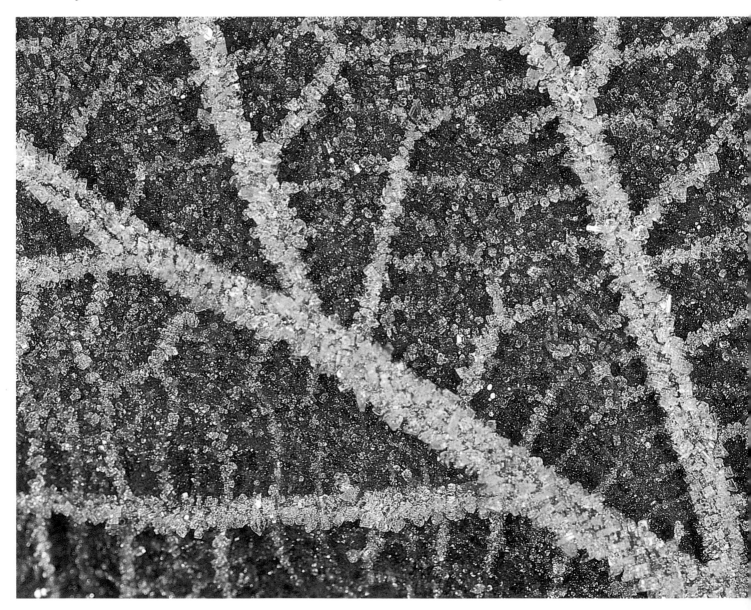

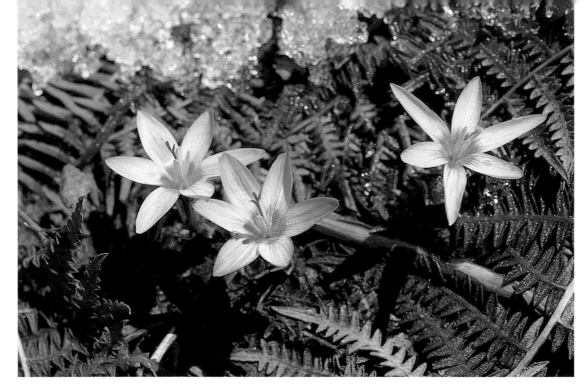

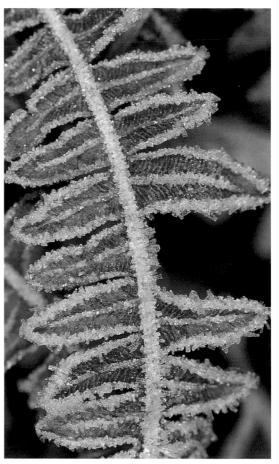

◄ Cyprus crocus (*Crocus cyprius*), Mount Chionistra, Cyprus

As soon as the snow melts on high mountains a host of flowers begin to bloom. Crocuses are my favorites, heralding the start of spring for another year.

CAMERA Nikon F4

LENS 28mm f/2.8 wide-angle

FILM Fujichrome Velvia

SHUTTER SPEED ¹/₃₀ sec

APERTURE f/16

FILTER none

▲ Stinging nettle (*Urtica dioica*), Oxford, England

A twin flash was used to illuminate the nettle leaves, and the TTL exposure was governed by the camera's matrix meter. The balance between light ice crystals and dark leaf in fact resulted in a neutral-toned subject.

CAMERA Nikon F4	**SHUTTER SPEED** ¹/₆₀ sec
LENS 60mm f/2.8 AF macro	**APERTURE** f/16
FILM Fujichrome Velvia	**LIGHTING** SB21B macroflash

Batteries, in particular, drain much faster when cold. Photographers working in cold regions overcome this problem by carrying a separate battery pack close to the body, connected to the camera via a cable.

In extreme cold, the lubricants used in camera gear trains can often become more viscous, and mechanical performance is affected adversely. To cope with this problem, a camera can be "winterized" by a qualified camera repairer, using special lubricants.

▲ Bracken frond (*Pteridium aquilinum*), Cowbridge, Wales

In the depths of winter the ground can appear devoid of life. Frost adds a transforming element, and you can explore the geometry of leaves and twigs carrying ice crystals.

CAMERA Nikon F4	**SHUTTER SPEED** ¹/₁₂₅ sec
LENS 60mm f/2.8 AF macro	**APERTURE** f/16
FILM Fujichrome Velvia	**LIGHTING** SB21B macroflash

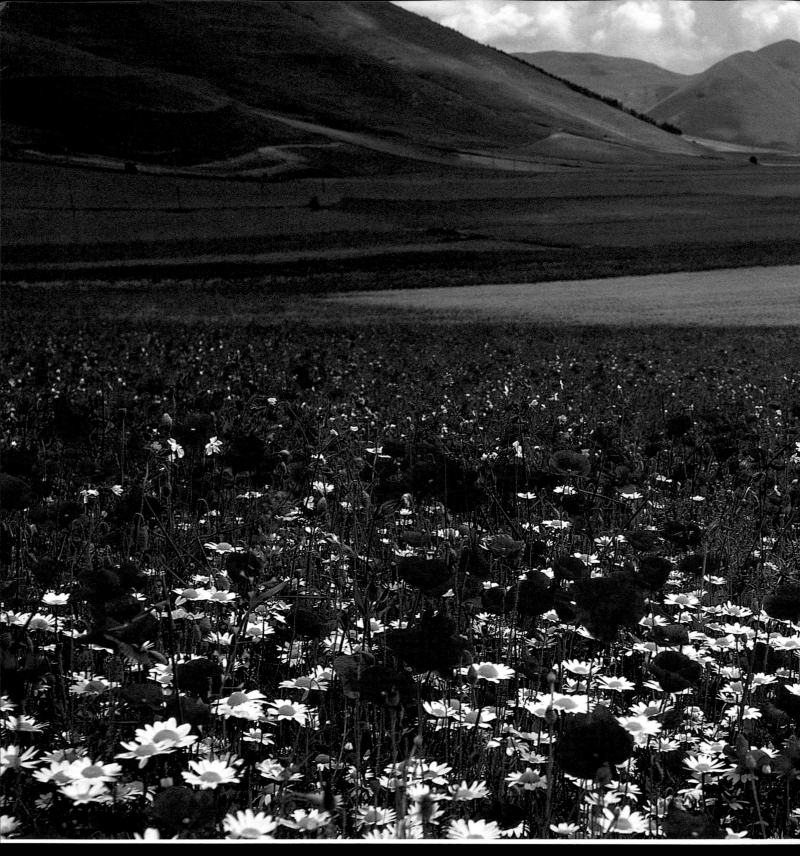

▲ **Cornfield "weeds," Piano Grande, Mte Sibillini, Italy**
Each year, high on the Piano Grande, poppies and cornflowers
flourish in abundance—the display is never in the same place.
The secret is to scan the landscape for the tell-tale strips of

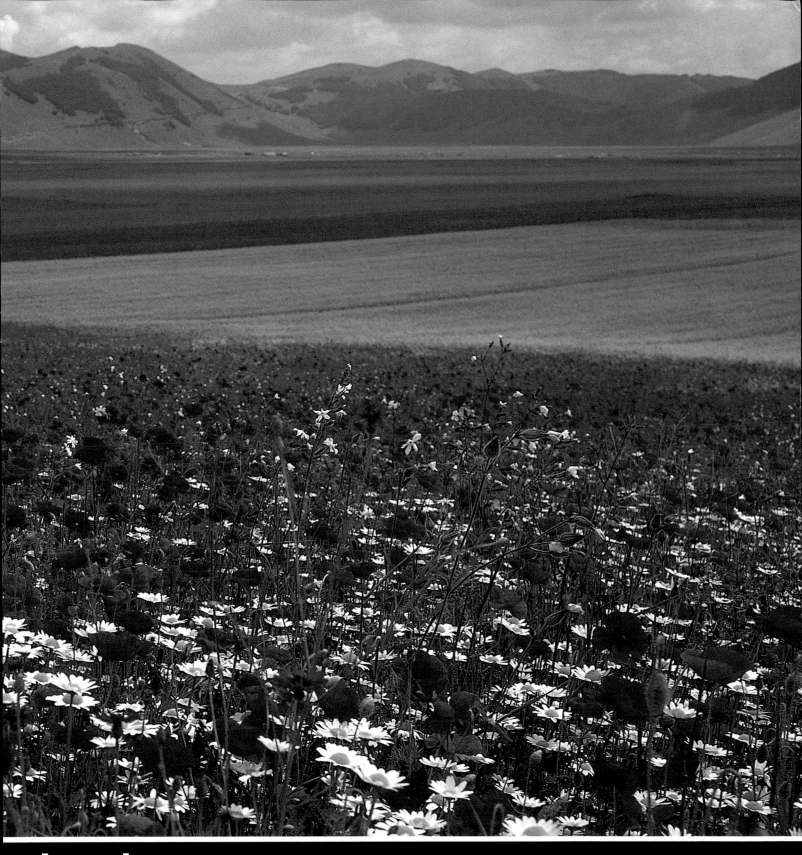

Lighting

LIGHT IN THE EARLY MORNING or late afternoon has a warmth that gives photographs taken at these times a very different quality from those taken in the harsh light of the midday sun. The position of the sun in the sky affects not only the direction of the light (see pages 26–27) but also its "quality."

In the nineteenth century, many painters became ecstatic about the quality of light in the Mediterranean region—particularly in Italy and the South of France—and they flocked there in the spring and fall. At these seasons the air is clearer than in summer, due to the comparative absence of dust particles.

Furthermore, the light is "warmer" because there is a greater proportion of those wavelengths of visible light toward the red end of the spectrum. When the sun is low in the sky, light from it is traveling obliquely through the atmosphere to reach the earth's surface. During this comparatively long journey, more light at the blue end of the spectrum is scattered and absorbed.

When photographing ancient sites, with their associated flowers, I choose to work in the early morning or from mid to late afternoon. Limestone or sandstone is often the base material for such ancient walls and columns, and the low angle of the sun reveals its surface texture, while the warmth of the light intensifies flower color.

In the couple of hours following sunrise, many flower buds begin to open, and nothing enhances the appearance of freshness better than droplets of dew. Roses, in particular, look their very best at this time of day.

When you cannot choose the time of day for your shots, color correction filters are useful: on a dull day with a "cool" edge to the light, a warming filter can help considerably (see page 29).

Wild delphiniums (*Consolida ambigua*), Anatolia, Turkey
A low sun highlighted these delphinium flowers so that the field stood out from far away. By the time we reached them the sun had disappeared behind clouds on the horizon. We went on working until it was barely possible to see.

CAMERA Nikon F4
LENS 24mm f/2.8 AF wide-angle
FILM Fujichrome Velvia
SHUTTER SPEED 1/4 sec
APERTURE f/16
FILTER warming 81B

Color balance

Even in the middle of a sunny day, light from a hazy white sky has a very different quality from light from a cloudless blue sky, and flower colors, which we perceive by reflected light, are affected. Color temperature is a way of describing the color content of "white" light from any source. It also categorizes artificial light from tungsten and other sources.

Essentially, white light is the continuous radiation emitted by a very hot object—the hotter an object gets, the brighter the light and also the higher the proportion of the energy emitted at the blue end of the spectrum. As you increase the electric current through the filament of a light bulb it glows first dull red, then red, orange-red, yellowish white, bright white, and eventually bluish-white.

COLOR TEMPERATURE

Light source	Color temperature (degrees K)	Conversion filter for daylight balanced film	Exposure increase
Clear blue sky	10,000–15,000	orange 85B	⅔ stop
Open shade in summer sun	7,500	warming 81B or 81C	⅓ stop
Overcast sky	6,000–8,000	warming 81C	⅓ stop
Sun overhead at noon	6,500	warming 81C	⅓ stop
Average daylight (4 hours after sunrise to 4 hours before sunset)	5,500	none	
Electronic flash	5,500	none	
Early morning or late afternoon	4,000	blue 82C	⅔ stop
One hour before sunset	3,500	blue 80C	1 stop
Tungsten photopearl	3,400	blue 80B	1⅔ stops
Quartz bulbs	3,200–3,400	blue 80A	2 stops
Tunsgten photoflood	3,000–3,200	blue 80A	2 stops
Household lamp 100W	2,900	blue 80A+82C	2⅔ stops
Golden sunset	2,500	blue 80C+80D	
Candlelight or firelight	2,000	blue 80A+80B	

▲ Meadow flowers, Gargano, southern Italy

I like the afternoon light in spring, when its warmth is just right for bringing out the colors in flowers such as the pink hawksbeard (*Crepis rubra*). I tend to use a polarizer as a matter of course for the slight intensification of color it gives.

CAMERA Mamiya 645 pro TL **SHUTTER SPEED** ¹/₆₀ sec
LENS 45mm f/4 wide-angle **APERTURE** f/8
FILM Fujichrome Velvia **FILTER** linear polarizer

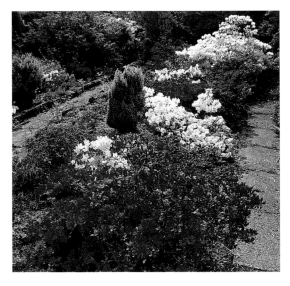

▲ Garden border with azaleas, Wales

I try to avoid overhead sun, but in spring the sun is not high in the sky even at midday. To add warmth, use a warming filter, which gives the effect of late-afternoon light.

CAMERA Mamiya 645 pro TL **SHUTTER SPEED** ¹/₆₀ sec
LENS 45mm f/4 wide-angle **APERTURE** f/11
FILM Fujichrome Velvia **FILTER** warming 81A

Direction of Light

IF YOUR PHOTOGRAPHS ARE LOOKING "flat," this is usually because lighting and its direction have been overlooked. Lighting for photography falls into two broad categories: frontal lighting and back lighting.

Frontal lighting

As the name suggests, for frontal lighting the light source—whether natural light, flash, or tungsten—is placed in front of the subject.

The midday summer sun provides harsh overhead lighting, and lack of shadow gives featureless results. Shadows are extremely important in two-dimensional images, for they create modeling by distinguishing one side of an object from the other. Surface relief—the way all the details on a surface cast tiny shadows—is also essential to the way we gain the impression of sharpness in a photograph.

In the morning and evening the light is strongly directional, and winter sunlight with its low angle creates lengthy shadows. When photographing lichens on rock, for example, I find that late afternoon sunlight gives just the relief needed to show them at their best.

⬛ **Red tulips (*Tulipa doerfleri*), Crete, Greece**
Flowers with "globes" always look better with a degree of back lighting, which makes the petals glow. For this, the sun must be fairly low in the sky—you can choose early morning or late afternoon, according to the direction that gives the background you want.

CAMERA Mamiya 645 pro TL	**SHUTTER SPEED** 1/15 sec
LENS 45mm f/2.8 wide-angle	**APERTURE** f/16
FILM Fujichrome Velvia	**FILTER** linear polarizer

RELIEF AND SHADOWS

It is the angle at which light strikes a surface that creates the impression of relief in a two-dimensional image by casting shadows on a surface.

When I am running photography workshops on close-up and still-life work, I always suggest that the participants investigate the effects of lighting by moving a couple of desk lamps around an object that has a fair amount of surface detail (see pages 124–125). By moving first one lamp, then two, you can see how the effect of the light varies when it is close to the lens axis and when it comes from a range of directions all the way to an extreme glancing angle. This exercise does not take long to do, but it will help you to understand the importance of lighting angle, both in the field and in the studio.

The further to one side of an object the light source, the more prominent the tiny shadows cast by surface details and the more pronounced the effect of relief. A second light source on the other side can be positioned to throw some light into the shadows and control their depth. In natural light, you can achieve this using a reflector (see pages 34–35).

▶ **Cornfield weeds, Umbria, Italy**
A chance look over a wall revealed these "weeds" at chest height on the other side. The morning light picked out hairs on the stems and gave the picture the "feel" I wanted: a celebration of nature—gardener *extraordinaire*—with a collection of flowers rarely seen in this age of intensive cultivation.

CAMERA Nikon F4
LENS 24mm f/2.8 AF wide-angle
FILM Fujichrome Velvia
SHUTTER SPEED 1/30 sec
APERTURE f/11
FILTER circular polarizer

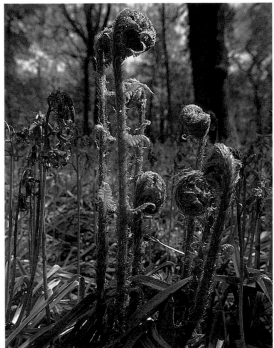

▲ **Bracken fronds (*Pteridium aquilinum*), Henley-on-Thames, England** *(photo Lois Ferguson)*
With a mixture of frontal and back lighting, the hairs on the unfurling fronds of young bracken are accentuated, making the fronds stand out against the sea of bluebells beyond.

CAMERA Nikon F60	**SHUTTER SPEED** ¹/₃₀ sec
LENS Sigma 24mm f/2.8 AF wide-angle	**APERTURE** f/11
FILM Fujichrome Provia	**FILTER** circular polarizer

Back lighting

When flowers have large petals and a globular, or cup, shape—such as tulips or poppies—light from behind makes the flowers appear to glow. Back light is also good at picking out the tiny hairs on plant stems or showing the veins on brightly colored, translucent leaves.

Care is needed when using wide-angle lenses with back lighting, as it is easy to induce flare if the sun is too near the field of view. This softens the image and creates flare spots. It is important to use a suitable lens hood (even the skillful use of a hand just out of the field of view may be sufficient) and to adjust your position so that the subject is still back lit but the sun is further out of view. Avoid taking your exposure reading directly from the back-lit area—it will be reproduced as a mid-tone. Instead, take your reading from petals that are not lit in this way, and the back-lit parts will appear much brighter.

Bright Sun

Light reflected from non-metallic surfaces is plane-polarized. When sunlight is scattered from molecules in the upper atmosphere—the process that gives us blue skies—it is also polarized to a degree. In photography, polarizing filters can be used to enhance the blue of the sky. The maximum effect is obtained by facing the sun and then turning 90 degrees either way.

Surface reflections from water can be cut out in the same way, by pointing the lens at the water surface along an axis at about 54 degrees to the vertical (the Brewster angle). The colors of flower petals and leaves appear to be intensified in the absence of reflections from their surfaces.

The best position for intensifying the blue of the sky is unlikely to coincide with the best position for reducing leaf reflections. You will have to arrive at a compromise between the two.

Neutral density filters

The contrast between land and sky can sometimes be too great for a film to handle. Graduated neutral density filters vary from clear to a

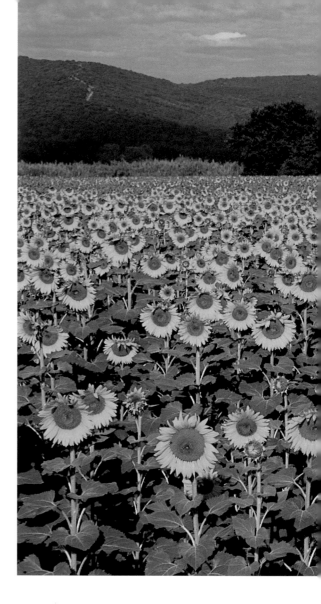

> **Sunflowers (Helianthus annuus), Provence, France**
> Fields of sunflowers, grown as a crop, cover vast expanses in southern Europe, and they are highly photogenic. A graduated neutral density filter reduced the contrast between ground and sky and the polarizer was used both to enhance the blue of the sky and to cut reflection from the leaves and petals.

CAMERA Nikon F4
LENS 24mm f/2.8 AF wide-angle
FILM Fujichrome Velvia
SHUTTER SPEED ¹/₁₅ sec
APERTURE f/16
FILTERS graduated neutral density; circular polarizer

> **Bermuda buttercups (Oxalis pes-caprae) Algarve, Portugal**
> (photo Lois Ferguson)
> Clear January light made these flowers almost sing out—as the yellow is highly reflective, a polarizer was used to cut reflections and intensify the color.

CAMERA Nikon F60
LENS Sigma 24mm f/2.8 AF wide-angle
FILM Fujichrome Provia
SHUTTER SPEED ¹/₃₀ sec
APERTURE f/16
FILTER circular polarizer

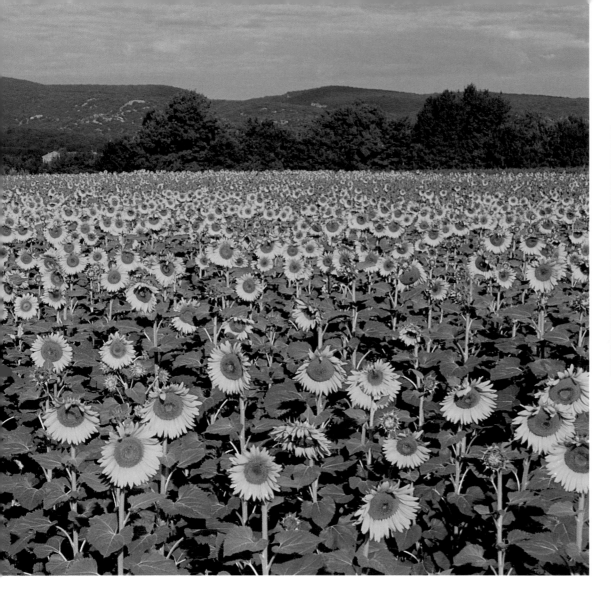

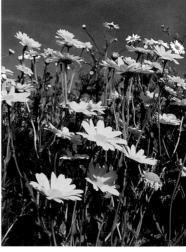

△ **Sunflowers (*Helianthus annuus*), Provence, France**
Overuse of a polarizer in the late afternoon can turn a blue sky nearly black, which is dramatic but unrealistic. Sunflower leaves can appear gray because of the light they reflect from their surfaces—a polarizer cuts this out. However, when the light from the blue sky and the leaves is not polarized in the same direction. you have to make compromises.

CAMERA Nikon F4
LENS 28mm f/2.8 wide-angle
FILM Fujichrome Velvia
SHUTTER SPEED 1/30 sec
APERTURE f/16
FILTER polarizer

predetermined gray that cuts light intensity. They are used in a filter holder that allows you to match the graduated region with a horizon.

Color correction filters

On gray days, or when the sky is bright but white, the 81 series of warming filters is useful. The filters are coded 81A–81F in order of increasing strength. They can also accentuate warm light such as sunsets. A correspondingly cool cast can be created with the 82 series: 82A–82C.

Clear ultraviolet (UV) filters can reduce the bluish cast on film exposed in mountain regions, where the light has a high UV content. But you have to bear in mind that every piece of material put in front of a lens, however clear, causes deterioration in the image. Over time, glass filters can get dirty and greasy, and resin filters are easily scratched, softening the image.

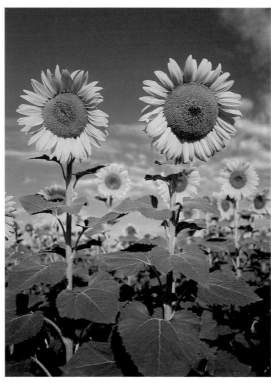

◁ **Corn marigolds (*Chrysanthemum segetum*), Gower, Wales**
A polarizer will bring out wispy clouds you did not even notice were there when you took the picture.

CAMERA Nikon F4
LENS 28mm f/2.8 wide-angle
FILM Fujichrome Velvia
SHUTTER SPEED 1/30 sec
APERTURE f/11
FILTER circular polarizer

Diffuse Light

Ask any keen plant photographers about their favorite lighting conditions and they will almost always wax lyrical about the softness of diffuse sunlight. Some will favor diffuse light for woodland and meadow flowers, and bright sunshine to bring out the best in boldly colored desert flowers.

Diffuse sunlight is the light seen on bright days when the sky is lightly overcast with wispy cloud cover, or on sunny days when there are plenty of white fluffy clouds in the sky acting as secondary light sources. In these conditions, the sky effectively becomes a very broad light source and shadows are softened because light is thrown into them from a range of directions. The effect is quite different from the highly directional harshness of a bright point source such as the midday sun in a clear sky.

In the studio, such lighting can be mimicked by using umbrellas, or even by bouncing the light off white walls. Portrait photographers generally use diffuse lighting because it is much more flattering to faces.

Large hammerhead flash guns have enough power to be used far from a subject, but they then act as point sources and produce shadows that are unacceptably hard. Some have integral or clip-on diffusers, or can be fitted with softboxes to create broad sources. The lighting is then much better when used for close-ups (see pages 114–115), since the shadows are diffuse and there is a softer "feel" to the lighting.

Photographers can become overly concerned about their use of appropriate lighting. Some refuse to use flash at all and feel that the only acceptable light for flowers is soft, diffuse, natural light. But the fact is that plants and their details are extraordinarily diverse, and a thorough appreciation of the various other forms of lighting that are available to you can help you bring out different aspects of their "character" in your photographs. It is important to remain open to all the possibilities.

Bluebells (*Hyacinthoides non scripta*) near Henley-on-Thames, England *(photo Lois Ferguson)*
On film, diffuse light on a dull day produces far more realistic colors for bluebells than direct light. However, young leaves in the tree canopy can impart a cool green cast to the picture; this can be improved by using a warming filter, or removed by the addition of magenta at the print manipulation stage.

CAMERA Nikon F60
LENS Sigma 24mm f/2.8 AF wide-angle
FILM Fujichrome Velvia
SHUTTER SPEED 1/15 sec
APERTURE f/11
FILTERS 81A warming, circular polarizer

DIFFUSION TENTS

When sunlight is highly directional, a diffusion tent offers more suitable light conditions. It is basically a cone of diffusing material lit from the outside. The largest tents will allow the photographer, camera, and tripod all to be enclosed with the subject in an environment where shadows are soft and there is no air movement. This permits lengthy exposures to ensure the greatest depth of field. Diffusion tents work particularly well on sunny days in woodlands. They reduce the contrast between the shadows and shafts of sunlight that penetrate the leaf canopy.

Small light tents are very useful in the home studio (see pages 124–125), lit by several flash guns or tungsten lamps. The camera lens pokes through an aperture in the side or top. Surrounding reflective subjects with light in this way reduces specular images—hot spots that, when magnified, prove to be disturbingly detailed images of lamps or windows.

▲ **Astilbe hybrid, garden origin, near Oxford, England**
Light cloud cover imparts a softness to flower colors and yet allows enough light to make exposures, even with slow films. I find that purples are also recorded more faithfully in these conditions than in direct sunlight.

CAMERA Mamiya 645 super pro TL F4	**FILM** Fujichrome Velvia
	SHUTTER SPEED ¹/₃₀ sec
LENS 45mm f/4 wide-angle	**APERTURE** f/11

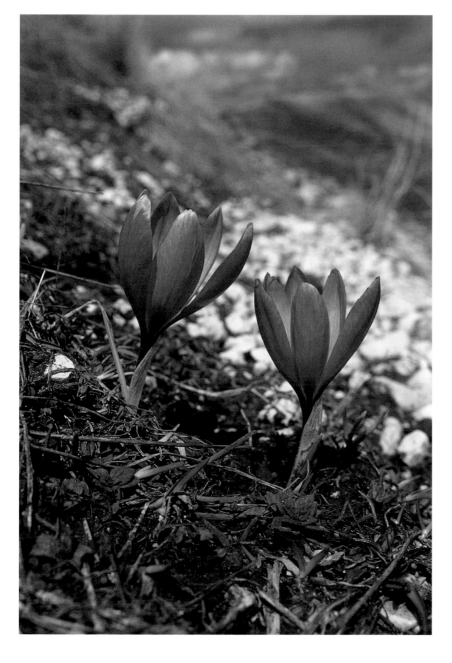

◄ **Spring crocus (*Crocus vernus*), Umbria, Italy**
The presence of light cloud not only improved the color rendition of the flowers and softened shadows but also reduced glare from patches of highly reflective rock everywhere in the mountain landscape.

CAMERA Mamiya 645 pro TL F4	**SHUTTER SPEED** ¹/₃₀ sec
LENS 45mm f/2.8 wide-angle	**APERTURE** f/16
FILM Fujichrome Velvia	**FILTER** linear polarizer

Rain and Reflections

MANY WOULD-BE plant photographers are reluctant to take photographs in the field in wet weather. Yet you will find that colors actually acquire a certain vibrancy when they are photographed in the rain.

A fine atmospheric mist of water droplets acts to filter out both ultraviolet and infrared radiation. The blues of mountain flowers such as gentians, or bluebells in woodland, are especially vibrant on rainy days.

Mountain clouds and early morning mists condense on flowers into fine water droplets. You can simulate this with an atomizer spray on fruit

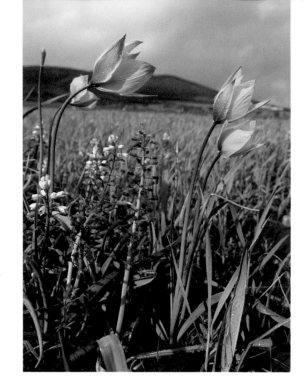

⟫ **Yellow tulips (*Tulipa australis*), Gargano, Italy**
On rainy days colors can be really vibrant. Unfortunately there is a downside to working in rain: these plants grew in fields where the fine, wet soil built up on my boots, making movement difficult.

CAMERA Mamiya 645 super pro TL
LENS 45mm f/2.8 wide-angle
FILM Fujichrome Velvia
SHUTTER SPEED 1/15 sec
APERTURE f/11

⟫ **Raindrops on variegated grass leaf, Gower, Wales**
Raindrops offer many possibilities, especially when combined with leaf veins. Remember that highlights occur in water drops and both heads of a twin flash will be faithfully reflected in each drop. I try to use a single flash head with a diffuser.

CAMERA Nikon F4
LENS 105mm f/2.8 AF macro
FILM Fujichrome Velvia
SHUTTER SPEED 1/30 sec
APERTURE f/16
LIGHTING single flash

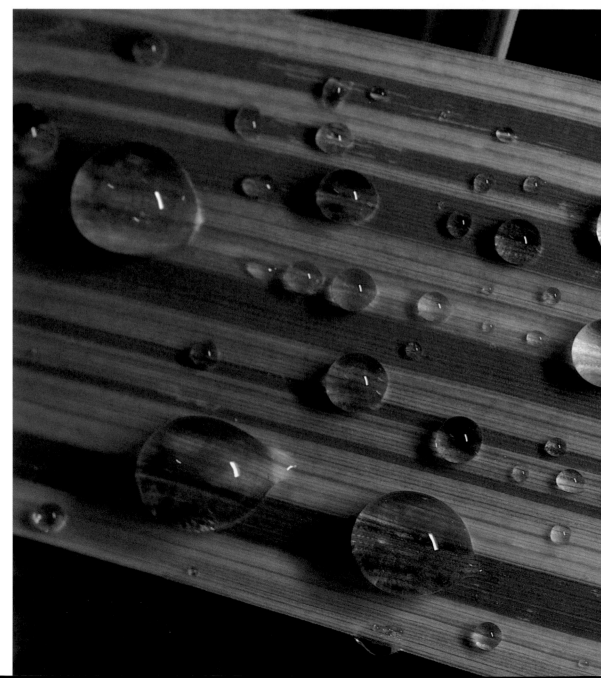

and vegetable arrangements in the studio to give that essential impression of freshness.

The French painter Pierre Joseph Redouté made water droplets on petals a trademark in his extraordinarily detailed studies of roses at the end of the eighteenth century, and the idea has been enthusiastically adopted by photographers. But, like any technique, it can easily be overdone and become clichéd.

Moisture and electronic systems do not go well together, so if you are going to work for any length of time in situations in which you will encounter mist, rain, or even the risk of sea spray, a camera cape is an excellent investment. It fits around the lens and covers camera, lens, and photographer while the pictures are taken.

IMAGES IN RAINDROPS

The lens effect of raindrops can be used to create intriguing trick shots by positioning the camera so that you see a tiny image of a flower in each drop. I have used this technique in the early morning, when grasses are laden with droplets. You need to beware of careless movement or sudden breezes, which can unsettle drops and ruin your intentions.

When experimenting at home, you can try using different liquids: glycerol is used by food photographers to simulate water droplets, but nothing produces natural looking drops like water. I have sprayed the stamens of large lilies very lightly with silicone wax to lower the surface tension, permitting larger droplets to form under control. I was then able to move the subject and create the images I wanted in the drops.

Each droplet is in effect a lens of short focal length and thus must be very close to the subject you want to shoot—so close that the subject itself forms a virtually unrecognizable background. I have found that a long-range macro lens —in my case a Sigma 180mm f/3.5 apo macro—gives excellent results.

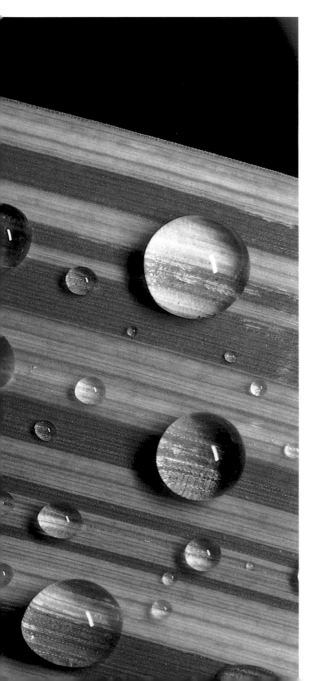

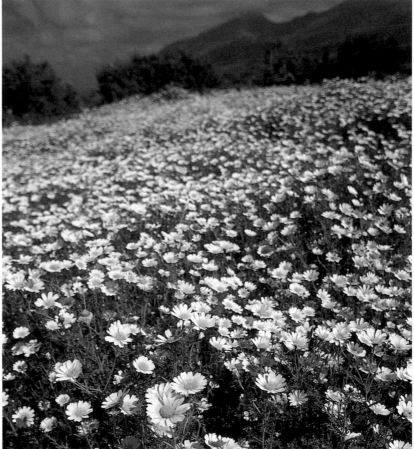

▲ **Crown daisies (*Chrysanthemum coronarium*), northern Crete, Greece**
Storm light produces almost black skies with front-lit subjects. For just a few moments these crown daisies were lit by sunlight from a break in the clouds. Storm light does not occur to order, of course; you have to seize your chances during changeable weather in spring and fall.

CAMERA Mamiya 645 pro TL
LENS 45mm f/2.8 wide-angle
FILM Fujichrome Velvia
SHUTTER SPEED 1/60 sec
APERTURE f/16
FILTER circular polarizer

Reflectors

Sometimes, particularly in bright or highly directional sunlight, you may be faced with bright highlights and dark shadows on the same flower. Results are always disappointing when you try to make a film do more than it was designed to do. A reflector can be used to throw some light into the shadows and reduce the contrast range the film has to handle.

⚠ **Hybrid lily, garden origin, Royal Horticultural Society Gardens, Wisley, England**
A small foldable reflector was used to throw light onto the stamens of the flower, which were deeply shaded by the petals of the lily, to allow a closer match with the contrast range of the film.

CAMERA Nikon F801	**SHUTTER SPEED** ¹/₃₀ sec
LENS Sigma 24mm f/2.8 AF wide-angle	**APERTURE** f/16
	FILTER circular polarizer
FILM Fujichrome Provia	

While sheets of white paper (or even white summer hats) can be better than nothing at all in an emergency, I carry a couple of Lastolite reflectors. These are highly portable and unfurl with a deft flick of the wrist. They have a white surface on one side and silver (or gold for warm tones) on the other. In larger sizes they can also be used to throw light into bushes when you are dealing with shots of whole plants—an obliging assistant or a propped-up camera bag can support the reflectors while you check the result through the viewfinder and make hands-free adjustments to get the degree of shadow you want.

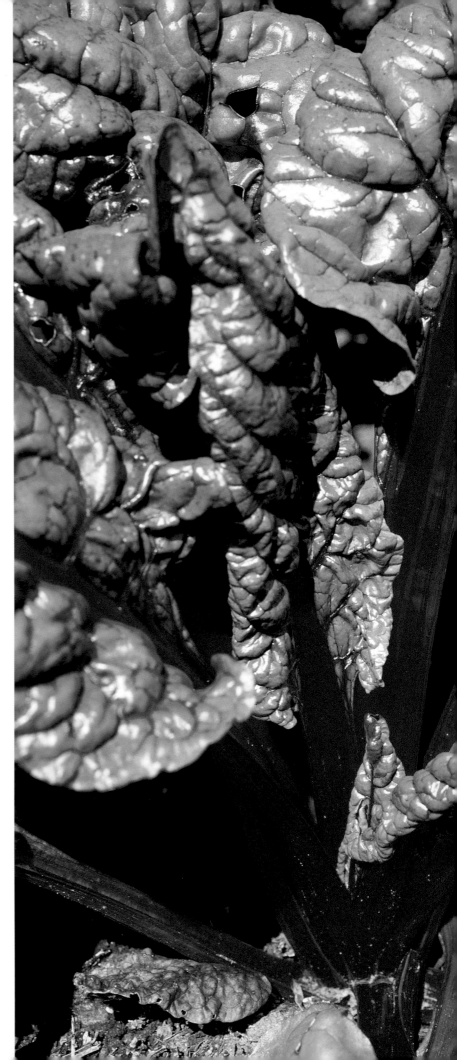

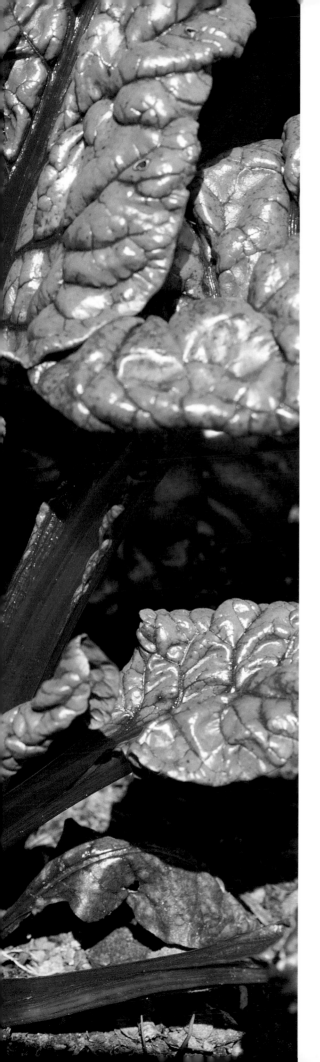

◀ **Ornamental chard (*Brassica* sp), Bath, England**

The red stems of this ornamental chard were obscured by the dark green leaves so, to bring out the strong color contrast, a large Lumiquest reflector was positioned to light the stems. The effect was checked and modified through the viewfinder.

CAMERA Mamiya 645 super pro TL F4
LENS 45mm f/2.8 wide-angle
FILM Fujichrome Velvia
SHUTTER SPEED ¹⁄₃₀ sec
APERTURE f/16

▲ **Hazel leaf (*Corylus avellana*), Oxford, England**

This leaf was one of few remaining on the tree in late fall. A single flash was used together with a reflector held by a companion: the reflector became, in effect, a second light source of lower power, softening any harsh shadows.

CAMERA Nikon F4
LENS 28–80mm f/2.8 AF zoom
FILM Fujichrome Provia
SHUTTER SPEED ¹⁄₆₀ sec
APERTURE f/11
LIGHTING single flash with reflector

SYNCHRO-SUNLIGHT SHOOTING

I often mix together flash and natural light (see pages 118–119) when taking photographs in woodlands—a process called synchro-sunlight or fill-in flash. No sophisticated calculations are necessary. You first set the aperture manually to give the required depth of field, then adopt a shutter speed below the synchronization speed so the background is underexposed by up to 1 stop.

It is a good idea to use the integral diffuser in the flash gun or to employ a softbox on the front of a large flash gun to produce a broad light source.

The air must be perfectly still—and even photographer movement can affect this—otherwise you risk getting a "ghost" image generated by natural light in addition to the flash exposure of your subject. When photographing butterflies on flowers, the tiny nervous twitches of the insects' wings can produce the same ghosting if you are using a flash synchronization speed that is too low.

▲ **Spring color, Gargano Peninsula, Italy**
A chance turning toward the sea revealed a blaze of color on
sandy waste ground. Just three flower species contributed to
the color—pink silene, blue anchusa, and yellow vetches. The
camera was pointed to get different bleaches of color. Two
days later, the display had disappeared.

Plant Communities

Telling the Story

Aʟᴛʜᴏᴜɢʜ ᴘʟᴀɴᴛ ᴀɴᴅ ꜰʟᴏᴡᴇʀ images can be attractive in their own right, with a little imagination you can also capture other elements in the story. There is the question of habitat: how can it be portrayed most dramatically in relation to the plant (see pages 68–69)? What about close-ups of floral details, or of the insects that live on, or in the plant? Growing devices such as the spiral tendrils of climbing plants, or intriguing mechanisms for pollination or seed dispersal, can also be featured to enhance a picture and make it more informative. Alternatively, you can treat the flowers and leaves as abstract entities and let the design elements—shape, color, texture—speak for themselves.

Try never to say apologetically that a shot is "just a record," even when faced with flowers that have passed their best. It is always important to think about giving your pictures impact as well as making them useful. The botanical artist can use a degree of license in deciding which features to emphasize. So can you, to a certain extent, by your choice of lens and the viewpoint you select.

If you ever want to illustrate books on flowers, you must include diagnostic details that will aid in identification—and you need to research these before setting out, using authoritative floras. In my early days of flower photography, I photographed numerous yellow pea flowers, each filling the frame with an individual bloom. As a result it was impossible to tell to which species each belonged, since they all looked the same. Later, I was able to repeat many of the shots, and found that with a little judicious subject-moving it was possible to show leaf shapes, hairs on stems, tendrils, flowers, and even seedheads together in the same frame.

Biodiversity has become a buzzword as people slowly wake up to the complex web of plant and animal interrelations. By trying to capture examples on film, not only do you set yourself a challenge but your pictures may help to open the eyes of others, too.

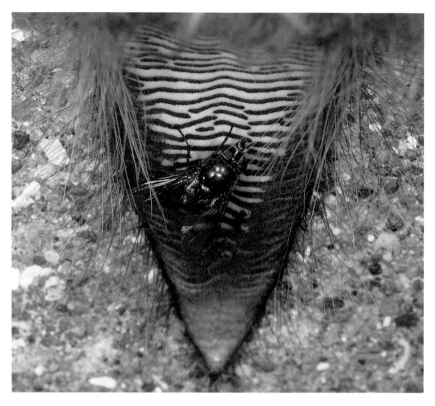

▲ **Toad cactus (*Stapelia variegata*), origin South Africa, pot-grown, Cowbridge, Wales**
The fetid scent of carrion produced by stapelia flowers attracts flies, who pollinate this plant.

CAMERA Nikon F4
LENS 105mm f/2.8 AF macro
FILM Fujichrome Provia
SHUTTER SPEED ¹⁄₆₀ sec
APERTURE f/16

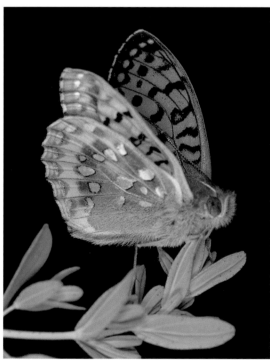

▲ **Fritillary butterfly (*Mesoacidalia aglaja*), Kenfig, Wales**
Insects use plants for many purposes, from specific food sources to a place to rest securely on a windy day, as here.

CAMERA Nikon F4
LENS 105mm f/2.8 AF macro
FILM Fujichrome Velvia
SHUTTER SPEED ¹⁄₆₀ sec
APERTURE f/16
LIGHTING SB21B macroflash

▶ **Cornfield weeds, Sibellini, Italy**
The story here is the sheer profusion of species in a traditional meadow. Setting flowerheads against the sky by adopting a low viewpoint helps to give impact.

CAMERA Mamiya 645 pro TL
LENS 45mm f/2.8 wide-angle
FILM Fujichrome Velvia
SHUTTER SPEED ¹⁄₃₀ sec
APERTURE f/16
FILTER polarizer

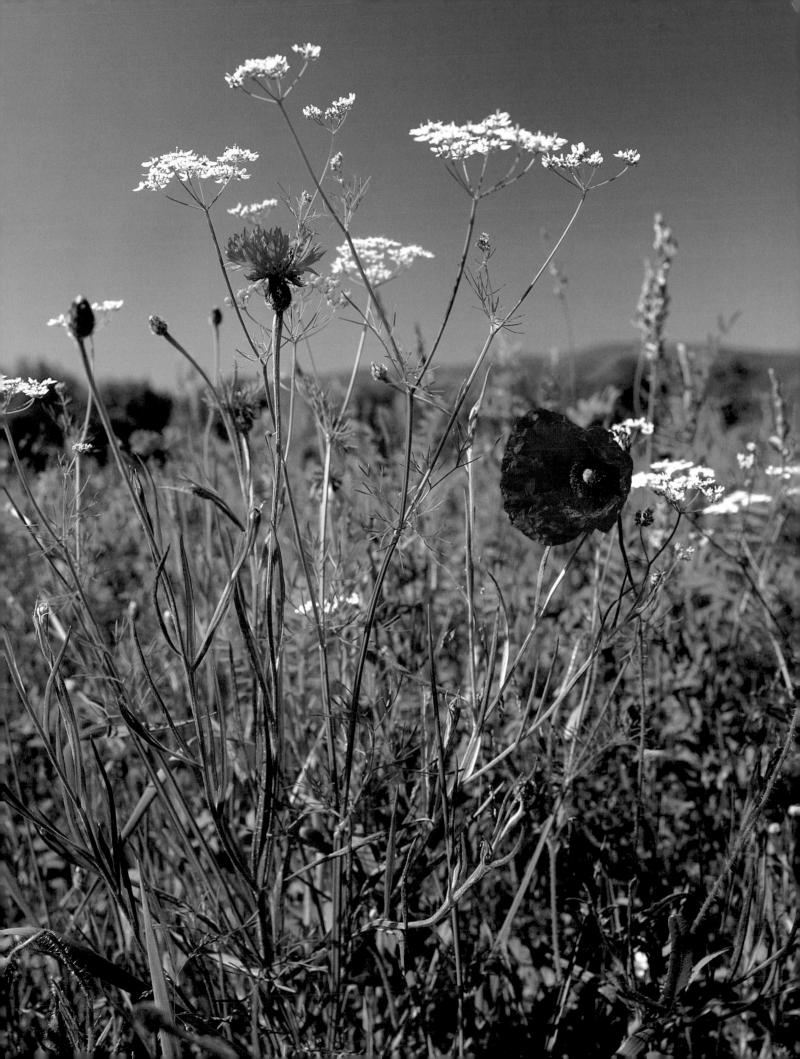

Meadows

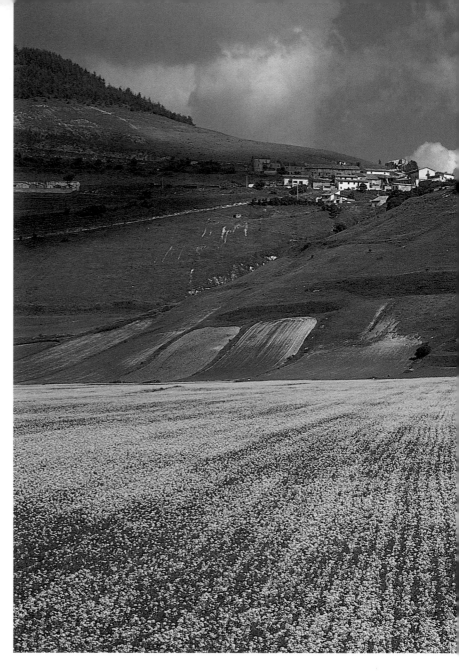

THE SEASONAL REGIMES of traditional cultivation in meadows and cornfields, and the grazing patterns on the grasslands and prairies of the world, have enabled unique collections of plants to adapt, evolve, and thrive over the millennia. Sadly, as intensive agriculture takes over, green desert results.

The legendary virgin prairie of the American Midwest is not easy to find now, but dedicated individuals have fought to create reserves where you can still see the glory of native flowers, and hints of former riches can be found at roadsides, where strips remain uncultivated and ungrazed. A sympathetic mowing regime by local authorities can assure the survival of marvelous flowers. Texas roadsides with their wild mix of blue bonnets (*Lupinus texensis*) and paintbrushes (*Castelleja indivisa*) are the supreme example.

Perhaps the world's finest grassland displays can be seen in Namaqualand in South Africa. If the winter rains have been good, this semi-desert region explodes with an abundance of daisies and mesembryanthemums for a short season of only a few weeks, from mid-August through into September. The locations of the most spectacular displays vary but, as in Texas, and for California's spring display of orange poppies (*Escholzia*), there

 Yellow tulips (*Tulipa australis*), Monte Sibillini, Umbria, Italy

Damp areas that persist after the snow melts are havens for a range of spectacular bulbs that flower *en masse*. My favorites are a mixture of yellow tulips and white poet's narcissus, which appear in early May.

CAMERA Mamiya 645 pro TL
LENS 45mm f/4 wide-angle
FILM Fujichrome Velvia
SHUTTER SPEED 1/30 sec
APERTURE f/11
FILTER linear polarizer

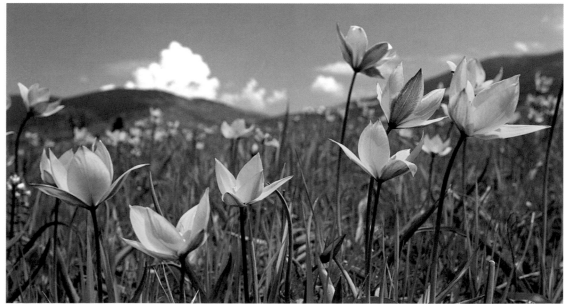

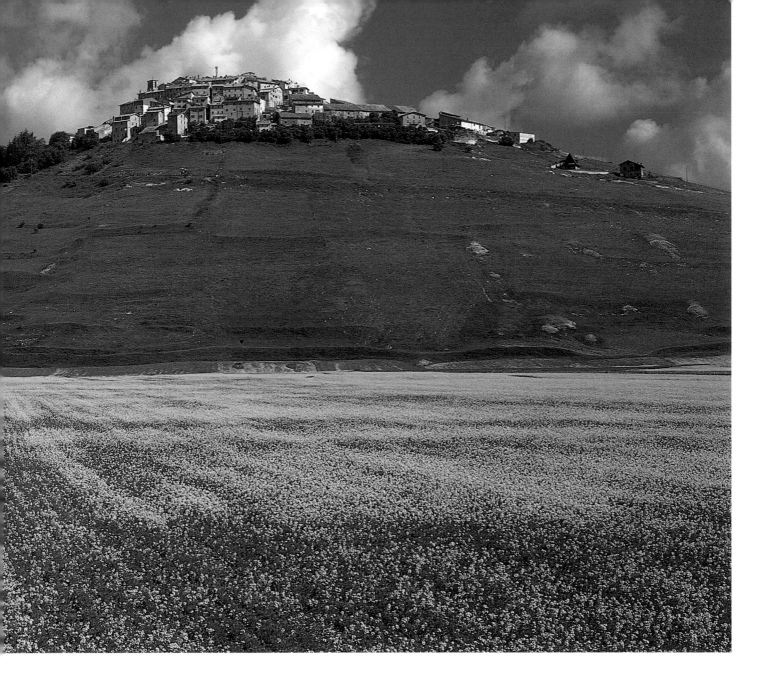

is a South African national "wildflower hotline" that gives up-to-the-minute news on the best places to view the flowers.

Wonderful meadows and grasslands still exist throughout Europe, but you usually have to go to mountain regions to find them. Sub-Alpine hay meadows, for example, are some of the most flower-filled places you could wish to see. Down in the valleys, poppies and cornflowers are still sometimes allowed to pepper the cornfields.

Both photographs on this spread show my favorite meadow of all—the Piano Grande in the Monti Sibillini National Park, between Umbria and Le Marche, Italy. The melting of the snows brings a parade of flowers beginning with lilac crocus, then white narcissus mixed with tulips. Purple meadow clary, and then poppies and cornflowers, color the cultivated parts with a density and hue that is hard to believe.

For the greatest photographic impact, a group of flowers in the near foreground, a wide-angle lens, and a small f-stop for maximum depth of field are good starting points. To convey an impression of the overwhelming richness of the flowers, choose a low viewpoint that lets the foreground flowers dominate the picture.

When you do find unspoiled meadowland, the sheer diversity of flowering plants, with insects such as butterflies and beetles, is a joy and a source of numerous rewarding images.

Mustard field near Castelluccio, Umbria, Italy
Traditional cultivation allows wild species to survive alongside crops—they flourish when the fields are left fallow as part of the cycle of cultivation. The following late spring saw an amazing display of poppies in this field.

CAMERA Mamiya 645 pro TL
LENS 45mm f/2.8 wide-angle
FILM Fujichrome Velvia
SHUTTER SPEED 1/30 sec
APERTURE f/11
FILTER linear polarizer

Poppies

THE INTENSE SCARLET of poppies has long encouraged an association with blood. To the ancient Egyptians they symbolized both blood spilled and new life, while the Romans associated them with their earth goddess Ceres. Poppies have spread successfully thanks to a specifically human practice—the tilling and disturbance of soil for cultivation—to become one of the world's best-known and most persistent weeds. Because of the way they colonize disturbed soil, poppies became closely associated with those who had lost their lives in the trenches of the First World War. Colonel John McCrae, a Canadian volunteer medical officer, was so moved by an explosion of scarlet flowers months after the winter carnage of 1915 that he wrote:

> In Flanders fields the poppies grow
> Between the crosses, row on row,
> That mark our place:

a poem that touched hearts all over the world.

A single poppy plant produces around 16,000 seeds on average, and these can remain viable, though dormant, for 40 years or more. But intensive agriculture, especially the spraying of weedkillers, has led to the demise of poppy fields.

Photographing a poppy field should never be rushed—be indulgent and take time to let the color sink in. But don't delay too long, for sudden storms can devastate the delicate blooms.

I favor early morning or late afternoon, when the yellow content of the light makes the colors sing. Low-angled light behind some of the flowers makes them glow, while the back light also picks out the rough hairs on the stems and buds.

There is no single correct shot: macro lenses can bring out individual flower detail, wide-angles the sheer glory of the landscape; with a telephoto you can condense perspective to concentrate the scarlet flowers.

▲ Field poppies (*Papaver rhoeas*) with corn, Provence, France
Stems of cereal crops create a soft, almost wispy background —careful use of depth of field is necessary to throw them out of focus to the right degree.

CAMERA Mamiya 645 pro TL	**SHUTTER SPEED** 1/125 sec
LENS 45mm f/4 wide-angle	**APERTURE** f/8
FILM Fujichrome Provia	**FILTER** linear polarizer

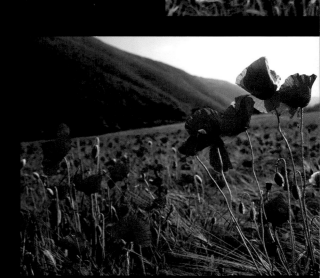

▶ Field poppies (*Papaver rhoeas*), Umbria, Italy
Evening light with a low sun angle provides the chance to back-light poppies: a low viewpoint isolates several of the back-lit blooms against dark mountain and pale sky.

CAMERA Mamiya 645 super pro TL
LENS 45mm f/4 wide-angle
FILM Fujichrome Velvia
SHUTTER SPEED 1/30 sec
APERTURE f/11
FILTER linear polarizer

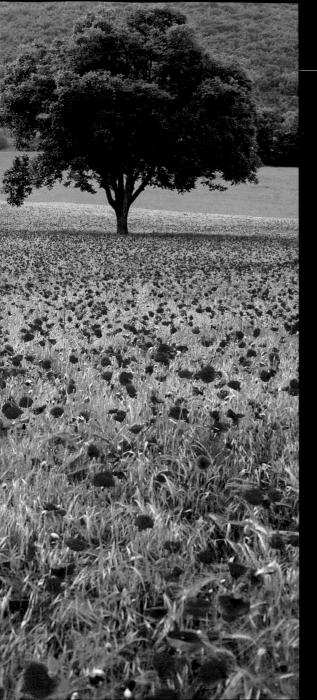

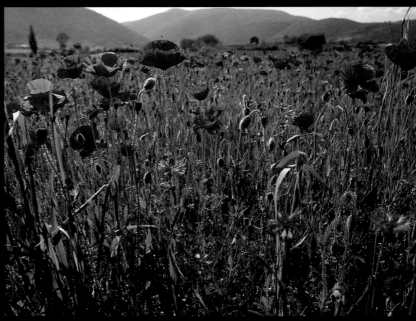

▲ Poppies (*Papaver rhoeas*) and cornflowers (*Centaurea cyanus*) near Norcia, Umbria, Italy
Poppies and cornflowers form one of my favorite floral combinations. The blue of cornflowers is "difficult," and when photographed in bright sunlight the flowers can appear purple. Diffuse evening light provides perfect light for poppies and results in a better blue for the cornflowers.

CAMERA Mamiya 645 super pro TL
LENS 45mm f/4 wide-angle
FILM Fujichrome Velvia
SHUTTER SPEED 1/30 sec
APERTURE f/16
FILTER linear polarizer

▲ Poppy field with oak tree, Umbria, Italy
Single trees—olives, chestnuts, and oak—are often retained in fields to signify boundaries, and stand ready for the photographer to use as elements in a composition.

CAMERA Mamiya 645 super pro TL	**SHUTTER SPEED** 1/30 sec
LENS 45mm f/4 wide-angle	**APERTURE** f/16
FILM Fujichrome Velvia	**FILTER** linear polarizer

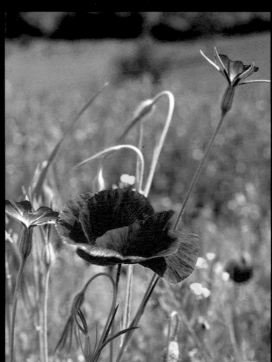

◀ Poppies (*Papaver rhoeas*) and corncockles (*Agrostemma githago*) Umbria, Italy
Poppies and their companion flowers, such as corncockles, can be isolated using a macro lens to create a portrait. The background of soft-focus greens helps to accentuate the sharpness of the subjects.

CAMERA Mamiya 645 super pro TL
LENS 80mm f/4 macro
FILM Fujichrome Velvia
SHUTTER SPEED 1/30 sec
APERTURE f/8
FILTER linear polarizer

Woodlands

Deciduous woodlands offer the best photographic opportunities in spring, when leaves are starting to appear, or in the fall, when those leaves are turning color.

In spring, British beech and oak woods can become carpeted with bluebells and white wood anemones, while mountain woodlands throughout mainland Europe shimmer with pink cyclamen and blue anemones. The Great Smokey Mountains of Tennessee boast one of the most varied of all woodland floras, including gems such as *trilliums* (wood lilies) and *erythroniums* (dog's-tooth violets).

Woodlands contain a huge range of living plants, from mosses through to orchids and trees of every variety, and a wood in its entirety is a

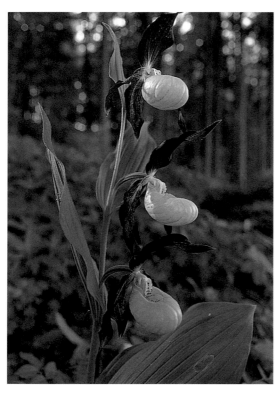

▲ **Yellow lady's slipper (*Cypripedium calceolus*), Swabian Jura, Germany**
A low viewpoint was needed to catch the inflated "clogs," which form the lips of the lady's slipper orchid, with back lighting. In woods you often have to wait patiently for the shafts of light to come through the trees.

CAMERA Nikon F4	**SHUTTER SPEED** ¹/₁₅ sec
LENS 28mm f/2.8 AF wide-angle	**APERTURE** f/11
FILM Fujichrome Provia	**FILTER** circular polarizer

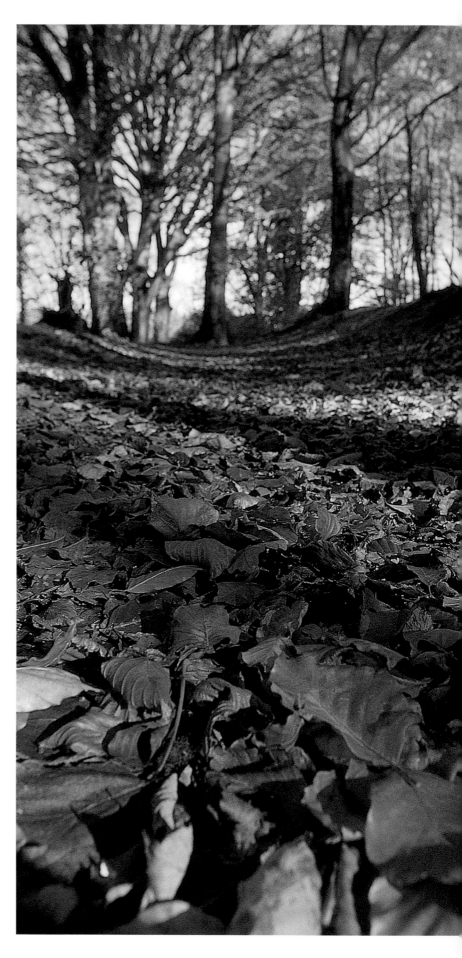

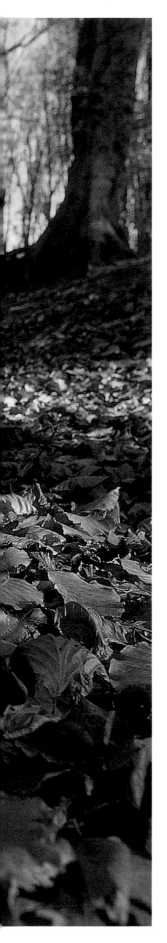

constantly changing entity. Trees seed, grow, and die, and even in death provide subjects for arresting images, as rotting stumps and bare branches make skeletal natural sculptures. Late in the year there is the added interest of fungi (see pages 82–83) both on the woodland floor and adhering to trees. A host of small creatures—beetles, woodlice, moths, and their caterpillars—are part of the story, too.

Woodland light

As soon as the leaves appear, their fresh green can add a color cast to your photographs. You can correct this using a warming filter, or add a touch of magenta at the printing stage. On sunny days, woodland shadows can create extreme contrasts – duller conditions are easier to handle, but a tent (see page 31) can give you control over the nature of the light. Those same extremes may also offer shafts of light that can make flowers appear as in a spotlight or, with the light from behind, as if they are glowing.

Natural coniferous woodlands offer a rich flora. In the deepest recesses, where the light is often very low, you may find saprophytic plants, such as some of the orchids. Flash, carefully used to give a balanced light (see pages 114–115), is likely to be the best option for such conditions.

▶ Black pine (*Pinus nigra*) stump, Dolomites, Italy

Tree stumps often become natural sculptures as they weather and suffer the attentions of a host of burrowing beetle grubs.

CAMERA Nikon F4
LENS 24mm f/2.8 AF wide-angle
FILM Fujichrome Velvia
SHUTTER SPEED ¹/₃₀ sec
APERTURE f/11
FILTER linear polarizer

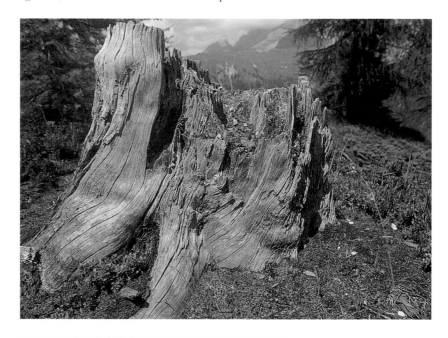

◀ Beech woods (*Fagus sylvaticus*) in fall, Bryngarw, Wales

Capturing the play of light on the fallen leaves necessitated lying on the ground. I focused on a point a short distance beyond the subjects in the foreground (the hyperfocal distance) to achieve the maximum depth of field.

CAMERA Mamiya 645 pro TL
LENS 45mm f/2.8 wide-angle
FILM Fujichrome Velvia
SHUTTER SPEED ¹/₁₅ sec
APERTURE f/16
FILTER linear polarizer

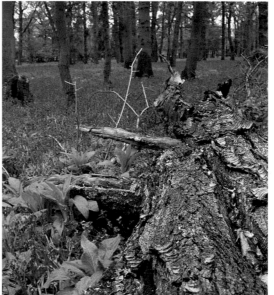

◀ Fallen tree and bluebells (*Hyacinthoides non scripta*)

(photo Lois Ferguson)
The skeleton of a tree was used to lead the eye into the picture after a long session photographing bluebells in which something "different" was called for.

CAMERA Nikon F60
LENS 24mm f/2.8 AF wide-angle
FILM Fujichrome Velvia
SHUTTER SPEED ¹/₁₅ sec
APERTURE f/11
FILTER polarizer

Mountains

MOUNTAIN SCENERY can offer some of the most spectacular backdrops imaginable for plant photography. The highly changeable weather conditions often encountered in high mountains greatly influence the photographic opportunities available. Make sure you allow yourself time to wait for any bad weather to change.

Some of the most photogenic plants are found in mountains, in spite of the harsh weather conditions. Flowers are produced quickly on short stems and are large in proportion to the plant to act as beacons for any insects around. For the photographer this results in delightful, low-growing subjects, often covered in flowers.

As you will be carrying all your equipment with you, weight is an important consideration. Good protection for cameras is essential, and a padded photographer's rucksack is a worthwhile investment, provided it has a properly designed frame for your comfort and freedom. You can often support the camera effectively by holding it firmly on or against a rock and using a bean bag (or your camera bag). However, a tripod is essential with formats larger than 35mm.

My needs for flower and landscape photography are often specific. I frequently work with a wide-angle lens, which offers good close focus in whatever format I choose, and small apertures, which permit sharp focus in the foreground with the background in soft focus but still recognizable. In the mountains, a 24mm or 28mm wide-angle, 60mm or 105mm macro, and a medium telephoto have long sufficed.

MOUNTAIN LIGHT

At high altitudes there is a increased level of ultraviolet light compared with that at low altitudes. UV radiation is not as well absorbed by the rarer atmosphere, and it can lead to an unpleasant bluish cast on your pictures unless you use a UV filter. If you prefer a warmer feel to your pictures, you can achieve it by using an additional 85A or 85B filter.

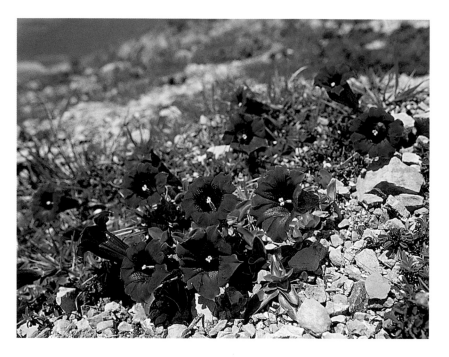

▲ **Trumpet gentians (*Gentiana acaulis*), Le Marche, Italy**
Bare screes provide a home for these spectacular plants, which benefit from a low viewpoint to set them in context. It pays to take time looking around at various flower groups before selecting the one you want in your photograph.

CAMERA Nikon F4	SHUTTER SPEED ⅟₃₀ sec
LENS 24mm f/2.8 AF wide-angle	APERTURE f/16
FILM Fujichrome Velvia	FILTER circular polarizer

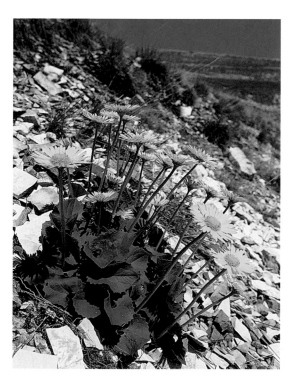

▷ **Wild lupins (*Lupinus angustifolius*), Crete, Greece**
You can capture magnificent backdrops when photographing in mountains. I carry a wide-angle lens for this purpose: 28mm for 35mm format or its 45mm equivalent in 6 x 4.5cm.

CAMERA Mamiya 645 super pro TL

LENS 45mm f/4 wide-angle

FILM Fujichrome Velvia

SHUTTER SPEED ⅟₃₀ sec

APERTURE f/11

FILTER linear polarizer

◁ **Arnica (*Arnica montana*), Dolomites, Italy**
Mountains provide strong contrasts between sky, stones, and flowers. Use a polarizer with care, as the sky can become too dark.

CAMERA Nikon F4

LENS 28mm f/2.8 wide-angle

FILM Fujichrome Velvia

SHUTTER SPEED ⅟₃₀ sec

APERTURE f/16

FILTER circular polarizer

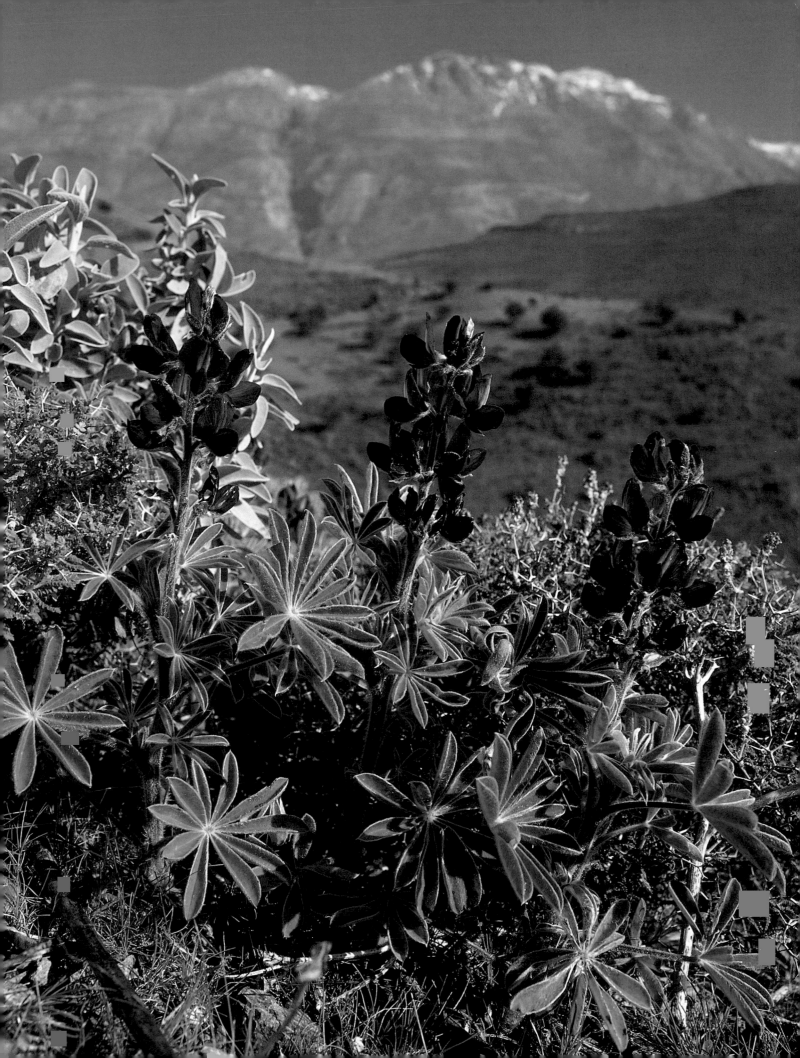

Plants on Ledges

THE FIRST ORANGE LILY (*Lilium bulbiferum*) I ever saw in flower in the wild stood tantalizingly on a ledge above a path in the French Alps. It beckoned me, siren-like. I could not walk away. I was completely unprepared for the climb and my companion at the time could not bear to watch my suicide attempt. Next day, a short walk from the hotel in the opposite direction revealed a hillside full of the plants. The lesson is that the risk is not worth it: if you find the plant you are looking for once, somewhere in the vicinity there will almost certainly be other specimens that are more accessible.

Ledges and rocky clefts—from seashore cliffs to high mountains—form ideal containers for plants, both from a growing and from an aesthetic point of view. The neutral browns and grays of rock offer plain natural backgrounds that often enhance flower colors. Limestone—including dolomite, chalk, and some sandstones—can be highly reflective, so it is important to take exposure from the flowers and leaves to avoid underexposure through a false reading.

Most of the pictures I have of plants growing in this way on ledges, whether natural or artificial, were taken with the minimalist outfit I carry from a hotel on mountain walks. This usually consists of a camera body, a manual focus 28mm f/2.8 Nikkor lens—which has an excellent close focus (about 14cm from the film plane) and serves as close-up and landscape lens—plus a Sigma 300mm f/4 apo telephoto, also with good close focus. Occasionally, space is also found in the bag for a single flash plus a 60mm macro. Camera bags, bean bags, arms, and legs all serve as braces and supports. If I take a medium format body (6 x 4.5cm), a 45mm f/4 wide-angle acts as the equivalent of a 28mm for 35mm film.

The nature of the location means there is seldom room to stand back and frame a subject without dire consequences.

▲ **Aubrietia (*Aubrieta columnae*), Gargano, Italy**
Many mountain plants are anchored in bare rock, with little to clutter the field of view. Successful portraits are easily shot. It is worth having a wide-angle lens with good close focus.

CAMERA Nikon F4	**SHUTTER SPEED** 1/30 sec
LENS 28mm f/2.8 wide-angle	**APERTURE** f/16
FILM Fujichrome Provia	**FILTER** circular polarizer

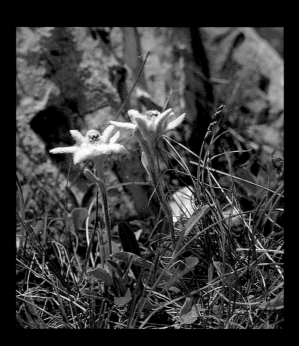

▲ **Edelweiss (*Leontopodium alpinum*), Dolomites, Italy**
Edelweiss has almost legendary status among alpine flowers, and has been immortalized in song and legend. The most attractive plants are those with short stems, growing in crevices. These are often just out of reach.

CAMERA Nikon F4	**SHUTTER SPEED** 1/30 sec
LENS 28mm f/2.8 wide-angle	**APERTURE** f/11
FILM Fujichrome Velvia	**FILTER** linear polarizer

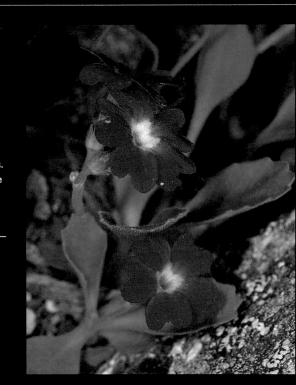

► **Villous primula
(*Primula villosa*),
Dolomites, Italy**
The comparatively large
flower size of low-growing
alpine species makes them
extremely attractive.
Primulas are particular
favorites with both
photographers and growers.
Many of the more attractive
species favor acid rocks—
deep clefts in granite form
an ideal habitat.

CAMERA Nikon F4
LENS Nikkor 60mm f/2.8
AF macro
FILM Fujichrome Velvia
SHUTTER SPEED 1/60 sec
APERTURE f/16
LIGHTING SB21B macroflash

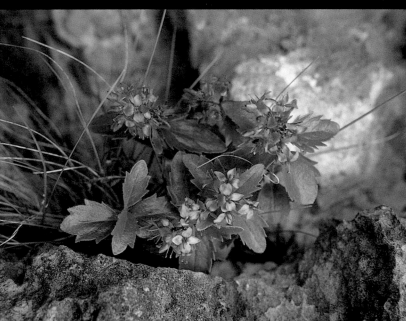

◄ ***Verbascum arcturus*, Crete, Greece**
This mullein is endemic to Crete, where it
grows high out of reach on ancient walls. I
carry a 300mm lens in a 35mm outfit, but
the extra power of a matching 2x converter
was needed to get a frame-filling shot.

CAMERA Nikon F4
LENS 300mm f/4 apo macro with 2x converter
FILM Fujichrome Provia
SHUTTER SPEED 1/125 sec
APERTURE f/8

▲ **Bluish paederota (*Paederota
bonarota*), Dolomites, Italy**
Though rather insignificant, the appeal of this
species lies in its rarity. The intention here
was to photograph both leaves and flowers
to aid identification in a handbook.

CAMERA Nikon F4
LENS 70–210mm f/2.8 zoom
FILM Fujichrome Provia
SHUTTER SPEED 1/60 sec
APERTURE f/11

Coastal Flowers

THE PROXIMITY OF THE SEA imposes harsh conditions, both on plants and on your precious photographic equipment, but it also provides a distinctive habitat for photogenic flowers.

Sand can be highly reflective and this can affect light meter readings adversely. In summer the best times to take pictures are in the hours just after sunrise and immediately preceding sunset. Not only is the light warmer but the lower light angle creates shadows that add form and texture to sand and coastal rocks.

Strong coastal breezes blowing the flowers around are a perennial problem. As I prefer to use fine-grained film, I set up the shot then wait for a lull in the wind while looking through the viewfinder. To some extent you can learn to anticipate movement. Some photographers construct windbreaks of transparent material to deal with this difficulty, but stray reflections are often difficult to see in the viewfinder.

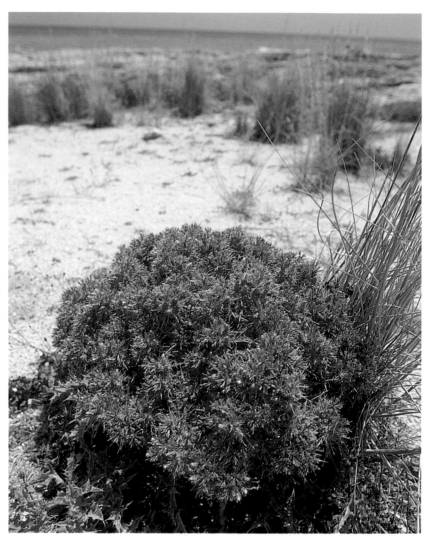

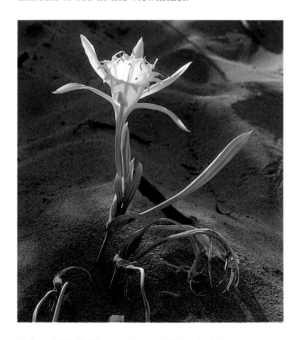

▲ **Sea daffodil (*Pancratium maritimum*), Akamas, Cyprus**
The sun just rising over the dunes back-lit the trumpet of the freshly opened daffodil, as well as defining the contours of the undulations in the sand behind it.

CAMERA Canon F1 **SHUTTER SPEED** 1/60 sec
LENS 28mm f/2.8 wide-angle **APERTURE** f/16
FILM Kodachrome 64

PROTECTING EQUIPMENT

However light the breeze when you are working in coastal areas, it is always bound to be salt-laden, as indicated when you lick your lips. Salt is highly corrosive to metals, so whenever you have used a camera near the sea you should wipe it over carefully with a damp cloth or tissue.

Fine airborne grains of sand are also a menace as they find their way into gear trains and lens threads where, settled into the lubricant, they act as an abrasive. Never rub a lens with a cloth before using °a blower brush, as sand can create fine surface scratches. Treat your equipment with care and spend time cleaning it. For maximum protection you cannot beat underwater camera housing.

▲ **Cardopatium (*Cardopatium corymbosum*), near Agia Napa, Cyprus**
Some plants have evolved to survive the harsh conditions of the Mediterranean sea shore. This thistle is fiercely spined to prevent animals attacking it, and as it grows it forms a globe to cut down water loss. This picture was taken in late afternoon light.

CAMERA Nikon F4
LENS 24mm f/2.8 AF wide-angle
FILM Fujichrome Velvia
SHUTTER SPEED 1/30 sec
APERTURE f/16
FILTER circular polarizer

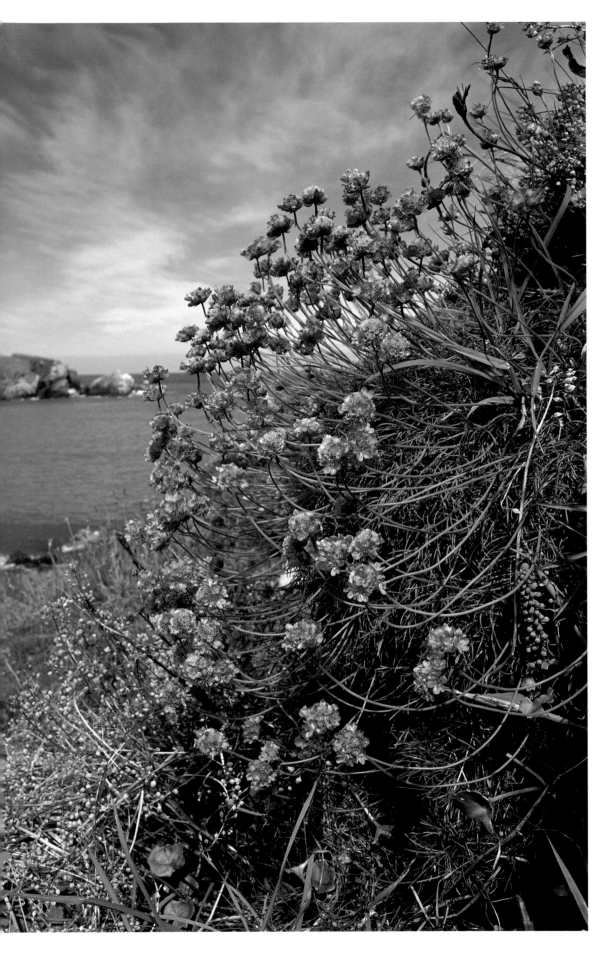

◄ **Thrift (*Armeria maritima*), Pembrokeshire, Wales**
Each year at Whitsuntide pink thrift explodes into flower along the incomparable West Wales coastline. I decided to use a wide-angled lens in "portrait" format to show the plant in the context of the coast.

CAMERA Mamiya 645 pro TL
LENS 45mm f/2.8 wide-angle
FILM Fujichrome Velvia
SHUTTER SPEED $1/30$ sec
APERTURE f/11
FILTER linear polarizer

Aquatic Plants

Wᴇᴛ ᴀʀᴇᴀꜱ ꜱᴜᴘᴘᴏʀᴛ an astonishing diversity of plants. Trees, reeds, and irises grow at the water margins, while rafts of water lilies form on river and lake surfaces, with a host of "pondweeds" growing below the surface. Bogs boast a beautiful and unique flora including sundews, pitcher plants, and other insectivorous species (see pages 54–55), and mosses and liverworts can be found in wet flushes.

Consequently, wetlands provide opportunities to use virtually every lens in your collection. Polarizers are extremely useful for cutting surface reflection when water is included in the viewfinder (see pages 28–29). The water appears darker and the plants growing beneath the surface become visible.

Water lilies are among the most attractive of water plants, though a telephoto lens might be needed to capture individual flowers. A polarizer will intensify water-lily colors dramatically.

Working in wetlands

When working in wet areas you cannot be too precious if you want the best pictures—the perfect viewpoint may involve lying down: it is up to you how far you go in the pursuit of excellence. Luckily, I have never been well known for sartorial elegance.

It is all too easy to become absorbed with the image in the viewfinder and forget niceties such as equipment care. I was taught one lesson long ago when working in a freezing cold bog photographing mosses: my hands became so numb with cold that I dropped a lens. From such disasters I learned that gasket-sealed cases were a great idea (and just as useful in desert and rainforest conditions).

Even if you know an area well, there are risks to working alone in wetlands—particularly if you are exploring those deceptive blanket bogs formed of sphagnum rafts: they look solid, but slowly sink once you put your weight on them. In large swamps, be safe and employ a good guide.

PERISCOPES AND AQUARIA

Underwater plants can be photographed from above, but you cannot always eliminate surface reflections with a polarizer and get exactly the view you want. Ripples on the surface also create problems.

A simple periscope can help when you are standing in shallow water, or it can be held over the side of a canoe. If you don't want to get involved with lengths of drainpipe, painted matte black on the inside and with watertight seals, a small aquarium works well.

A waist-level viewfinder is essential—standard with medium-format cameras, these are also available with some 35mm systems. Success depends on the clarity of the water, and this is usually assured in areas with chalk or limestone rocks and fast-flowing streams. Wherever there is rotting vegetation the water will be discolored—the black streams in rainforests are an extreme example.

Using a camera such as a Nikonos with a split-field lens enables you to get regions above and below the surface in simultaneous focus.

▲ **Dordogne River, France**
Clean rivers offer an abundance of habitats, from trees on the banks to plants at the margins, and both on and below the water.

CAMERA Mamiya 645 pro TL
LENS 45mm f/2.8 wide-angle
FILM Fujichrome Velvia
SHUTTER SPEED $^1/_{30}$ sec
APERTURE f/11
FILTER linear polarizer

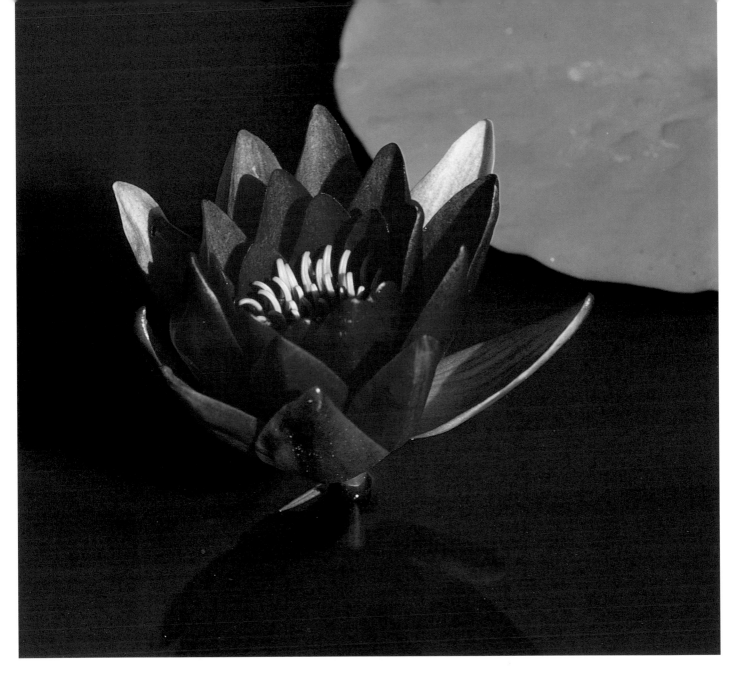

△ **Water lily (*Nymphaea* hybrid), Funchal, Madeira**
(*photo Lois Ferguson*)
Water lilies often grow just out of reach, so a telephoto or zoom lens is useful for getting portraits of the flowers. I always use a polarizer, not only to cut down leaf reflection but also because it "darkens" the water surface, making it transparent by cutting stray reflections.

CAMERA Nikon F4	**SHUTTER SPEED** 1/30 sec
LENS Sigma 180mm f/3.5 AF apo macro	**APERTURE** f/16
FILM Fujichrome Provia	**FILTER** polarizer

▷ **Reeds with tree frog (*Hyla arborea*), Lake Apolyant, Turkey**
Sometimes plants need a little help to produce an interesting photograph. Here, a tree frog eyeing a mosquito broke up the lines of the reed stems.

CAMERA Nikon F4
LENS 28mm f/2.8 wide-angle
FILM Fujichrome Velvia
SHUTTER SPEED 1/30 sec
APERTURE f/8

Carnivorous Plants

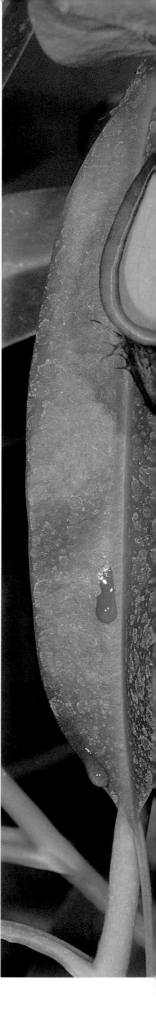

Photographing any type of carnivorous plant requires a certain amount of dedication from a photographer. In temperate regions the plants are often at their best in the summer months when midges and biting flies seem to be awaiting your expedition. In tropical regions, in addition to insects, there can be nasties such as leeches in the moist vicinity of your chosen plant.

It is difficult to photograph insectivorous plants in botanical gardens because there are usually notices asking you not to touch the plants and trigger the leaf traps. Luckily, many are easily cultivated at home. It is important to use de-ionized or soft water (pure rainwater if possible) to keep them in a damp environment. To capture a flytrap closing on its prey requires some sort of trigger, but the best pictures are often those where an insect is large enough to break free and can be photographed as it struggles out.

Butterworts (*Pinguicula* species) have bright green sticky leaves that secrete digestive enzymes and trap midges and other small insects. Sundews (*Drosera* species) have a halo of sticky droplets fringing each leaf, the more so when they have trapped some hapless insect. When working with flash each droplet can create a tiny image of the flash system which, magnified on screen, shows the number of guns you used. A single flash or daylight gives realistic highlights. Most leaf surfaces are highly reflective, and flash lighting needs to be employed with a diffuser.

Pitcher plants come in a variety of guises. Insects trying to land on the slippery inner surface of the pitcher fall into the fluid below, where their bodies are slowly digested. The best known are the sarracenias—with their tall pitchers and curious nodding flowers—which grow in countless thousands in eastern North America, including the cobra plant (*Darlingtonia californica*) of bog land in California and Oregon. Nepenthes are pitcher plants from Southeast Asia and northern Australia, easily cultivated in a tropical greenhouse in hanging baskets.

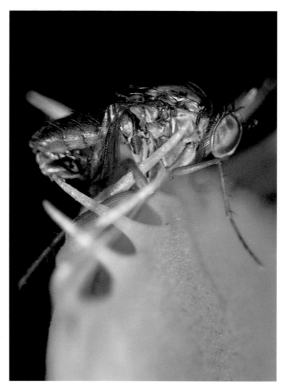

▲ **Venus fly trap (*Dionaea muscipula*), New Forest, Hampshire, UK**
Surface hairs on the leaves of this plant act as triggers, causing the leaves to close and trap landing insects. Back lighting may reveal the silhouette of a trapped insect, frontal lighting the insect detail. Sometimes—as in this case—an insect breaks free.

CAMERA Nikon F4	**SHUTTER SPEED** ¹⁄₆₀ sec
LENS 105mm f/2.8 macro	**APERTURE** f/16
FILM Fujichrome Velvia	**LIGHTING** single flash with diffuser

Perhaps the most intriguing of all are the bladderworts (*Utricularia* species), aquatic plants that put up yellow flowers above the water surface, while below the surface is a mass of tiny leaves and bladders the size of a pinhead. They are capable of trapping cyclops and other tiny crustaceans. The hair-triggered trap mechanism is hydraulic and can work in about ¹⁄₅₀₀ sec or faster.

Getting a flash to trigger at the right moment is a problem I have not solved—yet. However, superb pictures can be obtained with the prey, such as a tiny waterflea entrapped within a bladder. The subjects themselves are best photographed in a studio, in a small tank mounted on some sort of optical bench with a degree of back lighting.

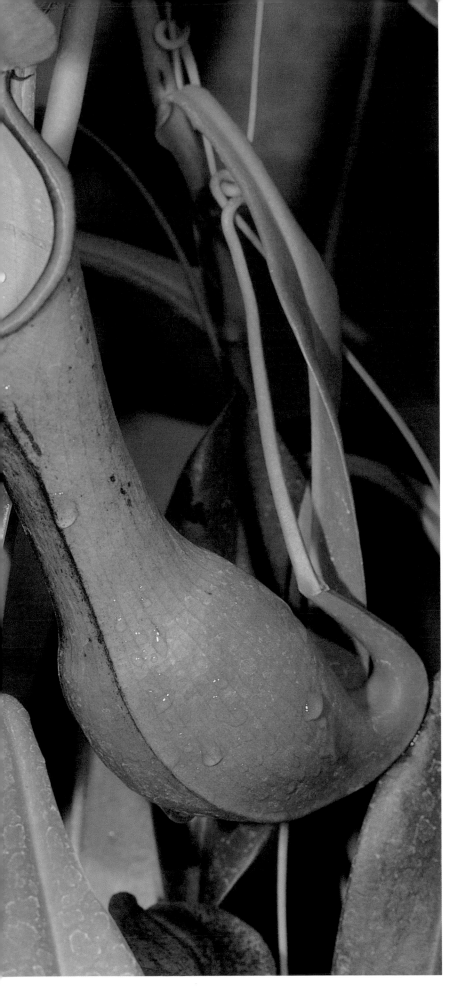

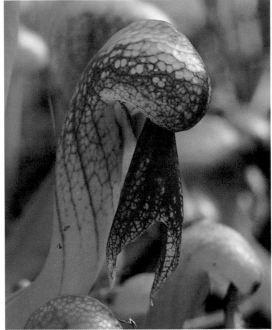

▲ **Cobra plant (*Darlingtonia californica*), California, USA**

The suggestive "tongue" that gives the plant its common name is also the feature that proves most photogenic.

CAMERA Nikon F4 **SHUTTER SPEED** 1/30 sec
LENS 105 mm f/2.8 AF macro **APERTURE** f/11
FILM Fujichrome Provia

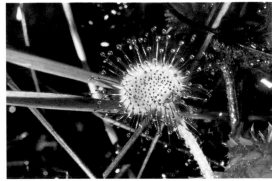

▲ **Round-leaved sundew (*Drosera rotundifolia*), Pembrokeshire, Wales**

The tiny, sticky hairs surrounding each leaf blade make sundews intriguing camera subjects. The hairs can hold anything from midges to larger insects such as dragonflies.

CAMERA Nikon F4 **SHUTTER SPEED** 1/60 sec
LENS 60mm f/2.8 AF macro **APERTURE** f/16
FILM Fujichrome Velvia **LIGHTING** SB21B macroflash

◄ **Pitcher plant (*Nepenthes hookeriana*), origin Sabah; Royal Botanic Gardens, Kew, England**

Insects fall into the pitcher and drown, and their slow decay releases nutrients essential to the plant.

CAMERA Nikon F4 **SHUTTER SPEED** 1/30 sec
LENS 105mm f/2.8 AF macro **APERTURE** f/11
FILM Fujichrome Provia

Deserts and Succulents

THERE IS SOMETHING about the starkness of a desert landscape that leaves many of those who experience it deeply affected. Sculpted dunes and rock forms are revealed by long shadows toward evening or shortly after sunrise, when intense colors can be brought out with a polarizer.

Rain, on the rare occasions when it falls, can bring the desert briefly to life, though such events are difficult to predict. When a desert flowers, the event is often newsworthy and attracts a lot of visitors—vast tracts of usually barren land are colored with flowers stimulated into sudden growth from dormant seeds. In some deserts, such as South Africa's Namib and Namaqualand, such flower displays occur predictably, as cold moisture-laden air comes off the sea each winter. But the most truly spectacular desert displays are those that are rare and unexpected.

For the photographer, the large expanse of the desert sky and the highly reflective rocks and sands that form the background to plant subjects can play havoc with automatic meter readings, leading to underexposure. Regular checking with a hand-held meter helps.

Protecting equipment

In the dry desert climate, dust and grit particles are carried in the air. They get everywhere and are highly abrasive. Although some cameras claim to have "O" ring seals, taping over all joints is a worthwhile extra precaution. Keep film in plastic canisters at all times, and brush the film leader carefully to dislodge grit. If there is the slightest breeze, use a changing bag for loading the camera and even for changing lenses. It is inconvenient but helps prevent disasters.

Excessive heat leads to color casts on films, buckles roll film, loosens lens cement, and causes camera lubricants to run. Equipment is best kept in reflective camera cases—never use black—with sealed rims. You could even consider covering cases with a damp white towel, which will cool by a process of evaporation.

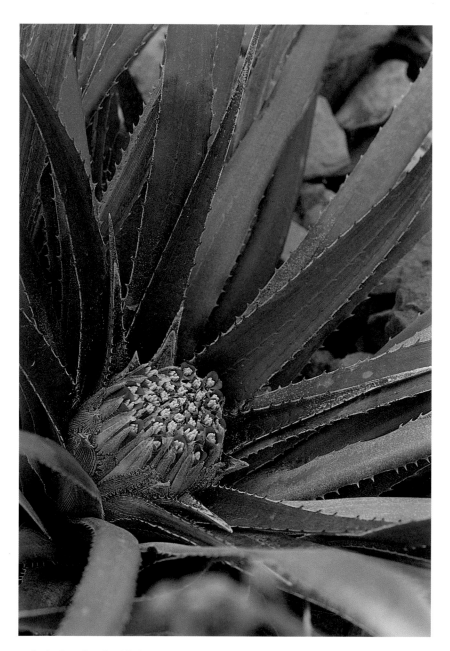

▲ *Fasicularia bicolor*, **National Botanic Garden of Wales**
This species originates high in the dry mountains of Chile. The flower was placed in the frame using the "rule of thirds" (see page 70) as a guideline.

CAMERA Nikon F4	**FILM** Fujichrome Provia
LENS Sigma 180mm f/3.5 AF apo macro zoom	**SHUTTER SPEED** 1/30 sec
	APERTURE f/11

⟩ Giant reed (*Arundo donax*), Terceira, Azores

Desert conditions can exist in volcanic areas—here, the giant reed was the only plant, other than lichens, to have colonized the area of volcanic ash deposits.

CAMERA Nikon F4

LENS 28mm f/2.8 wide-angle

FILM Fujichrome Velvia

SHUTTER SPEED 1/30 sec

APERTURE f/16

FILTER circular polarizer

▽ Mother-in-law's seat (*Echinocactus grusonii*), Huntingdon Botanic Garden, Los Angeles, USA

The geometry of large cacti has long intrigued me. I spent some time just grouping the large spiny spheres in the viewfinder, experimenting with patterns.

CAMERA Nikon F4

LENS 24mm f/2.8 wide-angle

FILM Fujichrome Velvia

SHUTTER SPEED 1/30 sec

APERTURE f/11

FILTER polarizer

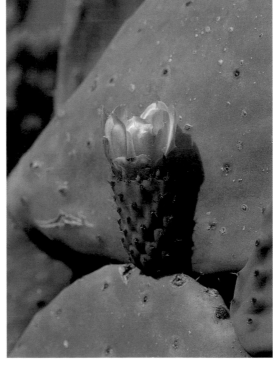

⟨ Prickly pear (*Opuntia ficus-indica*), Paphos, Cyprus

The photographing of cacti comes with a health warning—when you are looking through the viewfinder, it is easy to touch parts of the plant inadvertently. I remember this back-lit shot for that very reason.

CAMERA Nikon F4

LENS 24mm f/2.8 AF wide-angle

FILM Fujichrome Velvia

SHUTTER SPEED 1/30 sec

APERTURE f/16

FILTER circular polarizer

Rainforests and Cloud Forests

Most rainforest and cloud forest occurs in a narrow band close to the equator, although the photographer may encounter similar light and humidity conditions in temperate regions, too.

My first impression of a rainforest was of how dark it was and how little there was to be seen—until I looked closely. Much that is of interest to the plant photographer is epiphytic, literally growing on trees. Any recently fallen tree will provide material for days of photography, and the space it occupied will be filled by butterflies and other creatures attracted to the clearing.

A good, reliable flash set-up is essential: for plants out of reach, a Fresnel lens, which gives a flash a longer throw, may be useful for shots with telephoto. Wipe all flash contacts and adaptors regularly, since tiny areas of moisture lead to corrosion and loss of electrical contact.

Heat and humidity are the lethal enemies of photographers working in tropical forests, but common sense can prevent most damage to film and equipment. Never break the seal on a film container until it is needed, and get it processed as soon as possible, for the gelatin acts like agar on a culture dish for airborne fungal spores. These same moulds can grow on and in lenses—etching the glass surfaces in extreme conditions.

I make extensive use of coolboxes with seals. A refrigerator is less useful, as condensation quickly forms on anything cold in these climates.

EXPEDITIONS

While simple precautions will suffice for a fortnight's trip, careful planning is needed for lengthy stays and expeditions. Equipment cases should be reflective and have sealed gaskets. They are best kept fully packed to cut down air space, with sachets of silica gel to remove moisture. The small sachets supplied with lenses are useless. I invest in large jars of silica gel, bought from a local lab supplier, of the kind that is self-indicating (blue when fresh, pink when saturated) and pack it in muslin bags. Periodic heating to above 212°F (100°C) drives off stored moisture and "regenerates" the gel.

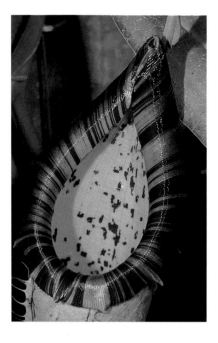

Pitcher plant (*Nepenthes* hybrid), Royal Botanic Gardens, Kew, England
Tropical pitcher plants are rewarding subjects.

CAMERA Nikon F
LENS 105mm f/2.8 AF macro
FILM Fujichrome Velvia
SHUTTER SPEED ¹⁄₆₀ sec
APERTURE f/16
LIGHTING SB21B macroflash

Ginger (*Zingiber gracile*), nursery grown, Bristol, UK
The gingers have intriguing flowers and are commercially cultivated in the tropics.

CAMERA Nikon F
LENS 28mm
FILM Kodachrome 25
SHUTTER SPEED ¹⁄₂₅₀ sec
APERTURE f16
FILTER 20cc blue

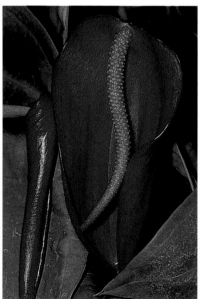

Tailflower (*Anthurium andreanum*), Funchal, Madeira
Although its origins are tropical, the tailflower is a familiar greenhouse plant. Its striking color disguises a highly reflective surface—any flash used should be employed with a diffuser.

CAMERA Nikon F4
LENS 105mm f/2.8 AF macro
FILM Fujichrome Velvia
SHUTTER SPEED ¹⁄₆₀ sec
APERTURE f/16
LIGHTING SB21B macroflash

Mountain cloud forest conditions, Madeira
Low light and mist remove color from the scene, creating silhouettes and producing a dramatic monochrome effect on color film.

CAMERA Mamiya 645 super pro TL
LENS 45mm f/2.8 wide-angle
FILM Fujichrome Provia
SHUTTER SPEED ¹⁄₈ sec
APERTURE f/11

Epiphytes

Epiphytes are, quite literally, plants that grow on trees. Their name is derived from the Greek *epi* ("on") and *phyte* ("plant"). They use tree bark, and other elements such as tree-borne mosses, as a substrate to which they secure themselves and from which they draw moisture. By far the greatest proportion of the world's 25,000-plus orchid species thrive in this way, as do numerous other denizens of tropical forests, such as bromeliads and tillandsias.

Epiphytes are not parasites like mistletoe, which attacks the apple trees on which it grows for its nutrition. They do not harm their host tree, but obtain their nutritional needs from the moisture-laden atmosphere and from debris falling from the forest canopy, which either becomes trapped around their exposed roots or lands in the water conserved in the rosette of leaves formed by some species.

For many epiphytes, this mode of existence has evolved as a means of getting a "leg up" toward the available light. They have created a niche environment that also supports whole communities of small creatures, from spiders and ants to tiny frogs. One advantage of traveling to see epiphytes in their natural habitat is the richness of this associated community and the plethora of fantastic subjects it affords for the camera—to say nothing of the nighttime sounds of the forest that form an unforgettable part of the experience.

Many epiphytes grow where light levels are low, and it is essential to take a good flash set-up with you (see pages 114–115). You will often need to employ some sort of diffuser over each flash head, because many of the plant surfaces are reflective. This may not be obvious when you are looking through the viewfinder with barely enough light to focus, but hot spots will appear in the final results. They are not easy to remove with the post-production use of Adobe Photoshop—though this is great for reducing twin flash highlights.

If you are making an extended visit to tropical regions where epiphytes proliferate, you will need to take special care with all your film and equipment, for the very atmospheric moisture that is essential to the epiphytes plays havoc with cameras and film.

Failing a trip to the rainforest, many epiphytic plants are in cultivation and can easily be photographed in nurseries or botanic gardens. Once you have studied your early results and seen the plant labels and supporting wires that you did not notice in the viewfinder, you will soon become attuned to these potential blemishes—just as you do with telephone wires—and learn to avoid them before you press the shutter.

▲ **Tropical orchid (*Masdevallia ignea*), Costa Rica**
Masdevallias are one of many genera of small, tropical epiphytic orchids. While it is great fun to photograph them in the wild, many species are grown in greenhouses all over the world.

CAMERA Nikon F4
LENS 105mm f/2.8 AF macro
FILM Fujichrome Velvia
SHUTTER SPEED 1/60 sec
APERTURE f/16
LIGHTING single TTL flash head with diffuser

◀ Tillandsia cyanea,
origin Florida, USA;
Royal Botanic Gardens,
Kew, England
Orchids are by no means
the only successful family
of tropical epiphytes.
The tillandsias are another
group, part of the bromeliad
family. They are found in the
southern parts of the USA
and in South America.

CAMERA Nikon F4
LENS 105mm f/2.8 AF macro
FILM Fujichrome Velvia
SHUTTER SPEED 1/60 sec
APERTURE f/16
LIGHTING single TTL flash
head with diffuser

◀ Bulbophyllum
purpureorhachis, **origin**
West Africa; Royal
Botanic Gardens, Kew,
England
Many epiphytic orchids have
tiny flowers, and you will
need a higher magnification
than a macro lens affords
unaided: a 1.4x converter
gives a useful boost.

CAMERA Nikon F4
LENS 105mm f/2.8 AF macro
with 1.4x converter
FILM Fujichrome Velvia
SHUTTER SPEED 1/60 sec
APERTURE f/16
LIGHTING single TTL flash
head with diffuser

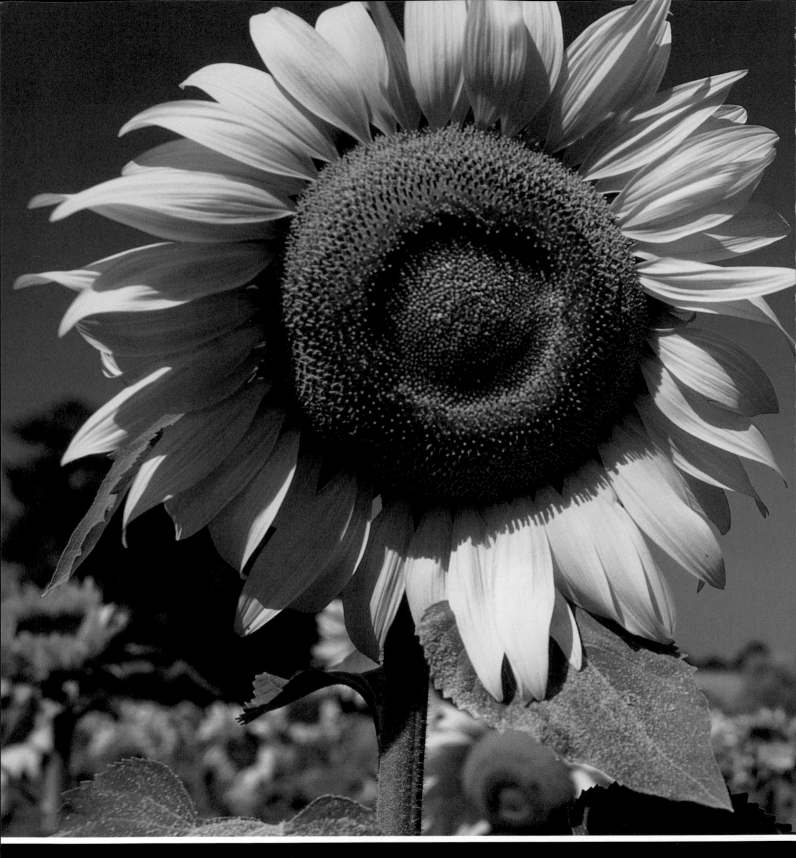

▲ **Sunflowers (*Helianthus annuus*), Provence, France**
For all travelers journeying through France in summer, the
fields of sunflowers brighten the landscape and the flower
heads turn to follow the sun. With blue skies, accentuated
by a polarizer, it is hard not to capture a great shot.

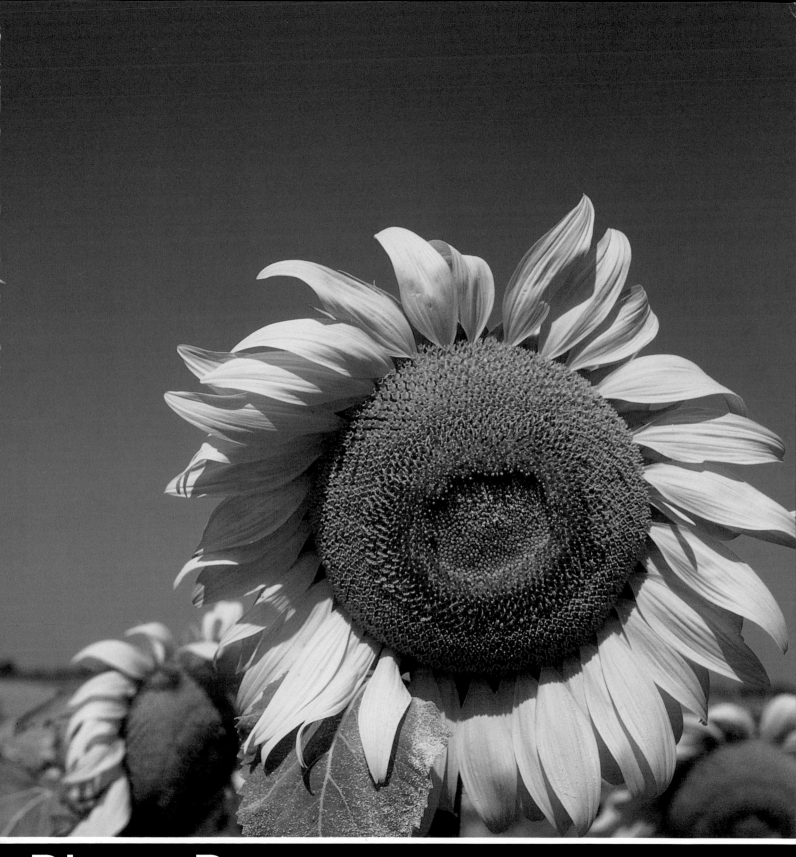

Plant Portraits

Plants in Groups

Finding the subject is only the first step: arranging the elements of the picture within the frame constitutes composition. Some people have an enviable "eye" for this and can instinctively choose the right viewpoint and frame the subject, but there are guidelines to help you develop your perception of what creates impact in an image.

Viewpoint

With close-ups, take time to move around and explore all possibilities. For three-dimensional subjects (see pages 70–71) a full-frontal view can be limiting. I start roughly 45 degrees to one side and the same above or below the flowers, but it is important to keep making changes, otherwise all your pictures will develop the same "feel." Extreme views are from vertically above a subject and the "worm's-eye" view from below. The former works well with flowers such as daisies and gerberas, or with carpets of leaves. A low viewpoint makes plants loom, and can create impact when used with a wide-angle lens.

Landscape or vertical

With 35mm and roll-film formats other than 6 x 6cm, the initial process of turning the camera

to give a choice of portrait (vertical) or landscape (horizontal) format makes a huge difference. Single plants, or groups of flowers on one stem, will often fit well into a vertical format, which enlarges to $8^{1}/_{4}$ x $11^{3}/_{4}$in (A4) page size with minimal cropping. A wide-angle lens in portrait format gives impact by creating a "window" effect.

Traditionally, landscapes are taken in horizontal format, and this ties in well with the current fashion for panoramic shots, whether you own a specialist camera such as Fuji's GX 617, or enlarge a portion of a transparency.

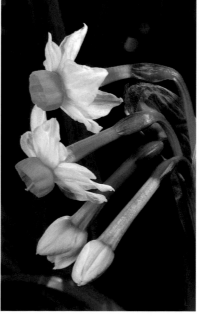

▶ **Dune marsh orchids (*Dactylorhiza coccinea*), Kenfig, Wales**
Single flowering stems do not always make dramatic subjects—it is often easier to use a group of flowering stems in a composition. For this picture, a low angle was chosen to give emphasis to the plants.

CAMERA Mamiya 645 pro TL
LENS 45mm f/2.8 wide-angle
FILM Fujichrome Provia
SHUTTER SPEED $^{1}/_{60}$ sec
APERTURE f/11
FILTER linear polarizer

▶ **Fuchsia (*Fuchsia boliviana*), West Palm Beach, Florida, USA**
Even with static subjects, arranging them along a diagonal within the frame of a picture adds interest by creating a sense of movement. This group of flowers was isolated so that the stamens appeared roughly along a diagonal— or that is how it turned out. At the time I just went for a shot that looked good.

CAMERA Nikon F4
LENS 60mm f/2.8 AF macro
FILM Fujichrome Velvia
SHUTTER SPEED $^{1}/_{60}$ sec
APERTURE f/16
LIGHTING SB21B macroflash

◀ **Rose of Sharon (*Narcissus tazetta*), Akamas, Cyprus**
The flower group was selected for shape—the curve of the upper stem was noticed first. The whole group is bounded by a loosely "ovoid" shape.

CAMERA Nikon F4
LENS 105mm f/2.8 AF macro
FILM Fujichrome Velvia
SHUTTER SPEED $^{1}/_{15}$ sec
APERTURE f/16
LIGHTING fill-in flash

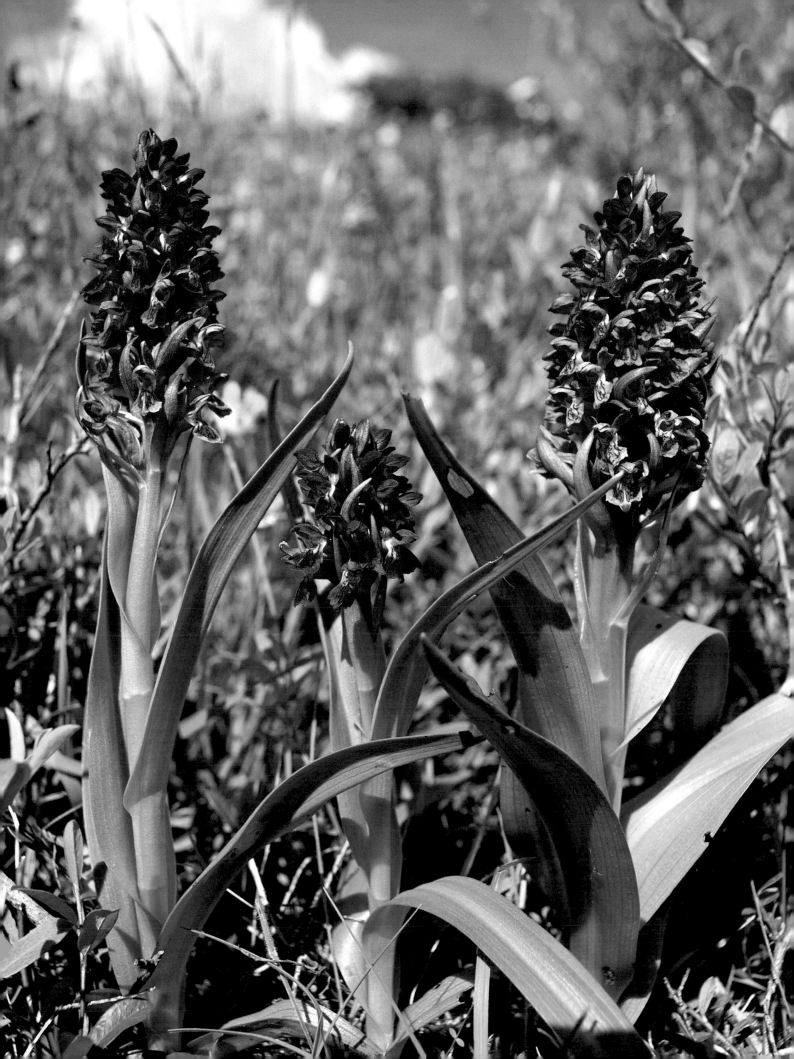

Orchids

The universal appeal of orchids seems to lie in the intriguing forms created by the flowers' modified third petal, the lip. Their outlandish shapes resemble a whole host of creatures, both realistic and fanciful. There are some 30,000 species of orchid worldwide and the flowers range from pinhead size to almost 8 in (20 cm) across.

Conveying an orchid's "three-dimensionality" can create problems with depth of field, particularly with some of the smaller species. The trick is to choose a viewpoint that captures the essential elements sharply, so that the eye is deceived into accepting the rest of the picture as sharp. A useful starting point is to face the flower and then change the viewpoint to about 45 degrees to the side and 45 degrees above.

At orchid shows, where there is no space for a tripod, I work with a macroflash set-up, which produces reliable results. Placing tissue paper or some other diffusing material over a flash gun cuts the "hot spots" caused by the highly reflective surfaces of some orchids.

A particular challenge is to catch orchids with their pollinators in action. The process can be very rapid and when you see it you are almost bound to have the wrong lens on the camera.

I have a special interest in the genus *Ophrys*, a group of insect-mimicking orchids concentrated mainly in and around the Mediterranean region. Their small, rounded, hair-fringed lips resemble insect bodies and they often have reflective areas designed to deceive and attract small male wasps. They also produce a scent which mimics the pheromone produced by a female wasp.

To photograph pollination you have to find a good population of orchids near dry ground – where the small wasps burrow – and wait until the ambient temperature is above 17 degrees C. That is the theory: in practice it takes long hours and a great deal of luck to get the pictures you want. Or you can use an infrared trigger.

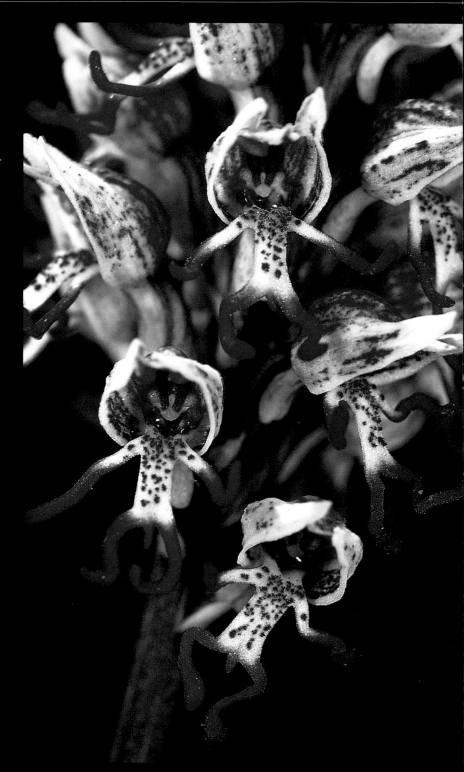

▲ **Monkey orchid (*Orchis simia*), Cevennes, France**
A smaller degree of magnification for individual flowers allows a greater depth of field. It can be more effective to shoot at a lower magnification and then enlarge after scanning to get shots of single or paired flowers.

CAMERA Nikon F801
LENS Nikon 60 mm macro
FILM Fujichrome Velvia
SHUTTER SPEED 1⁄60 sec
APERTURE f/16
LIGHTING SB21B macroflash

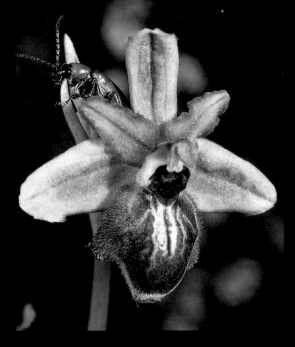

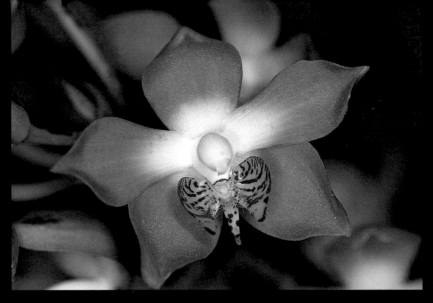

▲ The Aveyron orchid (*Ophrys aveyronensis*), near St Affrique, Massif Centrale, France

This species from the insect-mimicking genus *Ophrys* is restricted to a small area of south-central France. Pollination is effected by tiny bees, but this beetle may find parts of the orchid edible.

CAMERA Nikon F4
LENS Nikon 105 mm f/2.8AF macro
FILM Fujichrome Velvia
SHUTTER SPEED ¹⁄₆₀ sec
APERTURE f/22
LIGHTING SB21B macroflash

▲ *Huntleya burtii*,
Royal Botanic Gardens, Kew, England

When using flash, watch for highly reflective areas on orchids. A simple diffuser such as tracing paper over the flash gun helps greatly.

CAMERA Nikon F4
LENS Nikon 105 mm macro
FILM Fujichrome Velvia
SHUTTER SPEED ¹⁄₆₀ sec
APERTURE f/16
LIGHTING SB21B macroflash

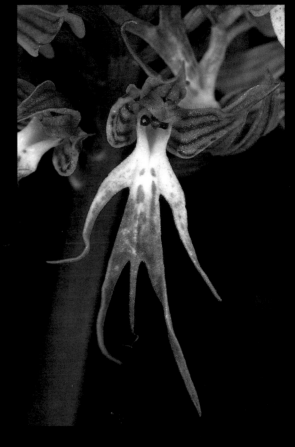

▶ **Butterfly orchid (*Psychopsis papilio*), Trinidad**

Orchid flowers photographed in part can reveal extraordinary shapes and designs that are not always evident in pictures of whole flowers or groups.

CAMERA Nikon F4
LENS Tamron 90 mm macro
FILM Fujichrome Velvia
SHUTTER SPEED ¹⁄₆₀ sec
APERTURE f/16
LIGHTING SB21B macroflash

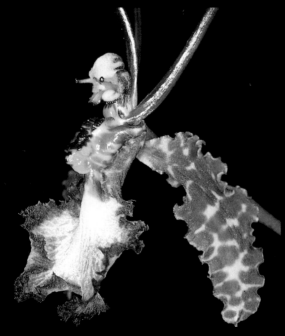

▲ Naked man orchid (*Orchis italica*), Gargano, Italy
These flowers can often only be individually portrayed using a macro lens, sometimes with extension tubes or a teleconverter, and a twin flash or macroflash unit.

CAMERA Nikon F4
LENS Tamron 90 mm macro with ×1.4 multiplier
FILM Fujichrome 25
SHUTTER SPEED ¹⁄₂₅₀ sec
APERTURE f/16
FILTER 20 cc blue
LIGHTING SB21B macroflash

Flowers in the Landscape

You can convey much more information about a plant by depicting it in a typical landscape. The habitat does not have to be in perfect focus—a slight blur enhances the sharpness of the subject.

I have long used wide-angle lenses for plants in a landscape because they can have extremely good close-focusing properties. In this respect fixed-focus lenses, particularly manual types, are more useful than the wide-angle end of most zoom lenses. Zoom lenses may focus down to around 3ft (1m), whereas a wide-angle lens focuses to within 8in (20cm) of the film plane. This means that a clump of flowers close to the lens can dominate the frame. Wide-angle lenses tend to distort perspective, which works well with flowers, exaggerating them slightly.

Using an extension tube on a wide-angle lens can increase magnification too much. Some manufacturers, however, make a very slim extension tube, which when added to a 28mm lens, allows dramatic close-ups with the background in focus. You will get the same effect using the smallest extension ring with a 45mm or 50mm wide-angle on a system such as the Mamiya 645. For maximum impact, use the smallest

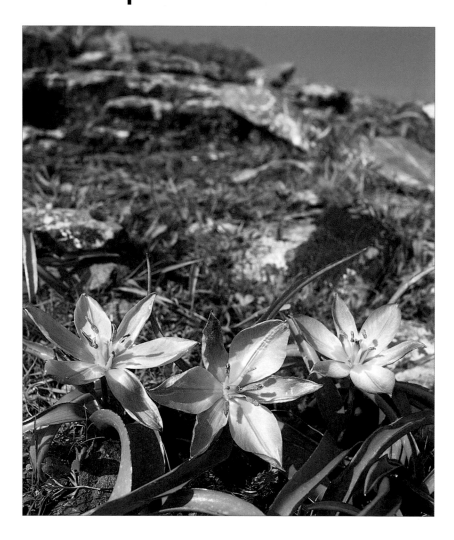

▲ **Rock tulips (*Tulipa saxatilis*), Crete, Greece**
A low viewpoint was used, and a short extension tube with a wide-angle lens gave a slight increase in magnification while retaining some background. A polarizer helped to saturate the colors by cutting down reflections.

CAMERA Mamiya 645 super	**SHUTTER SPEED** 1/30 sec
LENS 45mm f/2.8 wide-angle	**APERTURE** f/16
FILM Fujichrome Velvia	**FILTER** linear polarizer

HYPERFOCAL DISTANCE

At either side of the point of sharpest focus of a lens there is a small distance over which objects in the viewfinder still appear sharp. This is called the depth of field (see pages 106–107), and it increases proportionately as the lens aperture is made smaller.

When confronted with an object in the foreground, the trick is to make sure this object sits at the near limit of sharp focus when the lens is stopped to the chosen aperture.

In practice, you just refocus the lens using the scale by setting the near limit opposite the sharp focus point. Then move the camera position until the object appears in sharp focus—when the picture is taken, everything will be in focus from the subject to infinity.

The point of sharpest focus is then actually a little beyond the subject—at the "hyperfocal distance."

With SLR cameras it is possible to use the depth-of-field preview button (if your camera is equipped with one). First focus just beyond the subject, then stop down to see if the object in the foreground is sharp; adjust the camera position until it is. This is a quick, easy and visual procedure.

possible aperture (f/16 or f/22) consistent with other factors, such as a shutter speed high enough to overcome the breeze. Rather than carry windbreaks with all the rest of my equipment, I am content to look through the viewfinder and wait for a calm moment. With practice you can anticipate these.

To make the most of the available depth of field, focus just beyond the subject so that the subject is

at the nearest limit of sharp focus at the aperture used. The point just beyond the subject is at the "hyperfocal distance" (see box). This can be worked out from a depth-of-field scale, but in practice it is easier just to use the camera's stop-down facility. Even though the image darkens, you can see if things are in focus.

A substantial support is essential: since the greatest visual impact is from a low viewpoint I often rest the camera on the ground, a camera bag, bean bag, or other suitable soft surface. Whenever a tripod is used, a cable release is useful to trigger the shutter and cut any vibration from the photographer.

A polarizing filter is essential, not only because it deepens the blue of the sky, but also because it cuts down reflection from the surfaces of leaves and petals, and this makes colors appear more saturated. Use it with caution, however, as with a low angle sun it can create an almost black sky.

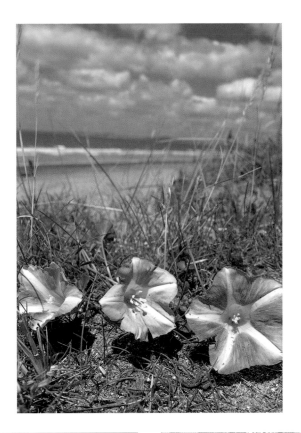

◀ **Sea bindweed (*Calystegia soldanella*), Wales**
A wide-angle lens emphasizes the flowers and a small aperture ensures that the sea remains recognizable, even though it is not in sharp focus. Bent grass stems give a hint of the perpetual breeze near the shore.

CAMERA Nikon F4
LENS Sigma 24mm f/2.8 AF wide-angle
FILM Fujichrome Velvia
SHUTTER SPEED 1/30 sec
APERTURE f/16
FILTER circular polarizer

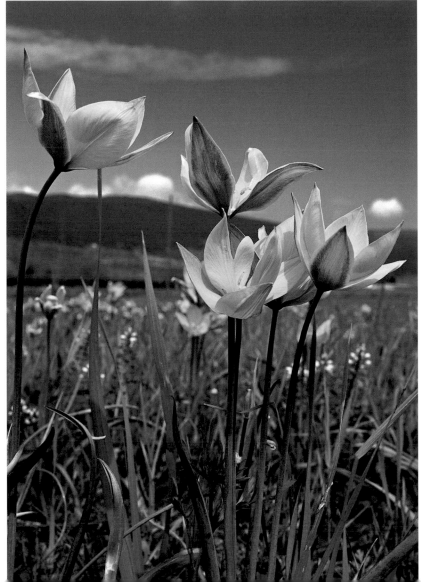

◀ **Yellow tulips (*Tulipa sylvestris*), Umbria, Italy**
On the ground there always seems to be a breeze, and the trick is to watch for a moment of stillness. Here, the low viewpoint and wide-angle lens emphasize the foreground flowers and suggest the background.

CAMERA Mamiya 645 super
LENS 45mm f/2.8 wide-angle
FILM Fujichrome Velvia
SHUTTER SPEED 1/30 sec
APERTURE f/16
FILTER 20 cc blue

▲ **Cretan irises (*Iris cretensis*), Crete, Greece**
Some flowers are almost impossible to isolate from their background. Here, the wide-angle lens exaggerated the flower perspective, and its close-focusing ability gave the required magnification.

CAMERA Nikon F4
LENS Sigma 24mm f/2.8 AF wide-angle
FILM Fujichrome Velvia
SHUTTER SPEED 1/30 sec
APERTURE f/16
FILTER circular polarizer

Symmetries and Perspective

FLOWERS WITH RADIAL SYMMETRY—such as daisies—can be cut in many ways along their diameter to produce identical halves; tulips and lilies, whose flower parts are in threes, have radial symmetry to a lesser degree.

In contrast, when viewed face-on, flowers with bilateral symmetry can be cut in only one way—from top to bottom—to produce equal halves.

Photographing a flower from the bull's-eye position—with the flower dead center in the frame—is limiting, whatever the flower symmetry.

▼ **Snakeshead fritillary (*Fritillaria meleagris*), Wiltshire, England**
Imposing a rough grid of thirds over this photograph will show the outer flowers at the intersections of the grid lines.

CAMERA Nikon F4
LENS 24mm f/2.8 AF wide-angle
FILM Kodachrome 64
SHUTTER SPEED 1/30 sec
APERTURE f/16
FILTER polarizer

You can create greater interest by placing the center of the flower off-center in the frame.

The rule of thirds is used by photographers to lead the viewer's eye into a picture and to give greater impact. This is achieved by mentally dividing the area of the viewfinder vertically and horizontally into thirds, then placing the subject at or near one of the four points of intersection created by the divisions (see page 99 for another example of this). However, dividing a scene in half can sometimes be effective precisely because it breaks the rules.

Dominant elements

When a picture has dividing lines within it, a statement is effectively being made about the relative importance of each of the elements. For example, if the horizon is set along the bottom third then the sky dominates, since it occupies two thirds of the picture area. Conversely, placing the horizon along the top third gives emphasis to the land.

Positive and negative space

The shapes and lines in a picture delineate positive and negative spaces. The subject, the positive space, is defined by a pattern of lines, and

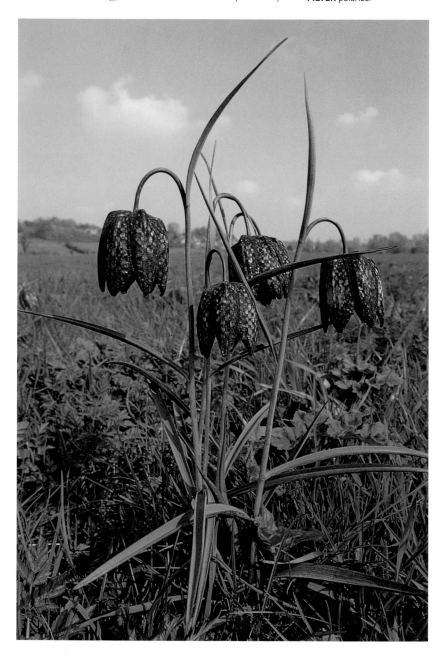

THE RULE OF THIRDS

Some judges in photographic clubs tend to treat the rule of thirds like the eleventh commandment—something that has to be followed at all times. You do not have to follow it in all your shots, but it is worth bearing it in mind when composing images and employing it where you feel it is appropriate.

The rule of thirds approximates to the golden mean, well known to the architects who designed the Parthenon in ancient Athens. To find the golden mean, divide a length into two in such a way that the ratio of the larger portion to the smaller is the same as the ratio of the whole length to the larger portion. The two lengths are very close to two thirds and one third.

▶ **Groundsel Family (*Senecio* sp.), origin S. Africa, photographed Funchal, Madeira**

The flowers are arranged so that, in theory, you can cut across the head in any direction to get equal halves. This is radial symmetry.

CAMERA Nikon F4
LENS 105mm f/2.8 AF macro
FILM Fujichrome Velvia
SHUTTER SPEED 1/60 sec
APERTURE f/16
LIGHTING SB21B macroflash

▶ **Barberton daisy (*Gerbera jamesonii* hybrid), origin South Africa**

The bull's-eye view is an obvious way to photograph flowers of the daisy family, but it is something to be used as only one of a range of possible viewpoints.

CAMERA Mamiya 645 super pro TL
LENS 80mm f/4 macro
FILM Fujichrome Provia
SHUTTER SPEED 1/60 sec
APERTURE f/16

what lies outside those lines constitutes negative space. The balance between the two elements is important and is affected by the position of the subject.

Perspective

Photographs are essentially two-dimensional representations of three-dimensional subjects. To give depth, you have to make use of perspective—the relationship between the elements in the frame. Two factors are important here: where you are standing in relation to the subject and its surroundings, and the lens used.

It is worth trying an experiment with a series of lenses or a zoom lens. Move the camera so that the subject is the same size in the viewfinder at each different focal length. By moving, you change the relationship between the object and its surroundings—that is, the perspective. The magnification, and hence the depth of field, is unchanged, but the views look very different because you stand much closer to the subject with a wide-angle lens than with a telephoto.

Now keep your position fixed and change the zoom setting—as the focal length increases, the depth of field decreases because you are increasing the magnification (see page 106). This has the effect of isolating the subject.

◀ **Slipper orchid (*Paphiopedilum haynaldianum*), origin Philippines; Santa Barbara, California, USA**

The bilateral symmetry of this slipper orchid is obvious: it can be cut into two equal halves only in one way—straight down the center.

CAMERA Nikon F4
LENS 105mm f/2.8 AF macro
FILM Fujichrome Velvia
SHUTTER SPEED 1/60 sec
APERTURE f/16
LIGHTING SB21B macroflash

Texture

MANY PETALS, leaves, and plant stems appear perfectly smooth until you light them in such a way that their true texture is revealed. Side lighting, either with artificial or natural light, creates the numerous tiny shadows that produce relief (see page 26) by delineating all the fine hairs and slight protuberances that help to convey the plant's texture and its three-dimensionality.

Sometimes texture is not obvious until you move in close on a subject. Hairs on the stems of plants such as poppies and nettles are revealed by using a degree of back lighting alongside the main frontal sources.

Some plants have a polished appearance, almost as if they have been highly waxed, and any strongly directional light will create "hot spots" in photographs. In such cases a large reflector, or even a diffusion tent (see page 31), is useful with natural light. If you are using flash, a diffuser is essential: this can be either a softbox over a large hammerhead flash, or pieces of white tissue paper over small flash heads.

Monochrome

When texture is the most important element in a composition, color can sometimes be a dis-traction. Monochrome is an ideal medium for conveying textures such as cactus spines or bark patterns (see pages 100–101). I ignored mono-chrome for many years because of a love affair with color, but the arrival of digital image processing changed that.

The first attraction was the way in which I could easily remove color and produce monochrome prints using a chosen tint. There was no more of the stomach-turning chemistry of sulphide toning to produce sepia prints. With renewed enthusiasm, I started to experiment with Agfa's superb film, producing black-and-white transparencies with the range of tones I had thought to be the sole province of master printers such as Ansel Adams.

▲ **Succulent leaves, Santa Barbara, California, USA**
The folds and spines of many cacti and succulents can be turned into abstract images when you move in close.

CAMERA Nikon F4	**SHUTTER SPEED** ¹/₃₀ sec
LENS 28mm f/2.8 wide-angle	**APERTURE** f/16
FILM Fujichrome Velvia	**FILTER** polarizer

▶ **Swiss cheese plant (*Monstera deliciosa*), Funchal, Madeira**
To reveal texture in a white surface, a degree of under-exposure is needed to produce various light grays. On a dull day, a reflector was used to throw light into the white "hood" or spadix of this arum lily, and exposures were bracketed. A ²/₃-stop overexposure on the meter reading produced the result shown here.

CAMERA Mamiya 645 super pro TL

LENS 45mm f/2.8 wide-angle

FILM Fujichrome Provia

SHUTTER SPEED ¹/₃₀ sec

APERTURE f/11

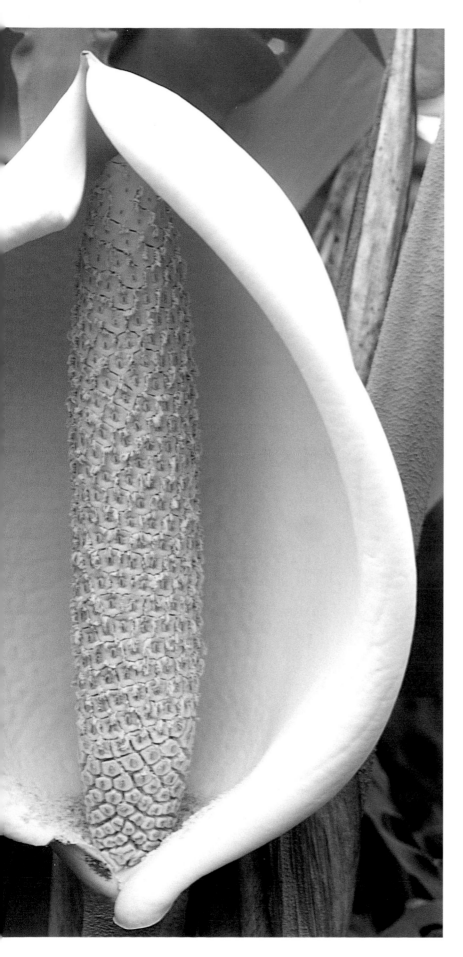

▲ **Japanese fern palm (*Cycas revoluta*),
Funchal, Madeira**
Cycads, or tree ferns, have a coarsely hairy structure at their tightly packed centers. On a uniformly cloudy day the lighting appeared very flat—a reflector was used to create a small but essential degree of modeling.

CAMERA Nikon F4	**SHUTTER SPEED** 1/30 sec
LENS 105mm f/2.8 AF macro	**APERTURE** f/11
FILM Fujichrome Provia	

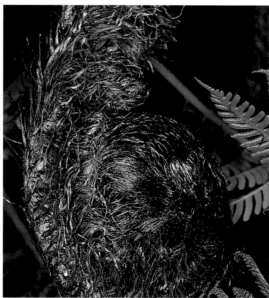

▲ **Bracken frond (*Pteridium aquilinum*),
Oxford, England**
The shape of the frond is lost in this close-up, which concentrates on the densely hairy structure. In this case a macroflash was used to provide illumination but a 2x neutral density filter was taped over one of the heads.

CAMERA Nikon F4	**SHUTTER SPEED** 1/60 sec
LENS 105mm f/2.8 AF macro	**APERTURE** f/16
FILM Fujichrome Provia	**LIGHTING** SB21B macroflash

Color

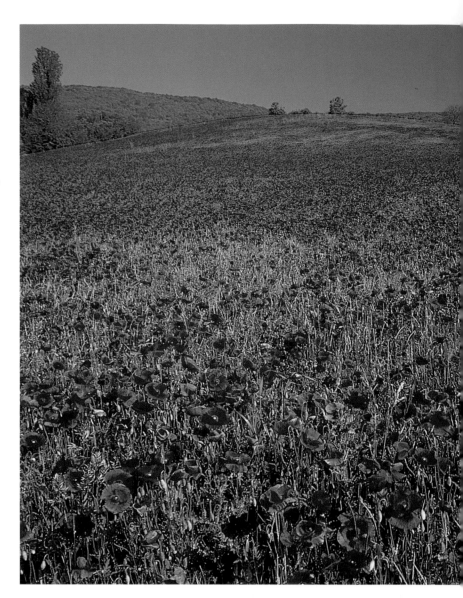

Since the cretaceous period, some 130 million years ago, flower colors have evolved to match the visual capabilities of the creatures that pollinate them. While color acts as a beacon to attract visitors, the shapes of the flowers have became modified by selection to fit the bodies of their pollinators.

Insects are sensitive to a range of light frequencies different from that seen by humans, and their perception is shifted toward the blue end of the spectrum and into the ultraviolet (UV). When used with UV sources, films sensitive to UV light show patterns on flower surfaces that appear plain to humans. Poppies, which look scarlet to us, also reflect UV: it is this light that attracts bees, which do not see red.

In temperate regions, there are comparatively few scarlet flowers, and yet in the tropics the color is common. This is because many tropical flowers are bird-pollinated, and bird vision is highly sensitive to reds.

Color contrast

Many of the most spectacular landscapes are created by strong color contrasts, such as the yellow of sunflowers against a blue sky, or the red of poppies against green fields. Mid-tones, such as the green of leaves or the various shades of brown and gray of earth and rock, make neutral backgrounds that accentuate the colors of the foreground subjects.

Simple, strong colors can often bring a sense of order to an otherwise complicated composition. Conversely, when faced with a subject that is a riot of color, a simple composition with a few balanced elements will set it off best.

▶ **Alpine milkwort (*Polygala alpina*), Dolomites, Italy**
The strong colors of these flowers suggested a simple composition, including three flowers rather than a single bloom to add interest. The bright yellow and magenta of the petals are emphasized by the dark green foliage.

CAMERA Nikon F4	**SHUTTER SPEED** 1/30 sec
LENS 105mm f/2.8 AF macro	**APERTURE** f/16
FILM Fujichrome Velvia	**LIGHTING** SB21B macroflash

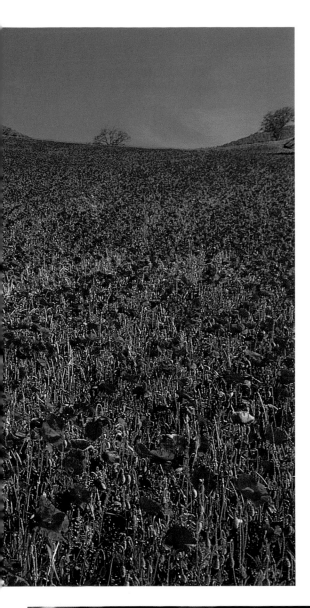

◀ **Poppy field (*Papaver rhoeas*), Umbria, Italy**
Poppies *en masse* show the strongest of reds. The blue sky and dark bushes and trees form distinct areas of color to keep the composition simple.

CAMERA Nikon F4
LENS 24mm f/2.8 AF wide-angle
FILM Fujichrome Velvia
SHUTTER SPEED 1/30 sec
APERTURE f/16
FILTER polarizer

I have never found it easy to choose colors that make good artificial backgrounds for flowers—I prefer natural tones and often use out-of-focus natural backgrounds to accentuate flower color (see page 130).

Black backgrounds

Any colored subject will be enhanced by a black background, since there is nothing to distract the eye: strong colors take on an added vibrancy when photographed against black (see pages 138–139). However, black backgrounds move in and out of fashion. They can sometimes be an accidental and unwanted consequence of using flash (see page 114).

I find it refreshing to deal with muted, soft tones after a number of days spent in sunny climes photographing mind-blowing landscapes filled with color. As always, it is the variety that is stimulating.

FILM CHOICE

To talk about faithful reproduction of color is not easy when color perception differs between one individual and the next. Color acceptance differs, too, for some of us like our colors vivid and warm, while others find a cooler cast suggests greater fidelity to the original. Films such as the Kodachromes, which were standard for much flower photography a decade or so ago, had a much cooler color rendition than emulsions from Fujichrome. The film you choose depends on what you prefer. However, many picture libraries and publishers force the choice because they prefer Fujichrome Velvia and Provia, which were designed with photomechanical processes in mind. The new Kodak Ektachrome emulsions are just as good for this purpose.

◀ **Kelkiewyn (*Babiana rubrocyanea*), Kirstenbosch, South Africa**
Striking is the only word for the color combination of this South African member of the iris family. In such a case, a bird's-eye view of the whole flower creates the simplest composition and emphasizes the colors.

CAMERA Nikon F4
LENS 60mm f/2.8 AF macro
FILM Fujichrome Velvia
SHUTTER SPEED 1/30 sec
APERTURE f/16

Roses

From Old Testament times to the present day, the rose has deservedly enjoyed its status as the most loved and revered flower of all.

*... And the desert shall rejoice, and blossom
as the rose ...* ISAIAH 35 v1

Probably more has been written on the rose than on any other flower.

There is little to surpass the simple beauty of the dog rose flower, or to match its scent. Plant breeders often manage to breed vulgarity into complex multi-petalled blooms, and in the rose their efforts have been supremely successful. But there are also many undeniably beautiful hybrid roses in cultivation.

When photographing roses, try to choose blemish-free blooms. Few roses in large public gardens will meet your requirements, but keen amateur gardeners can give plants the attention they need by tending to pests and dead-heading. Alternatively, you may be able to find a good florist where you can choose perfect roses in bud to photograph in the studio.

The large petal areas of roses, with their uniform color, impart a softness to the blooms which you can best capture on film using diffuse light on a hazy day.

Individual photographers have their own recipes for achieving soft focus: these include slight over-exposure (with darker roses) or using commercial soft-focus filters. A glass filter smeared with petroleum jelly to leave a central clear spot also works well.

Many consider raindrops or dew to be an essential accessory for rose pictures, and legions of "artistic" shots have been created this way. For the natural effect you need the early morning dew, but a garden spray or atomizer is a convenient substitute. Be careful to allow the droplets to coalesce before you take the picture, or the flower will look as if it has been frozen.

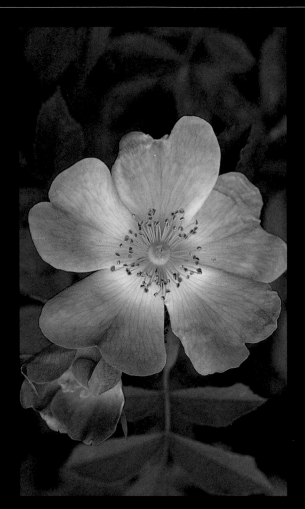

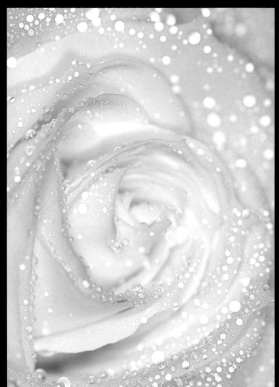

▲ **Dog rose (*Rosa canina*)**
This the simplest of all roses. Flowering in mid-summer, its blossoms cover hedgerows everywhere.

CAMERA Nikon F4
LENS 28 mm f/2.8 zoom
FILM Kodachrome 64
APERTURE f/8
SHUTTER SPEED 1/60 sec

▶ **Rose "Remember Me" with raindrops**
Photographing roses with their petals sparkling with droplets of water is a popular approach. The droplets enhance the uniformity of the color.

CAMERA Nikon F4
LENS 28–80mm f/2.8 zoom
FILM Fujichrome Velvia
APERTURE f/8
SHUTTER SPEED 1/60 sec

◀ Rose 'Elizabeth Harkness'
Light cloud produces a good diffuse light for roses.

CAMERA Mamiya 645 super pro TL
LENS 45 mm f/4 wide angle
FILM Fujichrome Velvia
SHUTTER SPEED 1/30 sec
APERTURE f/11

▲ Rose 'Iced Ginger'
Work with freshly opened flowers early in the day, to avoid blemishes.

CAMERA Nikon F4
LENS 28 mm f/2.8 wide-angle
FILM Fujichrome Velvia
SHUTTER SPEED 1/30 sec
APERTURE f/11
FILTER polarizer

▲ Rose 'Precious Platinum'
The bird's eye shot is a useful one when photographing large numbers of roses, just to add a variety of approach. By moving in close you isolate the pattern of the petal tips.

CAMERA Mamiya 645 super pro TL
LENS 80 mm f/4 macro
FILM Fujichrome Velvia
SHUTTER SPEED 1/30 sec
APERTURE f/11
FILTER linear polarizer

▲ Rose 'Red Ace'
Cluster-flowered rose varieties produce their flowers in groups. It pays to take time to examine a group and choose a viewpoint which makes use of the overall shape of the collection of flower heads.

CAMERA Mamiya 645 super pro TL
LENS 150 mm f/3.5
FILM Fujichrome Velvia
SHUTTER SPEED 1/30 sec
APERTURE f/11
FILTER linear polarizer

Berries

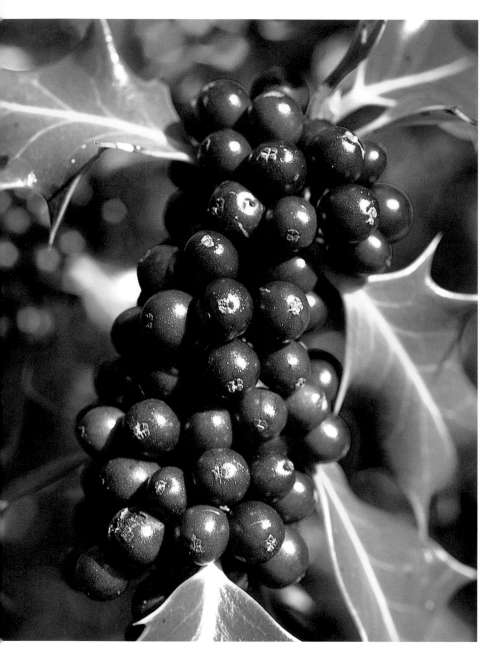

⌂ Holly (*Ilex aquifolium*), Cowbridge, Wales
For this study in natural light, a single flash head with diffuser was used as a fill-in to add bite to the color of the berries.

...

CAMERA Mamiya 645 pro TL
LENS 80mm f/4 macro
FILM Fujichrome Velvia
SHUTTER SPEED 1/30 sec
APERTURE f/16
LIGHTNG Metz 45 CT1 as fill-in

Fruits and berries of all sorts make attractive subjects for the camera. You can photograph them *in situ*, growing on shrubs and trees, or treat them as still-life subjects in the studio or in the market.

Many fruits are highly colored to attract the birds or animals the plant needs to disperse its seeds. Most bright berries, for example, are eaten by birds. The exterior and pith are digested, but the seed itself passes through the bird's digestive tract and is ejected with the feces, often far from the original plant. Mistletoes and other parasites have sticky fruits: the birds that eat them have to wipe their beaks on bark to remove them, and the seeds can then germinate in cracks in the bark.

Bird vision is especially sensitive to red (see pages 74–75) and it is no accident that many berries are bright red or orange in color. From a photographic point of view, this gives a sharp contrast with the surrounding green leaves.

For most fruit and berry photography a mid-range zoom will be able to cope both with single groups of berries and with berries in the context of the whole plant. Wide-angle lenses with a close-focus facility offer a slight distortion of perspective that exaggerates the berries dramatically, setting them against the background (see pages 68–69).

Many berries have a reflective outer coating that may create "hot spots" when flash is used. The solution is to place a piece of white tissue or a handkerchief over the flash to act as a diffuser.

For fruits on trees, such as horse chestnuts, acorns, oranges, and lemons, a telephoto lens is often necessary to isolate subjects at sufficient size in the viewfinder. When the fruit is shaded by leaves, a flash gun with a tele attachment will give sufficient coverage for a telephoto. If you are looking for exotic fruit trees to photograph, you may well find what you want in botanic gardens.

Still life

Freshly picked bunches of fruits such as grapes, blackberries, and strawberries make simple and effective still-life subjects. You can include a container, such as a basket or a rough-hewn olive wood bowl. Alternatively, you can move in close to let the fruits fill the frame.

Market stalls in Mediterranean and tropical countries offer a tremendous diversity of colorful fruits—and they are often set up in the shade so that the fruit does not suffer from the hot sun. Most stallholders are delighted to let you photograph their wares if you buy a bag of fruit.

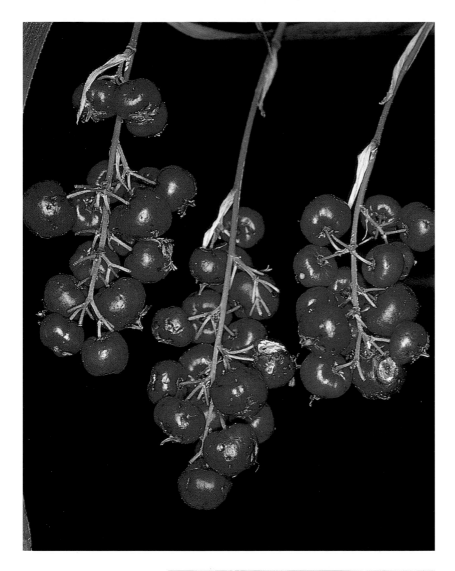

◀ Psychotria fruits, origin Venezuela; Funchal, Madeira

There are few blue-berried bushes in temperate regions, but this color shows against the tropical forest floor and is attractive to ground-foraging birds. It is difficult to reproduce on film. The color was corrected in Photoshop in the pre-production stage.

CAMERA Nikon F4
LENS 105mm f/2.8 macro
FILM Fujichrome Velvia
SHUTTER SPEED 1/60 sec
APERTURE f/16
LIGHTING SB21B macroflash

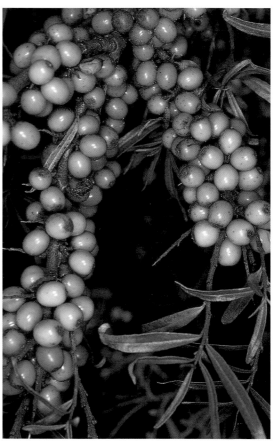

▶ Yew (*Taraxacum officinale*), Betws Churchyard, Wales

The three berries were isolated by use of the macro facility on a zoom lens—a useful all-round optic when photographing berries.

CAMERA Nikon F4
LENS 28–80mm f/2.8 zoom
FILM Fujichrome Provia
SHUTTER SPEED 1/30 sec
APERTURE f/16
LIGHTING single flash as fill-in

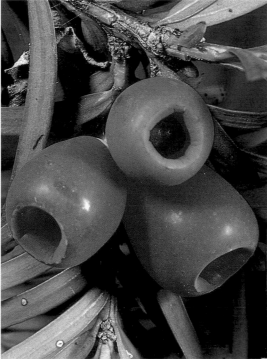

▲ Sea buckthorn (*Hippophae rhamnoides*), Merthyr Mawr, Wales

With its usually abundant supply of berries, the sea buckthorn allows you to look for groups that make patterns, to increase the interest of the picture.

CAMERA Nikon F4
LENS 28mm f/2.8 wide-angle
FILM Fujichrome Velvia
SHUTTER SPEED 1/30 sec
APERTURE f/16
FILTER polarizer

Seeds and Seedheads

THERE IS AS MUCH DIVERSITY in the shapes and forms of seeds and seedheads as there is in the flowers themselves—a fact that is appreciated by flower arrangers and craftworkers to a much greater extent than by photographers.

The range of sizes is dramatic, from the vast, lasciviously shaped, double-lobed nuts of the tropical coco de mer (*Lodoicea maldivica*) to the tiniest orchid seeds. Outlandish shapes include ridged wheels, winged keys, and spiked pods.

Developing seedheads can be photographed in situ—sometimes flowers and fruits occur simultaneously, and a photograph including both is more valuable as a botanical shot. Late fall is the best time to photograph chestnuts, when the litter beneath the trees is a mixture of freshly fallen leaves and seeds. While forming, these fruits are often inaccessible, and even using a powerful telephoto they do not fill the frame.

Many of the *Compositae*, that vast family encompassing daisies, dandelions, and thistles, produce crowded seedheads with a "pappus," or ring, of tiny hairs forming a parachute for each seed—the thistledown that fills the air in summer. Details of these seeds and seedheads can make dramatic macro shots, while the heads create rewarding silhouettes (see pages 92–93) or subjects for back lighting.

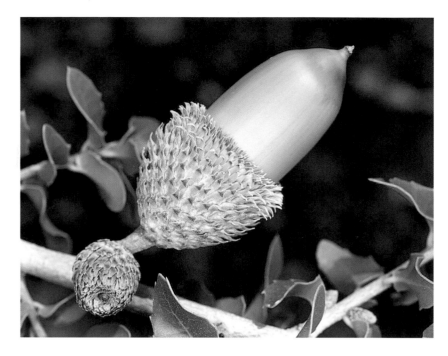

Even ardent opponents of flower-picking can hardly object to the picking of ripe seedheads, since it aids in the dispersal process and you get excellent still-life subjects into the bargain.

For culinary compositions, the kitchen spice rack can offer considerable diversity: cardamom, mustard, fenugreek, and coriander seeds. The various pulses—lentils and beans—have subdued colors that work well in frame-filling compositions (see page 127). These can create attractive screensavers for the computer.

▲ **Golden oak (*Quercus alnifolia*), Troodos, Cyprus**
Acorns are often best reached with a telephoto lens. Here, the subject has been arranged so that it lies along a diagonal to produce a less static composition.

CAMERA Nikon F4
LENS Sigma 180mm f/3.5 AF apo macro with 2x converter
FILM Fujichrome Velvia
SHUTTER SPEED 1/1250 sec
APERTURE f/16
LIGHTING SB25 flash with tele attachment

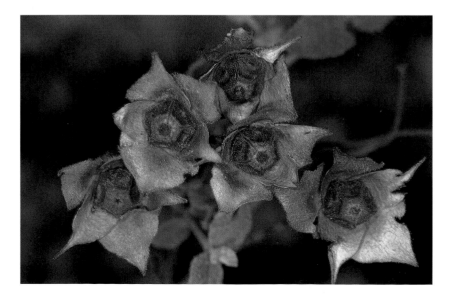

◀ **Sage-leaved cistus (*Cistus salviaefolius*), Crete, Greece**
The flower-covered bushes of cistus bring a brief but intense display of color to parched Mediterranean hillsides. The fruits are distinctive and often arranged in conveniently photogenic groups.

CAMERA Nikon F4
LENS 60mm f/2.8 macro
FILM Fujichrome Velvia
SHUTTER SPEED 1/60 sec
APERTURE f/11
FILTER polarizer

▶ **Goat's beard (*Tragopogon pratensis*), Kenfig, Wales**
Here, the structure of the seedhead with its tiny parachute seeds has been revealed by back lighting.

CAMERA Nikon F4
LENS 28mm f/2.8 wide-angle
FILM Fujichrome Velvia
SHUTTER SPEED 1/30 sec
APERTURE f/16
FILTER polarizer

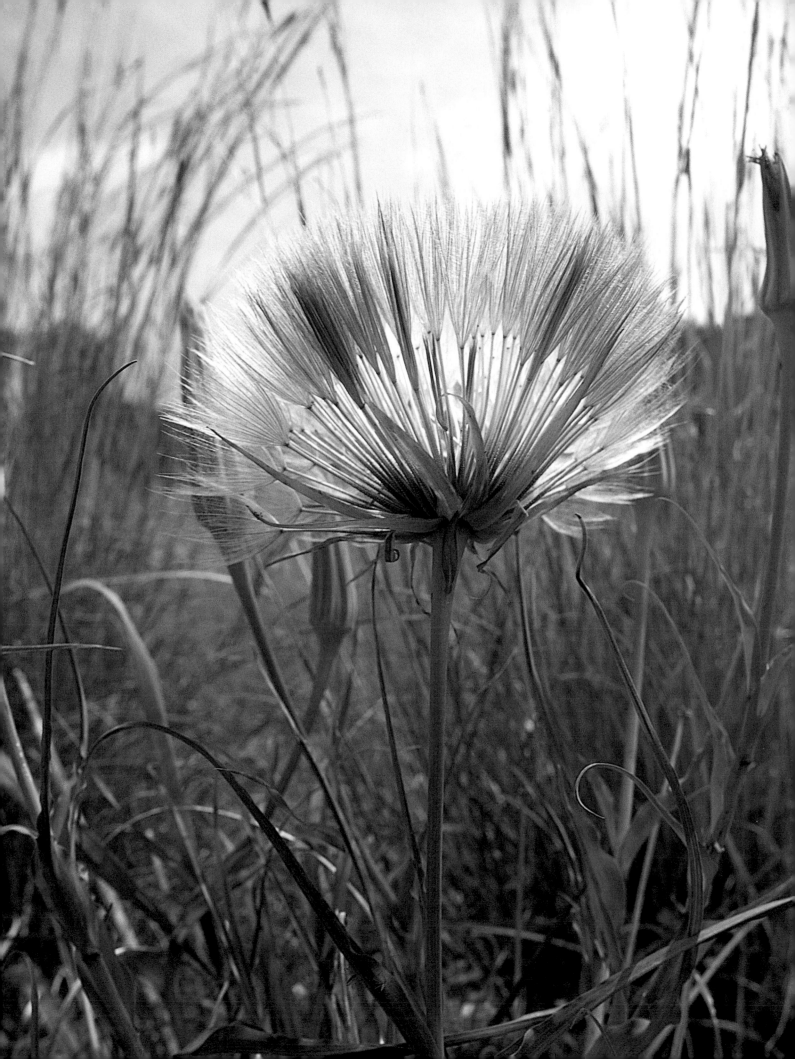

Fungi

Fungi are non-flowering plants, but they show an astonishing diversity of form and color that makes them extremely photogenic.

Some species grow out in the open—on dune land, for example, or in short, well-grazed turf. But woodlands are the best places to search for fungi, and most species emerge in the fall. Each woodland type—oak, beech, birch—supports its own characteristic fungi. What we see above ground are the fruiting bodies produced by the fungal threads, or mycelia, that pervade the soil.

The craze for cooking and eating wild mushrooms has led to increased private and commercial collecting, which has made some species rare. If you find groups of fungi, never put off taking pictures, for they decay very quickly.

Many small fungi and tiny slime molds are easily overlooked, yet they make attractive subjects for the macro lens. They can be found in cracks on rotten wood, on rotting fruit, and on moldy bread and other food.

At the other end of the scale, dead trees will often host large bracket fungi, which can be tackled only with a telephoto lens. Since you will be photographing them from below, your picture will inevitably include the sky, and so some form of fill-in flash will be needed to balance the exposure of the light background. Fungi can be highly reflective and pictures taken with flash can usually be recognized by specular reflection on the fungus surface.

Fungal colors and tints are often subtle and are best recorded using natural light. Although light levels are usually low in woodland, it is also a relatively sheltered habitat and many fungi have stout stalks, so that the problem of subject movement is eliminated and slow shutter speeds are feasible.

Fungi look particularly impressive when taken using a wide-angle lens, from a low viewpoint, with the camera mounted on a firm tripod. Sometimes the light is rather "cool" in a shady wood, and a warming filter may be needed.

▷ **Scarlet elf cup (Sarcoscypha austriaca), Pembrokeshire, Wales**
These small fungi are very easy to spot in the shady woods, where they grow in winter on decaying branches or on damp ground among mosses.

CAMERA Nikon F4
LENS 105mm f/2.8 AF macro
FILM Fujichrome Velvia
SHUTTER SPEED 1/125 sec
APERTURE f/16
LIGHTING SB21B macroflash

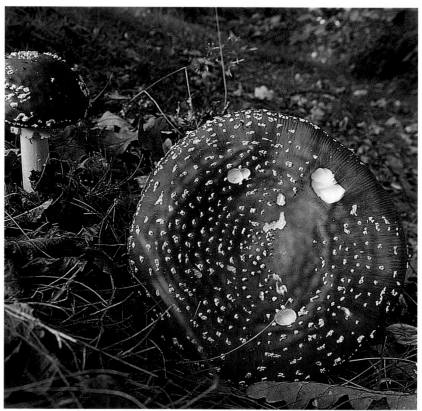

▵ **Fly agaric (Amanita muscaria), near Abercynon, Wales**
It is a horrible irony that this fungus, at one time much used in illustrations in children's books, is highly poisonous. But it is undoubtedly photogenic and is a common species in birch and pine woods.

CAMERA Nikon F4
LENS 24mm f/2.8 wide-angle
FILM Fujichrome Velvia
SHUTTER SPEED 1/8 sec
APERTURE f/16

▷ **Giant polypore (Meripitus giganteus), Foresta Umbra, Gargano, Italy**
Woodland fungi are best photographed in natural light, though as they grow in shade this can mean long exposures and slightly cool results. A steady tripod is essential, and 81A or 81B warming filters are often useful.

CAMERA Mamiya 645 super pro TL
LENS 45mm f/2.8 wide-angle
FILM Fujichrome Velvia
SHUTTER SPEED 1/2 sec
APERTURE f/16

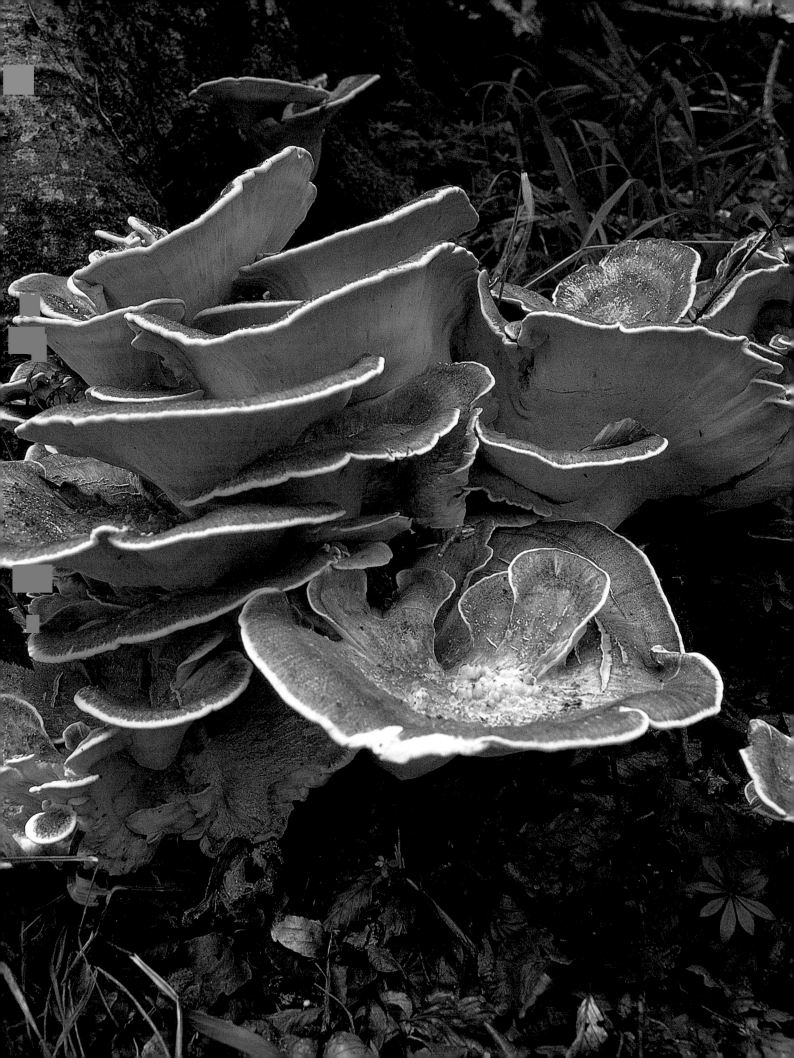

Mosses and Lichens

Mosses and lichens are among the smallest of plants and at one time were wrongly classified together. Mosses are now grouped with liverworts as bryophytes. Both mosses and lichens are often at their best as camera subjects in the winter months, which is useful when there is a shortage of other plant subjects.

A lichen is a dual organism, with a fungal and an algal component living in a symbiotic association. The algal part manufactures sugars by photo-synthesis, while the fungal part provides shelter and moisture. Lichens are very slow-growing, increasing by $\frac{1}{25}$–$\frac{1}{3}$ in (1–10mm) annually. The circular patterns made by lichens, which can often be seen on gravestones, are quite likely to be more than a hundred years old.

As lichens are adversely affected by atmospheric pollution, they are good indicators of clean air; they are also among the first colonizers of inhospitable territories such as Arctic tundra. They thrive on bare surfaces, where there is little competition from other plants. Seaside and desert rocks, old tree bark, stone roofs, walls, and dune land are all likely habitats for various species of lichen.

Lichens are capable of covering large areas, especially on coastal rocks just above the high water mark, and these veritable gardens make

▲ Moss capsules (*Leptobryum pyriforme*), Cowbridge, Wales
To photograph moss capsules—which look like a tiny forest—you need a macro lens and, in many cases, a means of getting a magnification greater than 1:1 (see pages 120–121).

CAMERA Nikon F4
LENS 105mm f/2.8 AF macro with 1.4x converter
FILM Fujichrome Velvia
SHUTTER SPEED 1/60 sec
APERTURE f/16
LIGHTING SB21B macroflash

▲ Crustose lichen (*Caloplaca marina*)
Late afternoon light is ideal for photographing coastal lichens. The low angle of the sun creates relief and picks out all the surface detail.

CAMERA Nikon F4	**SHUTTER SPEED** 1/30 sec
LENS 60mm f/2.8 AF wide-angle	**APERTURE** f/11
FILM Fujichrome Velvia	**FILTER** polarizer

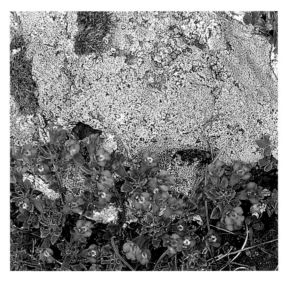

◀ Lichen garden, France
Lichens thrive where the air is pure and clean. Here, they color the surface of a rock as part of a natural garden in the French Alps.

CAMERA Nikon F4
LENS 28mm f/2.8 wide-angle
FILM Fujichrome Velvia
SHUTTER SPEED 1/30 sec
APERTURE f/11
FILTER polarizer

wonderful subjects for the camera with their intricate patterns and colors. Some species have the bonus of attractive scarlet cups on their fruiting bodies.

Low afternoon sunlight with long shadows delineates the surface detail most effectively—especially in the crustose lichens on rocks and gravestones. Lichens make excellent close-up subjects in natural light: since they are flat and immovably attached to rocks, wind is never a problem with them.

Favoring damp, shady locations in woodlands, under rocks and on damp banks, some species of moss grow into attractive fern-like patterns or form tiny, tight, green cushions on rock surfaces. Others, such as the sphagnum mosses, form thick, dense mats of vegetation in which many other plants grow. The fruiting bodies or capsules of mosses develop separately on short stalks, and a

forest of tiny orange-brown stems covers some mosses when they are fruiting. The winter months are best for bryophytes as at this time they are at their most lush and green. Patches of moss sometimes form the only spots of bright color in otherwise sombre woodlands.

Sphagnum mosses grow on open moors but many other species prefer the shade: liverworts, with their flat leaves, spread along damp surfaces and are also predominantly shade-loving. A good macroflash set-up (see pages 116–117) is useful for photographing bryophytes.

▼ Lichens, West Cork, Ireland
The moist, mild climate of West Cork encourages the growth of astonishing collections of lichens on the local black rocks, both near the sea and inland.

CAMERA Mamiya 645 super pro TL	**SHUTTER SPEED** 1/30 sec
LENS 45mm f/2.8 wide-angle	**APERTURE** f/8
FILM Fujichrome Velvia	

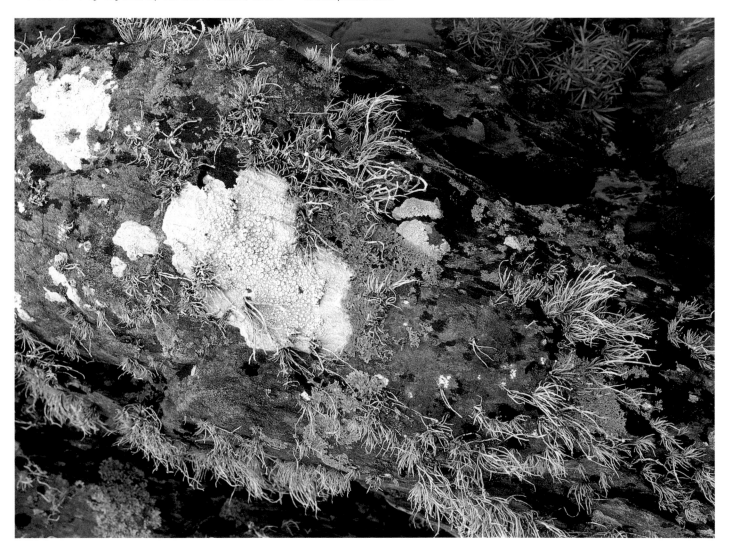

Ferns and Grasses

FERNS AND GRASSES have become popular garden plants in recent years. This seems to be due to a surge of interest in theme and designer gardens, which has encouraged gardeners to experiment with less traditional plants.

In their natural habitats, ferns are dependent on water during their reproductive phase and so flourish on damp mountains and moorland, in damp woods, and on old trees.

Ferns are photogenic as individual plants, especially when the young fronds are in a coiled state in spring. When back lit, the hairs on these coils are revealed almost like a halo. But it is the individual leaves that show a delicate beauty when photographed. Some ferns—such as the hart's tongue—have strap-like leaves, but in many the leaves are divided (pinnate) and those divisions that are thus created may be divided again and again (multipinnate).

Maidenhair ferns are translucent, which makes them ideal for photographing using back lighting to show their venation. This can be done either in the wild or in the studio. If you have collected ferns and are shooting in the studio, you can either place them on the white background of a light box or employ dark field illumination to produce dramatic results (see pages 132–133).

The fruiting bodies of ferns, called sori, develop on the undersides of the fronds. When ripe, they split to reveal the spores within. These sori are great subjects for the macro lens—as is the tiny prothallus stage from which the first leaves develop.

Grasses are at their most photogenic when they are in seed. There is a huge diversity of shape and form, from the steppe grasses with long wavy heads to quaking grasses with seedheads like tiny flattened cones. The familiar pampas grass, stalwart of many suburban gardens, has large, showy, fruiting heads.

Grass flowers are intriguing but are often overlooked because they are so tiny. Their delicate beauty is revealed in the realms of macro photography, but you will need to use coupled lenses (see pages 120–121) to get at least 2x–3x magnification on film.

▷ Fern sori and spores, Cowbridge, Wales
The sori are the containers for the tiny dust-like spores of ferns. They can be found on the reverse side of fern fronds and are interesting subjects for the macro lens.

CAMERA Nikon F4
LENS 105mm f/2.8 AF macro
FILM Fujichrome Velvia
SHUTTER SPEED ¹⁄₆₀ sec
APERTURE f/16
LIGHTING SB21B macroflash

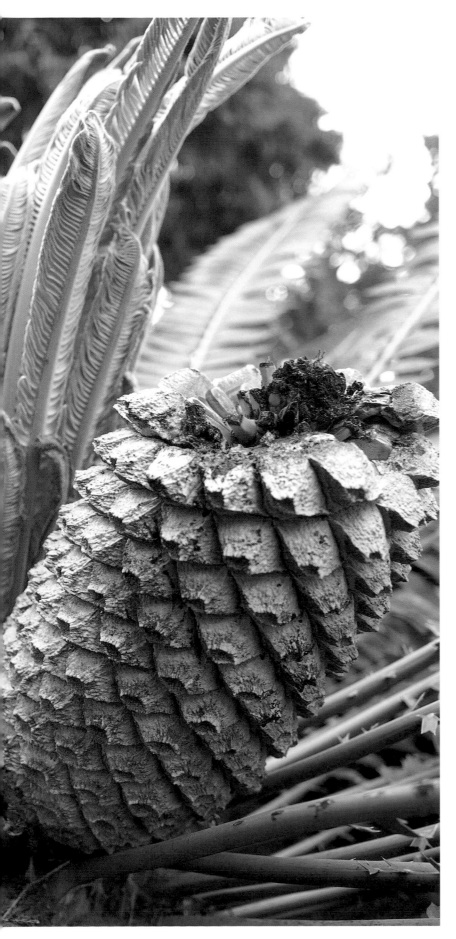

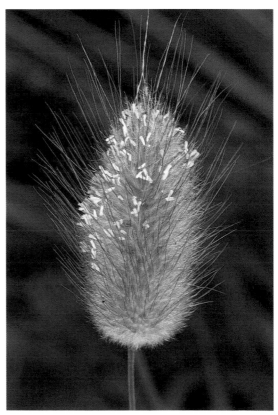

◀ **Japanese fern palm (*Cycas revoluta*), Funchal, Madeira**
Tree ferns are widely grown in parks wherever there are no winter frosts. They are very slow-growing, and their leaves take on a palm-like appearance.

CAMERA Mamiya 645 pro TL
LENS 80mm f/4 macro
FILM Fujichrome Velvia
SHUTTER SPEED ¹/₃₀ sec
APERTURE f/8
FILTER linear polarizer

▲ **Hare's tail (*Lagurus ovatus*), near Nicosia, Cyprus**
Individual grass flowers are in the realm of true macro photography, requiring a magnification of 4x upward to show their beauty, but the flowering heads can be photographed with an ordinary macro lens with 1:1 capability.

CAMERA Nikon F4 **SHUTTER SPEED** ¹/₃₀ sec
LENS 105mm f/2.8 AF macro **APERTURE** f/16
FILM Fujichrome Velvia

Seaweeds

Seaweeds, and various plants such as *Zostera* and *Poseidonia*, are usually photographed from beneath the water surface using a marine camera such as a Nikonos, or by employing a marine housing.

A surprising amount can be done from above the water in rock pools, or by using aquaria. One challenge is to eliminate the reflections from the water surface, which otherwise soften the image. Surface ripples and any turbidity due to material suspended in the water can also mar the result.

The camera is set up vertically above the rock pool and focused on the subjects below the surface. Reflections from this set-up can be eliminated by spreading a dark cloth or card to shade the surface. A flash held at 45 degrees to one side lights the subjects but any reflected light misses the lens. If you position the camera at the Brewster angle (see page 28) and use a polarizer you will also get a clear view below the surface of the water.

When winds, rain, salt spray, and sometimes all three, make conditions by the sea impossible for photography, I sometimes resort to collecting material in a bucket and taking it to an aquarium filled with a commercial seawater mix. I can then use back lighting or dark field illumination (see pages 132–133) with ease. After the session, everything is returned to the rock pool.

◀ **Ceramium rubrum, Worm's Head, Gower Peninsula, Wales**
The seaweed was placed in a glass dish of seawater above black flock paper. It was lit from below by placing flash guns slightly to one side, out of the line of vision, to achieve a degree of dark ground illumination.

CAMERA Nikon F4
LENS Nikon 105mm f/2.8 AF macro
FILM Fujichrome Velvia
SHUTTER SPEED 1/125 sec
APERTURE f/16
LIGHTING SB25 flash with reflector

▲ **Coral weed (Corallina officinalis), Worm's Head, Gower Peninsula, Wales**
Placed in a small aquarium, the seaweed was lit from the sides with flash. To eliminate reflections from the camera, a sheet of black card with a hole the size of the lens was placed in front of the aquarium glass.

CAMERA Nikon F4
LENS Sigma 180mm f/3.5 AF apo macro
FILM Fujichrome Velvia
SHUTTER SPEED 1/125 sec
APERTURE f/22
LIGHTING SB25 flash with reflector

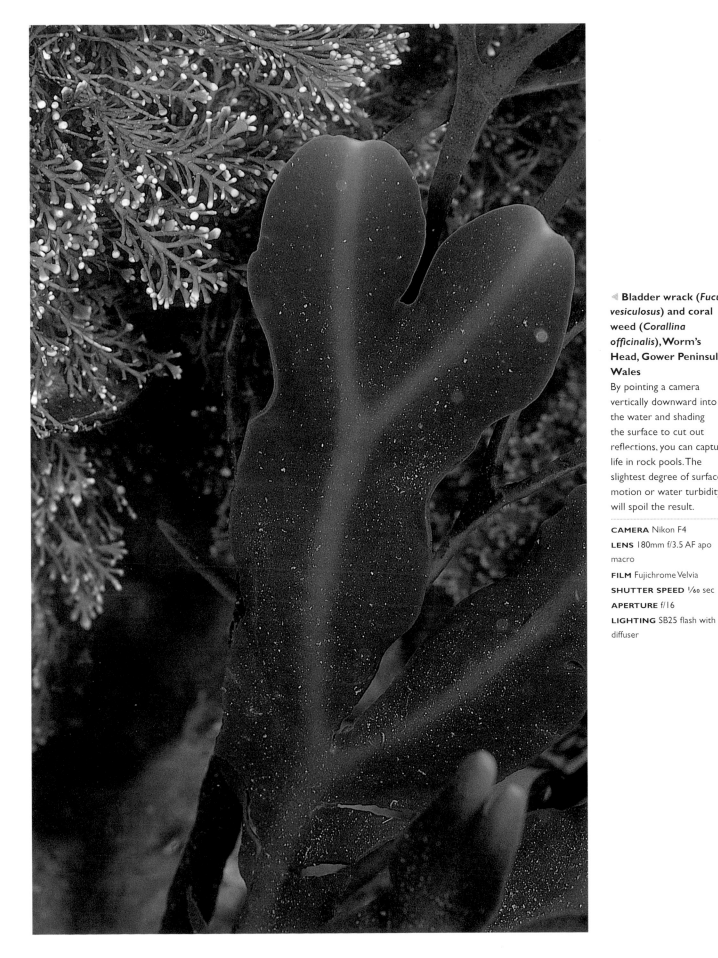

◀ **Bladder wrack (*Fucus vesiculosus*) and coral weed (*Corallina officinalis*), Worm's Head, Gower Peninsula, Wales**
By pointing a camera vertically downward into the water and shading the surface to cut out reflections, you can capture life in rock pools. The slightest degree of surface motion or water turbidity will spoil the result.

CAMERA Nikon F4
LENS 180mm f/3.5 AF apo macro
FILM Fujichrome Velvia
SHUTTER SPEED 1/60 sec
APERTURE f/16
LIGHTING SB25 flash with diffuser

▲ Dragon Tree (*Dracaena draco*), Funchal, Madeira
This peculiar tree is actually a member of the same family as
the onion. It grows in Madeira and the Canary Islands, and its
trunk exudes a red gum—once used medicinally as "dragon's
blood." Here, the leaves were captured almost as silhouettes
in late evening.

Trees

Silhouettes

WHENEVER AN UNLIT foreground subject is photographed against a brightly lit background, the result will be a silhouette. This is a treatment that can transform natural subjects such as trees, turning them into abstract, graphic images.

To be effective, the foreground subject must have a clearly defined structure, such as leafy trees on the horizon, a latticework of bare branches in winter, a finely divided leaf, or a seedhead. The background might be the bright blue of the sky close to the sun, white clouds, or the evening sky.

The silhouette need not invariably be the main subject of the photograph. Silhouetted shapes such as rocks, the sides of a cave mouth, an old stone window frame, or tree branches and trunks can be employed to create a frame around the brighter and properly exposed elements of a picture, and this can improve a composition dramatically. To avoid creating large areas of featureless black, the frame should not occupy too great a proportion of the viewfinder.

Extremes of contrast

Most color films handle tones varying from white to black over a range of about 5 stops (see pages 12–13). The faster the film, the less able it is to record a wide range of contrasts, and the easier it is to produce silhouettes inadvertently. In any composition that includes a wide range of tones, some elements, such as twigs and branches, will form silhouettes. This is because the film will not be able to record detail in the areas of deep shadow at the same time as rendering the bright parts accurately. If you want to lose all surface detail in the subject, there should be a difference of at least 4–5 stops between exposure readings for the foreground and the background.

You can, of course, produce highly dramatic silhouettes using monochrome, whether you start with black-and-white negative or reversal film, or just utilize a digital file from which all color has been removed (see pages 146–147).

◄ **Dwarf fan palm (*Chamaerops humilis*), Palermo, Sicily, Italy**
The palm leaf was photographed against white clouded sky— a sure recipe for creating silhouttes. In this case, I used a black-and-white reversal film.

CAMERA Nikon F4
LENS 180mm f/3.5 AF apo macro
FILM Agfa Scala
SHUTTER SPEED ¹/₅₀₀ sec
APERTURE f/16

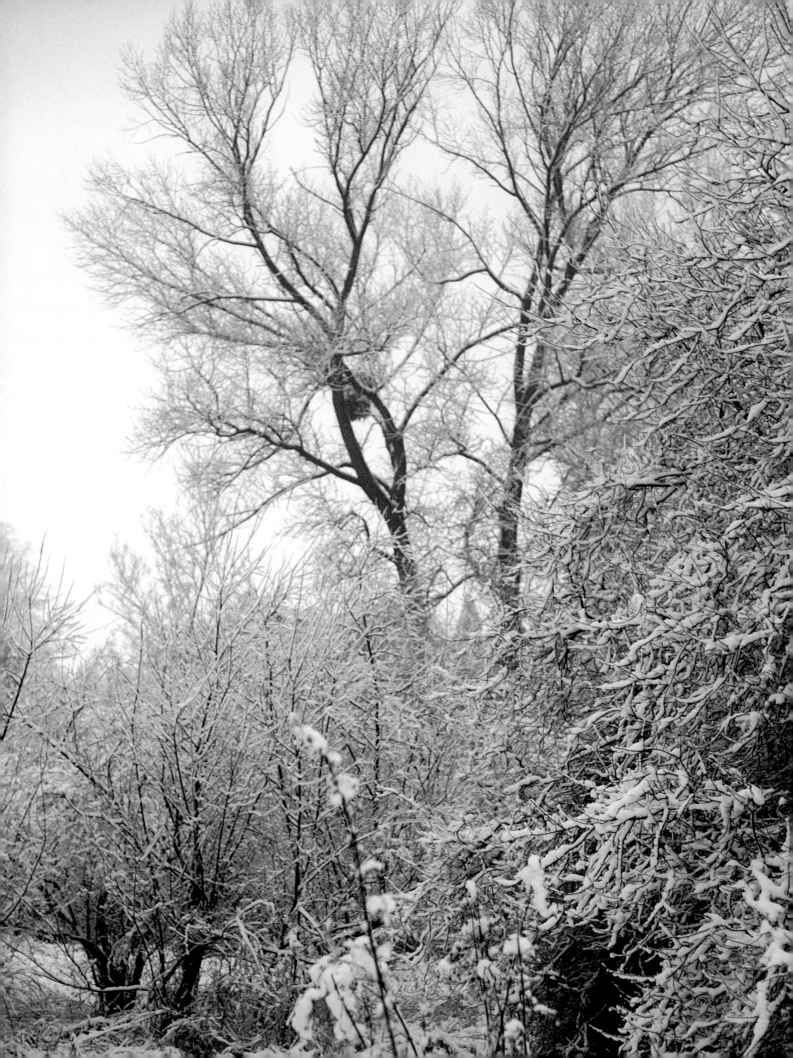

Tree Flowers

THE FLOWERING of cherry blossom in Japan is a time of national rejoicing, and no one who has seen a mist of almond blossom covering a Greek hillside, or the marvelous dogwoods of the Appalachians, will ever forget such images. Since the era of the great plant-hunters, spectacular flowering trees such as jacaranda, bauhinia, kapok, and poinsettia have been widely cultivated, and are often planted in urban streets and parks wherever the climate is suitable.

Trees, like all plants, fall into two broad categories: gymnosperms (naked seeds), which include firs and pines, and angiosperms (covered seeds). Angiosperms are further divided into dicotyledons, which produce paired seed leaves (such as oaks and maples), and the less numerous monocotyledons (such as palms), which produce a single, embryonic seed leaf.

Many flowering plants produce bisexual flowers but others, including many trees, have distinct male and female flowers. Some, such as poplars and date palms, produce male and female flowers on separate trees. Others, such as hazels, bear long male catkins and tiny female flowers on the same plant. Horse chestnuts have both male flowers and bisexual flowers in the same inflorescence. These present quite a challenge to the photographer wishing to portray them.

Individual blooms on early flowering trees can be photographed indoors when light conditions are unfavorable outside. But to capture the full glory of a flowering tree you need a range of lenses, from wide-angle, for the whole tree, to lenses with a close focus facility (macro, wide-angle, zoom) for individual flowers. Telephotos are useful for capturing highly colored flowers against a blue sky accentuated with a polarizing filter (see pages 28–29).

▲ **Blackthorn (*Prunus spinosa*), near Oxford, England**
In early spring, when flowers are abundant but the weather is harsh, there may be no alternative but to pick a twig and photograph it under cover. Here the flowers were placed in a bottle on a table and set in front of the camera on a tripod. The white flowers meant that the exposure had to be corrected by +1 stop.

CAMERA Nikon F4	**SHUTTER SPEED** 1/30 sec
LENS Sigma 180mm f/3.5 apo macro	**APERTURE** f/16
FILM Fujichrome Velvia	**LIGHTING** single flash with small white reflector as fill-in

▲ **Flame-of-the-forest (*Spathodea campanulata*), Funchal, Madeira**
Some tree flowers rival the most exotic garden blooms: in close-up, the flowers of the flame-of-the-forest resemble tulips (it is also known as the African tulip tree). *En masse*, they provide a blaze of color against the October sky.

▷ **Silk tree (*Albizia julibrissin*), Nicosia, Cyprus**
This species is grown as a street tree in many warmer countries. In order to isolate and photograph the flowers against a blue sky, a telephoto lens had to be used, with the camera supported on a tripod.

CAMERA Nikon F4
LENS Sigma 300 mm f/4 AF apo macro
SHUTTER SPEED 1/30 sec
APERTURE f/16
FILTER polarizer

CAMERA Nikon F4
LENS Sigma 180mm f/3.5 apo macro and 2x converter
FILM Fujichrome Provia
SHUTTER SPEED 1/60 sec
APERTURE f/8
FILTER circular polarizer

Leaves

Leaves are a lot more than the "lungs" of a plant, allowing an exchange of gases as oxygen diffuses in through tiny "mouths" (stomata) in the leaf surface and carbon dioxide diffuses out.

In addition to this function, the leaf has cells containing chloroplasts, tiny "factories" that synthesize sugars from water and carbon dioxide, using chlorophyl as the facilitator. Chlorophyl—the green pigment—strongly masks other pigments in leaves. But in fall, when the chlorophyl breaks down, the carotenoids show through and produce an astonishing parade of colors before deciduous trees drop their leaves in order to survive the winter.

Many people notice leaves only when the fall colors make them obvious—yet the variation in shades of green, leaf shapes, and vein patterns makes leaves intriguing subjects for the camera at any time of year.

Early botanists coined a lexicon of terms to describe leaves precisely: some reflect their shape, such as dentate (toothed), palmate (like a hand), sagittate (arrow-shaped), or hastate (spear-like), while others describe characteristics such as hairiness, or the shape of the lobes. The number of these terms in any botanical dictionary gives an idea of the sheer variety of leaves.

Leaf color can be intensified using a polarizer to cut down surface reflection. The clear blue skies of fall with maple leaves in full color is a combination few photographers can resist.

Nature will often arrange attractive patterns in fallen leaves, but few photographers can resist a little judicious adjustment to improve the composition. A warming filter is often helpful to enrich the tones in the cool woodland light.

▷ Japanese maple, Wales

Some of the most striking leaf color is exhibited by maple leaves—sugar maples and Japanese maples in particular. To emphasize the colors, you can isolate the leaves against out-of-focus grass or blue sky. It is worth trying both if you can.

CAMERA Mamiya 645 super pro TL	**SHUTTER SPEED** 1/125 sec
LENS 150mm f/3.5	**APERTURE** f/8
FILM Fujichrome Provia	**FILTER** linear polarizer

▲ Fall color, Bath, UK

A shallow depth of field was enough to isolate the foreground subject from the background and emphasize the color of the leaves.

CAMERA Nikon F4

LENS 70–210mm f/2.8 zoom

FILM Fujichrome Provia

SHUTTER SPEED 1/30 sec

APERTURE f/11

FILTER polarizer

▷ Fallen leaves, Oxford, UK

Fallen leaves make patterns of their own— it is simply a matter of turning the camera to frame them and deciding how close you want to be to isolate a group.

CAMERA Nikon F4

LENS 28–80mm f/2.8 zoom

FILM Fujichrome Provia

SHUTTER SPEED 1/30 sec

APERTURE f/11

FILTER polarizer

Leaf Patterns

Leaf geometry has long intrigued me, as has the search for pattern in nature generally. Leaves, both individually and in groups, have a great deal of potential as elements in a composition. Moreover, if you look closely at their structure, the details you find there will inspire your creativity in the realms of close-up and macro photography. At this level, portions of leaves can be made into frame-filling designs that are extremely satisfying.

The rule of thirds—or golden mean—offers a start for positioning a subject so that the eye is drawn into the picture (see page 70). Each of the images on this page has its focus of interest at that off-center point, somewhere near where the imaginary lines dividing the picture into thirds would meet.

There is also a strong diagonal element in the way leaf veins are arranged, which helps to convey a sense of movement in a photograph.

Leaf structure

The leaf veins in the two great plant divisions—monocotyledons and dicotyledons—are quite differently arranged. In dicotyledons, the veins are essentially branching and create a net-like structure—the net that forms the leaf skeletons found among decayed leaves. Monocotyledons, on the other hand—such as grasses and lilies— have veins that run the length of each leaf. They are often closely parallel, though this is not always easy to see.

Many leaves are translucent: they can be shot against natural light or mounted on black card with a central hole and back lit using tungsten or TTL flash to reveal their venation.

◀ **Leaf veins, (mono-cotyledon), *Canna* sp, Kew, UK**
Monocotyledons have parallel veins. In some species those veins run parallel along the length of a leaf; in others, as here, they coalesce to form a central vein. Much of their appeal lies in this geometry. Here the intention was to position the veins to catch the sweep of the pattern.

CAMERA Nikon F4
LENS 60mm f/2.8 AF macro
FILM Fujichrome Velvia
SHUTTER SPEED 1/30 sec
APERTURE f/16
LIGHTING SB21 macroflash

▶ **Full-moon maple leaf (*Acer japonicum*), Wales**
A single flash gun placed behind a leaf and controlled by the camera's TTL system is enough to show up the complex branching vein structure in this maple leaf.

CAMERA Nikon F4
LENS 50mm lens reversed and coupled to 105mm f/2.8 AF macro (see pages 120–121) to give 2x magnification
FILM Fujichrome Velvia
SHUTTER SPEED 1/60 sec
APERTURE f/16
LIGHTING single TTL flash

▶ **Leaf pattern, Digitate or "fingered", (*Dizygotheca* sp), Funchal, Madeira**
A black background was used to isolate the leaf from any distracting surroundings, and use was made of the proportions of the rule of thirds to set the leaf center in the frame.

CAMERA Nikon F4
LENS 60mm f/2.8 AF macro
FILM Fujichrome Velvia
SHUTTER SPEED 1/30 sec
APERTURE f/8

Bark

TREE BARK is composed of dead cells. It forms a protective layer over all the living tissues lying beneath it that make up the trunks and branches of a tree. The intricacies of its surface offer the photographer two obvious areas for exploration: pattern and texture.

Bark tones are predominantly gray, ranging from the near-white of some birch species to the somber tones of the Corsican pine. Reds and browns are less common but do occur, either as part of a patchwork pattern or as the main color of the bark, as in the eastern strawberry tree (*Arbutus andrachne*). Even in color pictures, barks often generate a monochrome feel. They are also particularly well suited to black-and-white materials, especially with tinted prints.

The surface texture of tree bark can range from the deep ruts of ancient oaks to the smoothness of beech; from the peeling strips of eucalyptus to the hard spikes of kapok. Compositional possibilities for photographs are offered by everything from whole trunks with distorted shapes—often with a hint of something animate—to tiny portions of bark made to fill the viewfinder. In this realm, a macro lens can create an abstract image, in which lines and shapes within the bark are arranged to your choice. Details, such as lichens and mosses growing on the bark, or insects attempting to hide through camouflage, give extra interest to pictures.

Side lighting is essential to reveal the texture of bark, because it creates relief from the shadows cast by ridges and indentations. Under the tree canopy, the part you want to photograph is unlikely to be in sunlight at the time you want, if at all, so flash is useful. Even on-camera flashes that pop up from the pentaprism housing work well. Your subject is neutral in tone, and is ideally suited to a TTL exposure meter.

Patterns made by wood grain are another interesting area to explore, since each tree type has its characteristic grain, well-known to wood turners and furniture makers.

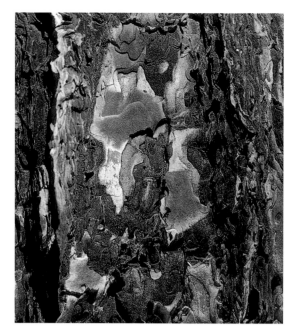

⛰ **Black pine (*Pinus nigra* ssp *pallasiana*), Troodos Mountains, Cyprus**
The peeled bark of the black pine reveals colors other than the grays normally associated with bark.

CAMERA Nikon F4	**SHUTTER SPEED** ¹/₃₀ sec
LENS 28mm f/2.8 wide-angle	**APERTURE** f/8
FILM Fujichrome Velvia	

⛰ **Umbrella pine (*Pinus pinea*), Gargano, Italy**
Bark texture can vary from the smoothness of birch and beech to the deep incisions and ridges of mature oaks.

CAMERA Nikon F4	**SHUTTER SPEED** ¹/₃₀ sec
LENS 60mm f/2.8 AF macro	**APERTURE** f/8
FILM Fujichrome Velvia	

▲ **Fetid juniper (*Juniperus foetidissima*), Mount Gingilos, White Mountains, Crete, Greece**
On high mountains, trees are low-growing and are often stunted and distorted by harsh conditions and occasional lightning strikes. The photograph shows a juniper found above the snow line in the mountains of Crete.

CAMERA Nikon F4	**FILM** Fujichrome Velvia
LENS 24mm f/2.8 AF wide-angle	**SHUTTER SPEED** 1/30 sec
	APERTURE f/11

◀ **Ancient beech (*Fagus sylvatica*), near Haverfordwest, Wales**
The ravages of age can leave trunks swollen and twisted—sometimes into fanciful shapes that have given rise to legends over the centuries.

CAMERA Nikon F4	**SHUTTER SPEED** 1/30 sec
LENS 28mm f/2.8 wide-angle	**APERTURE** f/16
FILM Fujichrome Velvia	**FILTER** polarizer

The Power of Monochrome

COLOR HAS BECOME the norm in so many areas of photography that black and white photography has tended to be seen as a thing of the past. In recent years, however, there has been a resurgence of interest in monochrome pictures, helped by the ease with which color images can be scanned and converted to monochrome or duotone. The traditional darkroom, with "hypo" leaving the taste of sulphur dioxide in the back of the throat, is now, for many, a distant memory.

It may seem that by eliminating color you are telling only half the story. Yet in some situations, color can get in the way. The shapes, tones, and textures of leaves, bark, and petals can be more powerfully conveyed in monochrome.

After a lapse of two decades, I have recently re-discovered monochrome. The first steps on my Road to Damascus were taken when scanning images to create digital files and simultaneously becoming addicted to Adobe Photoshop. Old family photographs were brought back to life and sepia-toned prints created.

When a client asked for pictures to be shot simultaneously on color and on black-and-white reversal material, I used the extraordinary Agfa Scala. This monochrome reversal film, available both in 35mm and roll film, is far from cheap and cannot be home-processed, but it allows an outstanding range and depth of tones. When enlarged, it retains its ultra-fine grain structure, appearing simply to reveal more and more detail. It can also be pushed to far higher film speeds than its rated ISO 200.

Traditionalists may abhor the digital approach, but it has made good black-and-white printing easy: using a scanner for transparencies or negatives, output is controlled by a personal computer and monochrome prints produced using a photo-realistic digital printer. I have long found that, every now and then, just when you are beginning to feel that your work is becoming a little predictable and even slightly stale, something happens to rekindle your interest.

▲ **Catalina ironwood (*Lyonothamnus aspleniifolius*), Los Angeles, USA**
These beautifully veined, translucent leaves are ideal candidates for back lighting.

CAMERA Nikon F4
LENS 28mm f/2.8 wide-angle
FILM Agfa Scala
SHUTTER SPEED ¹/₁₂₅ sec
APERTURE f/16

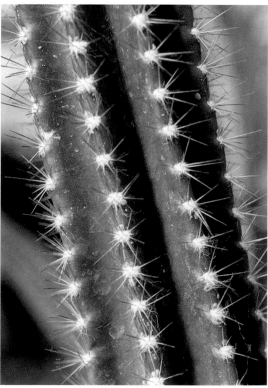

▶ ***Opuntia* sp, Huntingdon Botanic Garden, Los Angeles, USA**
Cacti have a simplicity of form that is revealed to advantage by monochrome.

CAMERA Nikon F4
LENS 60mm f/2.8 AF macro
FILM Agfa Scala
SHUTTER SPEED ¹/₁₂₅ sec
APERTURE f/16

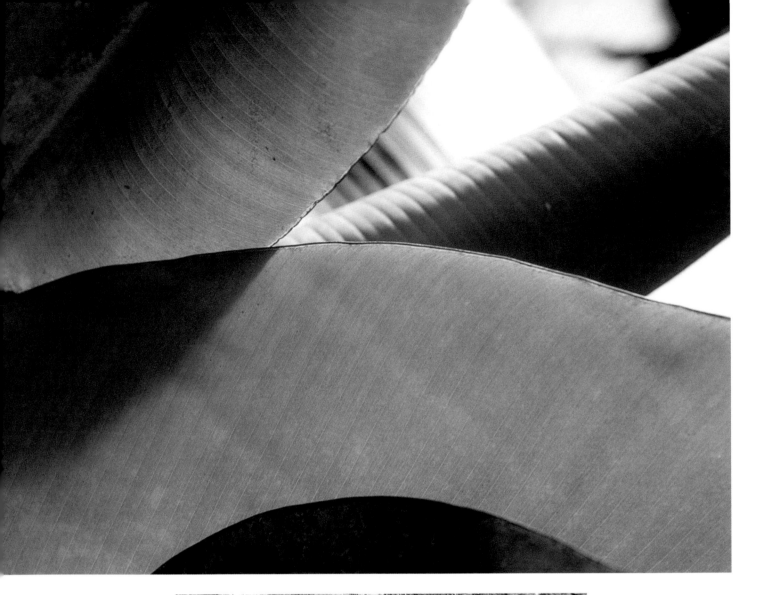

Banana leaves (*Musa* sp), Funchal, Madeira

While exploring the photographic possibilities of a tropical house, I noticed the way some banana leaves were partly back lit. Their geometry intrigued me, so I loaded the camera with black-and-white film.

CAMERA Nikon F4
LENS 28mm f/2.8 wide-angle
FILM Agfa Scala
SHUTTER SPEED ¹/₃₀ sec
APERTURE f/16
FILTER polarizer

Pine bark (*Pinus* sp), private arboretum, Wales

With bark a monochrome film shows the grays to advantage, while concentrating the eye on the textures and tones.

CAMERA Nikon F4
LENS 28mm f/2.8 wide-angle
FILM Agfa Scala
SHUTTER SPEED ¹/₁₂₅ sec
APERTURE f/11

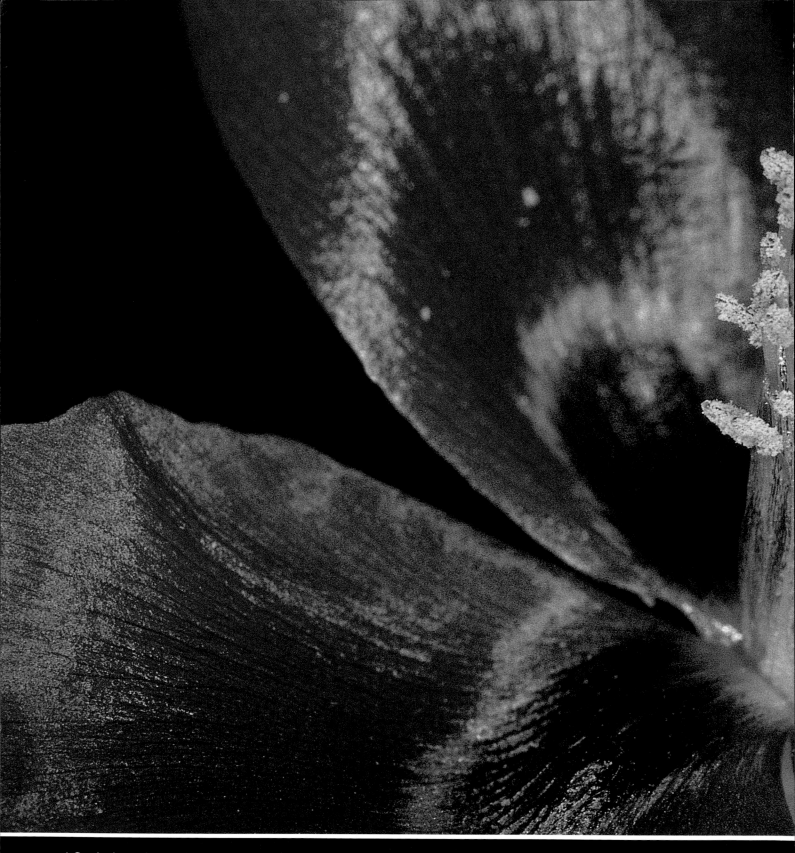

▲ **Scarlet horned poppy (*Glaucium corniculatum*),
Droushia, Cyprus**
These scarlet flowers, with black patches near the base
and yellow stamens, make a strongly contrasting subject.
Sometimes there is no need to capture a whole flower—
just a part of it can be very effective.

Close-up and Macro

Depth of Field

THE LENS APERTURE is essentially a hole through which light passes. Its size can be varied by opening or closing the iris diaphragm and, together with shutter speed, the aperture is used to control the amount of light reaching the film.

Each lens is marked with a set of "f" stops that run in a series in order of decreasing aperture size: f/1, f/1.4, f/2, f/2.8, f/4, f/5.6, f/8, f/11, f16, f/22, f/32. Moving from one number to the next produces a change in area of aperture by a factor of 2 (light intensity on film is doubled by opening up 1 stop and halved by closing down 1 stop). This is rather a coarse adjustment for modern films, and most lenses now have intermediate clicks for ½ stops.

In close-up and macro photography the size of the aperture is important, for it controls the depth of field—the smaller the aperture the greater the depth of field (see Technical Appendix pages 152–155). Wide-angle lenses often give the impression of greater depth of field than other lenses. This has more to do with where you are standing, for the reality is that the depth of field is fixed, whatever the lens, at a given magnification and aperture.

When using an aperture of f/5.6 or less for about half life size to higher magnifications, the depth of field is small. With a macro lens of 90–200mm focal length, a narrow range of sharpness can be defined, and this can be an effective compositional tool if you want to concentrate on a small part of a subject. Rather than using the focusing ring, it is much easier to set the magnification you want by rotating the lens barrel and then rocking back and forth—moving the whole camera – to get sharp focus.

DIAPHRAGM SHAPE

The more blades there are in a lens diaphragm, the more nearly circular is the aperture it maintains as it is closed down. This makes a subtle difference to the way detail is rendered and to the sharpness with which the subject is differentiated from the background. You can think of an image as built up of tiny images of the aperture—if the diaphragm forms a polygon or even a star shape as it closes, this makes a difference at small apertures. The best macro lenses have diaphragms with a minimum of eight blades.

▷ **Weevil (*Liparus glabrirostris*), Dolomites, Italy**
The weevil's determined feeding gradually produced a shape that mirrored its body. With insects, my aim is to get the sharpest picture I can, with all hairs visible, and good flash is essential.

CAMERA Nikon F4
LENS 105mm f/2.8 AF macro with 1.4x converter
FILM Fujichrome Provia
SHUTTER SPEED ¹/₁₂₅ sec
APERTURE f/16
LIGHTING SB21B macroflash

▷ **Crown anemone (*Anemone coronaria*), the Mani, Greece**
It is tempting always to maximize depth of field, but here I used a shallow depth of field in order to isolate a few of the unripe stamens early in the morning.

CAMERA Nikon F4
LENS Sigma 180mm f/3.5 AF apo macro
FILM Fujichrome Velvia
SHUTTER SPEED ¹/₁₂₅ sec
APERTURE f/5.6

▷ **Slipper orchid (*Paphiopedilum macranthum*), origin Yunnan, China; Los Angeles, USA**
With three-dimensional subjects, such as the staminode of this slipper orchid, you need to select a viewpoint to provide a plane of focus that will make best use of the depth of field. Moving slightly to one side often helps.

CAMERA Nikon F4
LENS 105mm f/2.8 AF macro
FILM Fujichrome Velvia
SHUTTER SPEED ¹/₁₂₅ sec
APERTURE f/16
LIGHTING SB21B macroflash

Sharpness

THE PERCEPTION OF SHARPNESS in an image depends on a number of factors. For the lens itself, there is the way it copes with changes from one shade of color to another, particularly at the edges of objects (contrast). Then there is its ability to separate fine details (resolving power). The lens designer has to juggle these differing requirements when creating a lens.

Depth of field imposes limits of sharpness, but by clever choice of which part of the subject should be sharply defined, the photographer can convey a general impression of sharp focus. For example, animal eyes or eye spots on insect wings have to be in sharp focus, otherwise the image becomes unacceptable. The best angles will put

▲ Gray dagger moth caterpillar (*Acronicta psi*) on bramble, Kenfig, Wales

For maximum sharpness with small subjects flash is an ideal light source, permitting small apertures to give good depth of field and bright, saturated colors. The fast speed eliminates subject or camera movement.

CAMERA Nikon F4	**SHUTTER SPEED** 1/60 sec
LENS 105mm f/2.8 AF macro	**APERTURE** f/16
FILM Fujichrome Velvia	**LIGHTING** SB21B macroflash

◀ Sawfly orchid (*Ophrys tenthredinifera*), near Palermo, Sicily, Italy

Choice of a suitable plane of sharp focus allows you to get the essential parts of a subject in focus—the eye forgives parts that are not sharp, unless you bring attention to them.

CAMERA Nikon F4	**SHUTTER SPEED** 1/60 sec
LENS 105mm f/2.8 AF macro	**APERTURE** f/16
FILM Fujichrome Velvia	**LIGHTING** SB21B macroflash

FACTORS AFFECTING SHARPNESS

The resolving power of a lens is quantified in terms of blur circles (see Technical Appendix pages 152–155) or separation of finely drawn lines (line pairs per mm). Other factors affecting sharpness include using fine-grained films and minimizing camera movement with a tripod and mirror lock-up. Subject movement is stopped by using flash. Lighting is crucial, particularly the angle at which light hits a subject. Surface detail is accentuated by creating relief through the tiny shadows that result from a degree of side lighting.

such elements of the subject on the plane of focus (see page 110), making maximum use of the available depth of field.

Soft focus

Some subjects lend themselves to images that are distinctly unsharp to create "mood." Simply defocusing a lens is hard to control, though some special lenses have a moveable element for the purpose. Most people want to use this effect only occasionally, and it can be achieved using a soft-focus filter or by lightly smearing petroleum jelly on a glass plate or filter in front of the lens. Usually the central portion of the lens is left clear (see pages 136–137). Images can be softened after an image has been digitized, either by scanner or directly from the camera. There are various "blurs" in Photoshop: the most useful is Gaussian blur, which can be used to throw a background out of focus (see pages 148–149).

Diffraction

The illusion of sharpness is usually enhanced by using the maximum possible depth of field. But as magnification increases, the ability of light wave fronts to spread at small apertures—diffraction—begins to soften the image. At high magnifications there is a compromise between aperture size to get the required depth of field and the limits imposed by diffraction.

◀ **Common wasps (Vespa vulgaris) on a rotten apple, Cowbridge, Wales**
A fine-grained film with high contrast is an important element in the quest for sharpness. Modern film emulsions with speeds of ISO 25–100 let you record very fine detail—as much as the lens can resolve.

CAMERA Nikon F4
LENS 105mm f/2.8 AF macro
FILM Fujichrome Velvia
SHUTTER SPEED 1/60 sec
APERTURE f/16
LIGHTING SB21B macroflash

▲ **Cape gooseberry (Physalis alkekengi), London, England**
Lighting is the element most often forgotten in close-up work, but it is the most important. If artificial lighting is needed, use of a flash gun with a reflector or second flash as fill-in produces softer shadows yet retains modeling.

CAMERA Nikon F4
LENS 105mm f/2.8 AF macro
FILM Fujichrome Provia
SHUTTER SPEED 1/60 sec
APERTURE f/16
LIGHTING single flash gun with reflector

Individual Flowers

Many large flowers can be photographed successfully using a good zoom lens. This allows you to fill the frame with a single flower, while simultaneously achieving a pleasing perspective by retaining sufficient distance between camera and subject.

Manual focus wide-angle lenses with a fixed focus such as 24mm or 28mm often have far better close focus capabilities than their auto-focus counterparts. When they are used for frame-filling portraits of individual flowers, they create a slight distortion of perspective. While this would be unacceptable in an image of a human or animal face, in plants it simply emphasizes the flower—which is, after all, the "beacon" we tend to see first.

The two wide-angle lenses I use—the Sigma 24mm f/2.8 and the Nikon 28mm f/2.8—both allow a closest focus of about 5½ in (14cm) from the film plane, and about quarter life-size magnification.

With small flowers you are in the realm of the macro lens. The photographer can control the extent to which the subject fills the frame, and whether the frame will be vertical or horizontal. The flower size and shape determine this choice. The element that creates impact is "aspect"—the view you take of a flower—and also the depth of field. With most macro shots the intention is to reveal as much detail as possible in the subject, and therefore to achieve maximum, not minimum, depth of field.

Choosing a plane of focus

The best angle is one that is going to make the most effective use of the available depth of field, and finding this involves moving around the subject. I look carefully at a subject—say a leaf or a daisy—and arrange the camera so that its back, and hence the film, is as nearly as possible parallel to the plane in which my subject lies: the plane of focus. On flowers, such planes are not always obvious, so you may have to visualize an imaginary plane in which the flower lies. It helps to have a camera where the lens can be stopped down to preview the resulting change in depth of field as you close the aperture.

Camera movements

With tilting fronts and backs on large format cameras, or on some specialized lenses for 35mm, you can change the plane of focus to give greater front-to-back sharpness in a subject that has depth (see Technical Appendix pages 152–155).

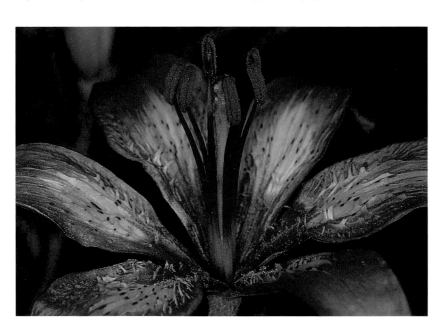

≫ Orange lily (*Lilium bulbiferum*), Dolomites, Italy

Concentrating on part of a flower produces a slightly different kind of portrait. I never take just one view of a flower: when the results come back from the processor the view you favored may not turn out to be the best one on film.

CAMERA Nikon F4
LENS 105mm f/2.8 AF macro
FILM Fujichrome Velvia
SHUTTER SPEED 1/60 sec
APERTURE f/16
LIGHTING Nikon SB21B macroflash

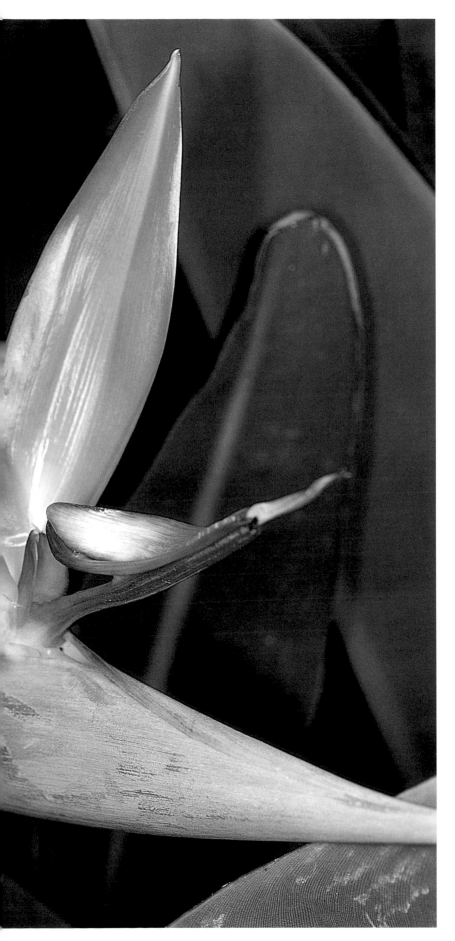

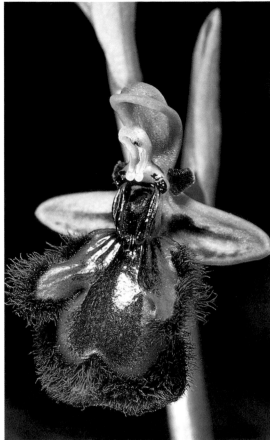

▲ **Mirror orchid (*Ophrys vernixia*), near Pylos, Greece**
Most flowers, like human faces, have a "best angle," and it pays
to take time looking through the viewfinder while changing
position to see the results. Complex flowers are often best
portrayed in a partial frontal/side view rather than as front or
side "mug shots."

CAMERA Nikon F4	**SHUTTER SPEED** ¹⁄₆₀ sec
LENS 105mm f/2.8 AF macro	**APERTURE** f/16
FILM Fujichrome Velvia	**LIGHTING** SB21B macroflash

◀ **Bird of paradise flower (*Strelitzia regina*),
Funchal, Madeira**
The shape of a flower can suggest the best way to portray it
—in landscape or portrait format, for example. Although a
small part of this exotic flower is lost, the other details are
emphasized by the vertical format.

CAMERA Mamiya 645 pro TL	**SHUTTER SPEED** ¹⁄₃₀ sec
LENS 80mm f/4 macro	**APERTURE** f/11
FILM Fujichrome Provia	**FILTER** linear polarizer

Back Lighting

Back lighting can be used to advantage with any subject that has a degree of translucency, as is the case with many flowers and leaves. The art is to balance frontal lighting and back lighting so that the back-lit portions of the subject seem luminous. You can achieve this by taking exposure readings from the front-lit portions—if the back-lit area predominates, it will be recorded as a mid-tone and the front-lit parts will be dull.

The pictures on this spread show a variety of back-lit subjects. All except one utilize only natural light and were taken when the sun was low in the sky. Because the light is coming from behind the subject, the background appears dark, accentuating the subject.

When photographing brilliantly colored fall leaves outdoors, I have often held a leaf in a small stand or clamp (see pages 128–129) against a sheet of black card with a hole in the center, which is positioned behind the leaf. The subject is more or less flat and is therefore easy to hold parallel to the film plane. This means that the depth of field can

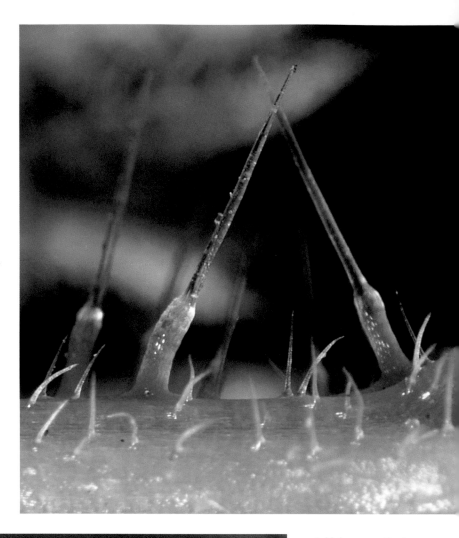

▷ **Sea daffodil (*Pancratium maritimum*), Lara Beach, Cyprus**
The first rays of the early morning sun illuminated the cup of the flower. The sun was so low that the sand background was barely lit. The result mixed frontal and back lighting to reveal the detail in the flower.

CAMERA Canon F1
LENS 28mm f/2.8 wide-angle
FILM Kodachrome 25
SHUTTER SPEED 1/30 sec
APERTURE f/11

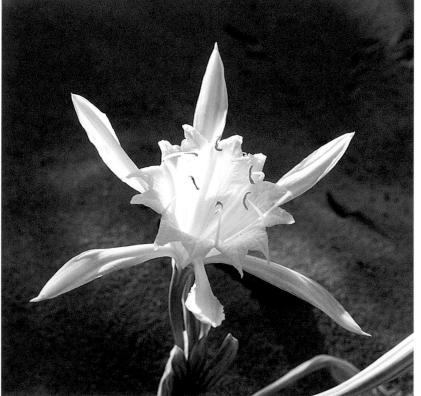

▲ **Hairs on a stinging nettle (*Urtica dioica*), Cowbridge, Wales**
The stinging hairs on a nettle are like tiny hypodermic needles. A single flash to the rear and well out of the field of view back-lit the hairs to reveal their detail. A magnification of 7x was obtained using a bellows and a special macro lens head.

CAMERA Nikon F4
LENS Olympus 38mm f/3.5 bellows macro lens
FILM Fujichrome Velvia
SHUTTER SPEED 1/60 sec
APERTURE f/16
LIGHTING single Nikon SB23 flash

be shallow, so you do not have to use slow shutter speeds. You need to experiment—try giving the subject ⅓–⅔ stops overexposure to make highlights of the most transparent parts.

The same set-up works effectively with a single TTL flash, used off-camera and placed behind the leaf or stem: again, slight exposure compensation may be necessary. Most matrix meters seem to read the situation accurately.

▶ Japanese maple (*Acer palmatum*), Bryngarw House, Wales

By choosing your position carefully you can achieve an angle in which leaves are back-lit by the sun against a blue sky. In fall, this can provide for very high color contrasts.

CAMERA Mamiya 645 super pro TL	**SHUTTER SPEED** ¹/₁₂₅ sec
LENS 150mm f/3.5 wide-angle	**APERTURE** f/8
FILM Fujichrome Provia	**FILTER** linear polarizer

▼ Prickly pear (*Opuntia ficus-indica*), near Malaga, Spain

Late afternoon light, because of the sun's low angle, often provides a degree of back lighting as a matter of course. With wide-angle lenses, flare spots can easily occur—either use an effective lens hood, or position a hand to shade the lens.

CAMERA Nikon F4	**SHUTTER SPEED** ¹/₆₀ sec
LENS 28mm f/2.8 AF wide-angle	**APERTURE** f/16
FILM Fujichrome Provia	**FILTER** circular polarizer

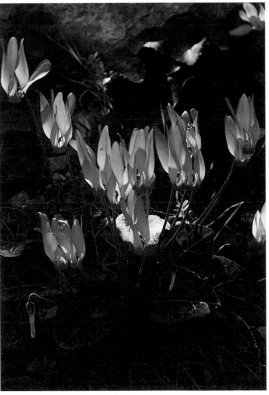

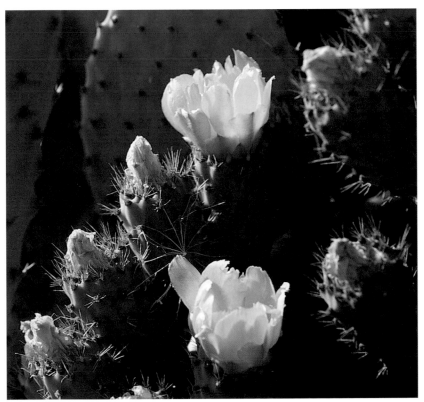

▲ Spring sowbread (*Cyclamen repandum*), Tuscany, Italy

Stray shafts of sunlight in woods can pick out individual flowers and make them glow. You have to act quickly, for the slightest movement of the sun can create shadows from branches in the canopy so that the picture is lost.

CAMERA Nikon F4	**SHUTTER SPEED** ¹/₆₀ sec
LENS 28mm f/2.8 AF wide-angle	**APERTURE** f/16
FILM Fujichrome Provia	**FILTER** circular polarizer

Lighting with Flash

Few photographers would deny that natural light can provide the best lighting for plants and flowers, but ideal conditions do not occur to order. Nevertheless, some people object to using flash for plant photography at all costs, citing colors that are too bright, unnatural shadows, and unacceptably dark backgrounds.

Black backgrounds can be avoided by using a large flash gun held further away from the subject, which will illuminate the background simultaneously. However, it will act as a point source and create hard shadows unless it is equipped with a diffuser or softbox.

Through-the-lens (TTL) flash control is one of the most ingenious pieces of trickery in modern photography—light discharged by a flash tube is reflected off the film surface during exposure and read by a sensor in the camera body. When enough light has reached the film the flash is quenched—all in a few nanoseconds.

Matrix metering systems provide you with flash exposure that is usually reliable, but problems may occur with highly reflective or very dark subjects (see pages 116–117). The lesson is to experiment with your own equipment to see what works best.

When working at higher magnifications and using a single flash as a broad light source, some TTL systems will give overexposure, because the gun is so close and quench times rapid. However, this tends to be a consistent problem, so after making test exposures you can simply use the compensation dial to correct it.

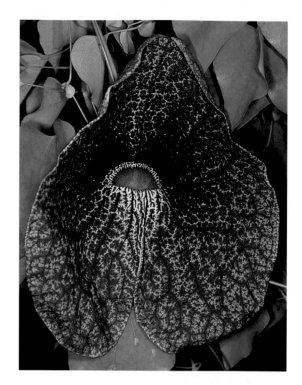

▷ **Calico flower (Aristolochia grandiflora), Funchal, Madeira**
With a large flower, an integral flash can give very good results. With smaller flowers, the flash position in the camera pentaprism makes it impossible to illuminate the subject.

CAMERA Nikon F60
LENS 28–80mm f/2.8 zoom
FILM Fujichrome Provia
SHUTTER SPEED ¹/₁₂₅ sec
APERTURE f/16
LIGHTING camera's integral flash unit

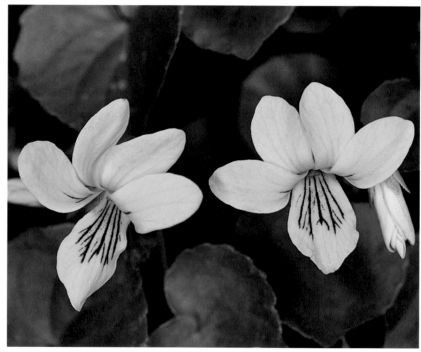

USING A SINGLE FLASH GUN

A single small flash gun used close to a subject acts as a broad source, much like a photoflood used with an umbrella, and produces lighting with soft shadows. But fall-off in light behind the subject is rapid (following the inverse square law of light intensity), and backgrounds have to be close to show color and avoid the unwanted black backgrounds that lead some people to avoid flash. Better relief is obtained with the flash used off-axis: a good starting point is to hold the gun about 30–45 degrees to one side and at the same elevation above the subject.

▲ **Twin-flowered violet (Viola biflora), Dolomites, Italy**
When the background is close, it receives enough light to look natural.

CAMERA Nikon F4
LENS 60mm f/2.8 AF macro
FILM Fujichrome Velvia
SHUTTER SPEED ¹/₆₀ sec
APERTURE f/16
LIGHTING SB21B macroflash

▷ **Mexican flame vine, (Senecio confusus), Funchal, Madeira**
For dark backgrounds, flash can be the main light source.

CAMERA Nikon F4
LENS 180mm f/3.5 AF apo macro
FILM Fujichrome Velvia
SHUTTER SPEED ¹/₂₅₀ sec
APERTURE f/16
LIGHTING single SB23 flash with diffuser

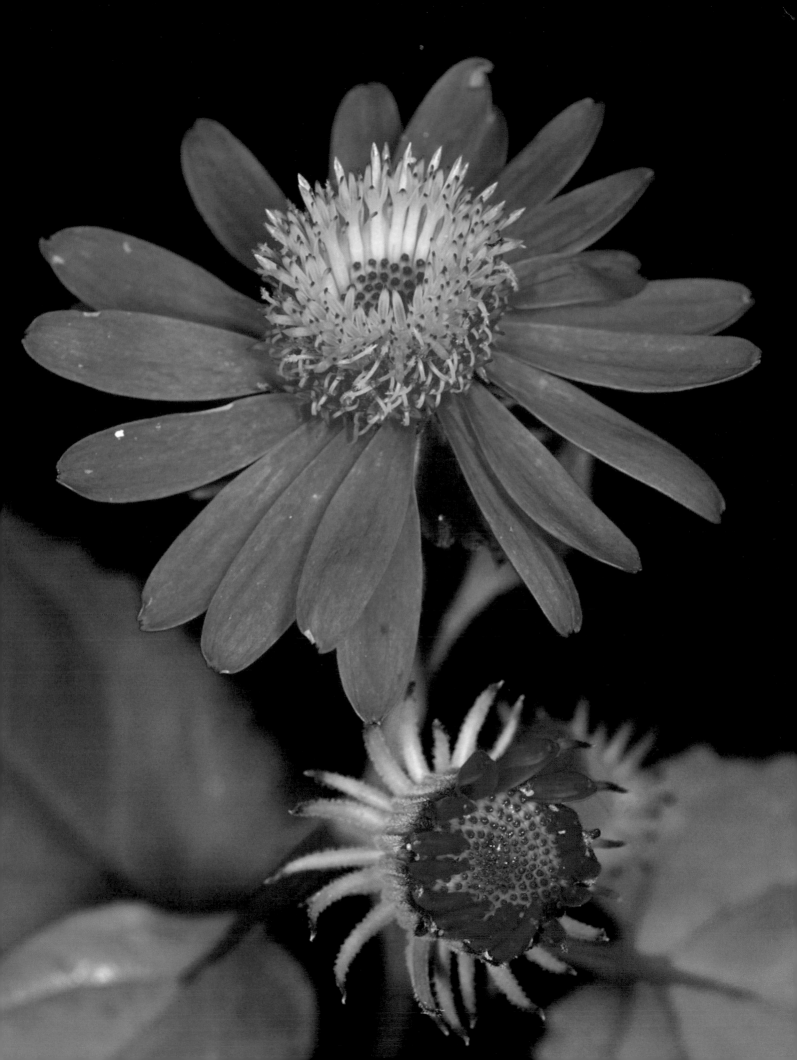

Macroflash Systems

Before I tried using commercial macroflash units for the first time, I felt that they looked far too much like ring lights and that the flash tubes were not sufficiently separated to provide relief. I was pleasantly surprised.

A macroflash you can trust is a huge boon, for it enables you to work quickly and consistently in nurseries and gardens. You set the approximate magnification you want, aperture stays at f/16 or f/22, and you tweak the exposure compensation for very light or very dark subjects (my set-up needs +$\frac{2}{3}$ stop for yellow subjects and +1–$1\frac{1}{3}$ stops for white, if they occupy a large proportion of the viewfinder). The secret is to avoid having the background so far away that the light fall-off results in a black background (see pages 130–131).

Several units allow you to set the tubes at different power levels so that one of them can act as a fill-in. When using flash on reflective surfaces, it is always important to avoid twin highlights on the subject. Tissue paper diffusers are effective when placed over the flash heads.

▷ **Lion's tail (*Leonotis leonurus*), Ribeira Brava, Madeira**
With the low power of most macroflash units, stark black backgrounds are likely to occur. They can be avoided by moving in on a subject so that it fills the frame and by composing the picture so that vegetation in the background is lit to some degree.

CAMERA Nikon F4
LENS 60mm f/2.8 AF macro
FILM Fujichrome Velvia
SHUTTER SPEED 1/60 sec
APERTURE f/16
LIGHTING SB21B macroflash

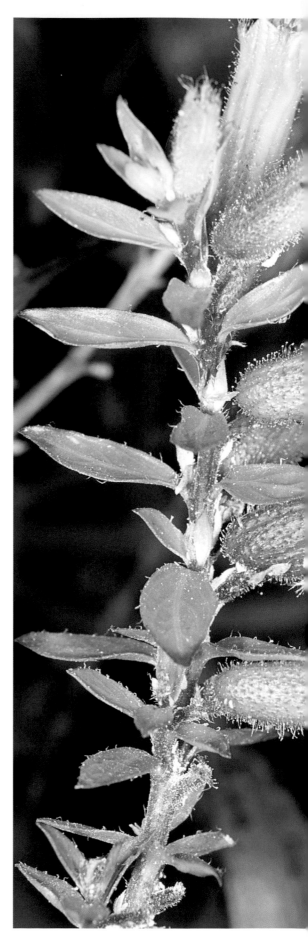

▷ **Tamarillo, Tree tomato, (*Cyphomandra betacea*), Funchal, Madeira**
Macroflash units are very useful when working commercially, with the need to take pictures quickly and reliably. It becomes largely a matter of "point and shoot" if the TTL system is reliable: focus is achieved by gently rocking back and forth, moving the whole camera, unless the lens has internal focusing and its length does not change.

CAMERA Nikon F4
LENS 105mm f/2.8 AF macro
FILM Fujichrome Provia
SHUTTER SPEED 1/125 sec
APERTURE f/16
LIGHTING SB21B macroflash

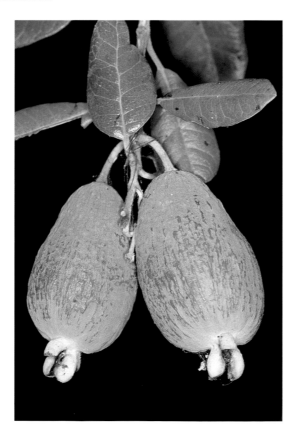

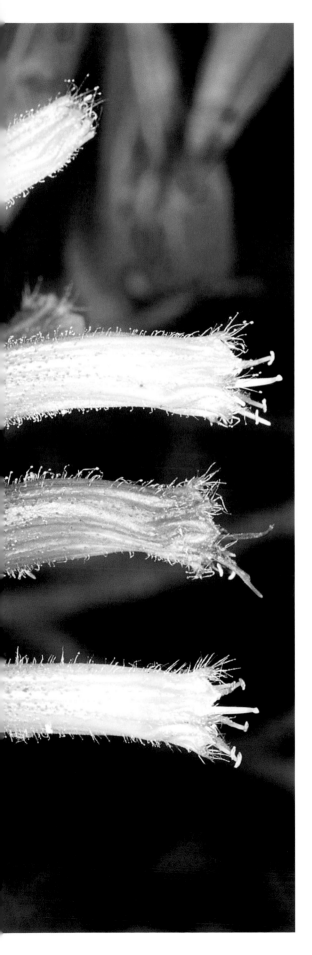

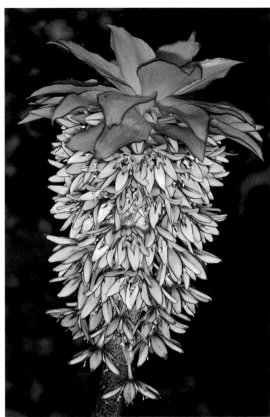

◀ **Pineapple lily
(*Eucomis bicolor*),
Funchal, Madeira**
Small exposure corrections
are often needed for very
light subjects (give slight
overexposure) or very dark
ones (slight under-
exposure). With larger
flowers, macroflash units
quickly show their low
power when used with a
105mm macro and
apertures smaller than f/8:
they give underexposure at
magnifications less than
about half size, for example.

CAMERA Nikon F4
LENS 105mm f/2.8 AF macro
FILM Fujichrome Velvia
SHUTTER SPEED ¹⁄₆₀ sec
APERTURE f/8
LIGHTING SB21B macroflash

Commercial macroflash units do not pack
sufficient punch to illuminate a subject when used
with macro lenses of longer focal length or at
magnifications less than 1:1. The choice is then
either to use natural light or to put together your
own macroflash unit. You can build this using a
couple of small TTL guns, leads, and suitable
commercial brackets such as Stroboframe and
Lepp—or construct your own from aluminum rod
from a hardware store and a few Hama or Kaiser
flash mounts.

LIGHTING RELIEF

When a macroflash is used with a macro
lens of focal length 50–60mm, for
around life-size magnification, the
position of the tube means that the light
comes from about 30 degrees off axis,
an angle that is enough to provide the
tiny shadows that delineate surface
relief. Even with 90–105mm lenses there
is appreciable relief, though the angle is
reduced to about 20 degrees.

Manufacturers of autofocus macro
lenses do not tell you that, with
moveable internal elements,
magnification is gained at the expense
of focal length change—most AF macro
lenses of around 100mm focal length
are actually closer to 80mm. The lens-to-
subject distance will therefore still be
small enough for the macroflash to
provide enough light.

Mixing Sun and Flash

A MIXTURE OF frontal and back lighting works wonderfully with subjects such as poppies growing in a field, either in the early morning or late afternoon with the sun low in the sky. This mixing of illumination can also be accomplished with natural and artificial light sources.

Mixing flash and sunlight is very useful in woods. Before switching on the flash, allow the camera to meter the background with the aperture set to the value you want—say f/16. Now adjust the shutter speed to give up to 1 stop under-exposure in the background.

Nikon users will encounter two terms in instruction booklets: these are the "fill flash" and "balanced fill flash" modes. The process described above corresponds to "balanced fill flash," which owners of sophisticated flash guns (such as the Nikon SB24 onward and various Metz guns) can program on the guns. Electronic ingenuity allows you to set the difference you want between flash (for the foreground) and ambient light (for the

> **Cockspur coral tree (Erythrina crista galli), Los Angeles, USA**
Flower interiors are often in the shade when you are photographing against the light. A degree of fill-in flash can throw light into the shadows and provide a more balanced result. Here the flash system took care of the exposure—the aperture was adjusted to allow the sky to be exposed naturally.

CAMERA Nikon F4
LENS 180mm f/3.5 AF apo macro
FILM Fujichrome Velvia
SHUTTER SPEED 1/60 sec
APERTURE f/16
LIGHTING Nikon SB25

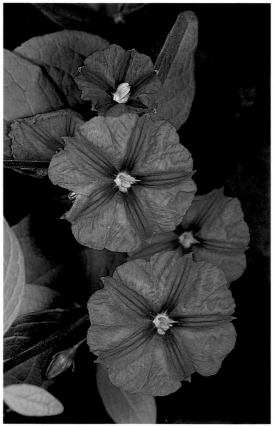

> **Potato vine (Solanum wendlandii), Henley-on-Thames, England**
Neither sunlight nor flash gives perfect results with some blue flowers—a flash gun gives off a surprising amount of infrared. Here, both were mixed and the final result had to be corrected for printing.

CAMERA Nikon F4
LENS 105mm f/2.8 AF macro
FILM Fujichrome Provia
SHUTTER SPEED 1/60 sec
APERTURE f/16
LIGHTING SB21B macroflash

background) on the flash gun—provided you can make heads or tails of the instructions.

You can set the flash exposure to be above or below the ambient light. If your flash exposure is less than the ambient light, this is called "fill flash." In effect, you are relying on natural light, but by using a short simultaneous flash exposure—$2/3$–$1\frac{1}{3}$ stop less than the ambient light—the shadows are softened. The flash reduces the contrast difference created by the natural light alone and also adds a "punch" to the colors, which looks remarkably natural.

Whenever I try this, I use the integral diffuser in the flash gun or employ a softbox on the front of the flash to produce a broad light source.

The air must be perfectly still—and even photographer movement can affect this. If it is not, you will get a sharp flash exposure of your subject together with a "ghost" generated by natural light. This is not the sort of thing you can pretend was creative photography.

A USEFUL COMBINATION

I use Fujichrome Provia 100F, rated at ISO 80, as my standard stock in 120, and also for butterflies and other insects in 35mm. By happy accident, on a sunny day this means I can avoid dark backgrounds when flash is the light source and I am working close up. This is possible because of the speed of the film and that "sunny f/16 rule" (see page 11). With a shutter sync speed of 1/125 sec and marked aperture of f/16 (the effective aperture is smaller), natural light gives a slightly underexposed background that emphasizes the subject. With slower films and in dull conditions, the shutter speed has to be adjusted to underexpose the background slightly.

▽ **Red passion flower (*Passiflora coccinea*), Funchal, Madeira**
On a cloudy day a degree of fill-in flash can be used to give "punch" to colors that might otherwise look dull. On the flash gun used, I set 1 1/3 stops underexposure; the main exposure was daylight.

CAMERA Nikon F4	**SHUTTER SPEED** 1/30 sec
LENS 60mm f/2.8 AF macro	**APERTURE** f/8
FILM Fujichrome Velvia	**LIGHTING** SB25 flash

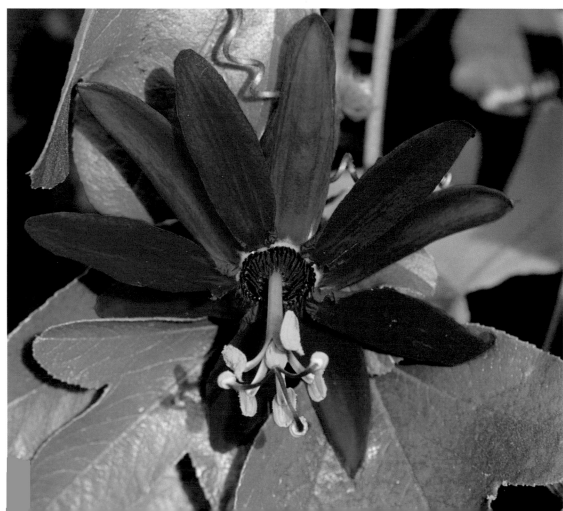

Reversing and Coupling Lenses

A DECADE AND MORE ago I abandoned all thoughts of finding a universal solution—one perfect set-up that would work for the whole range of magnifications I needed.

In practice, you need a way of getting an occasional magnified image, such as a detail of plant stamens showing the grains of pollen on them. This problem can be solved extremely well in a number of ways, using items you may already have to hand.

Coupled lenses

The coupling of lenses offers by far the best way to get the occasional shot at higher magnification in the field. In principle, it is the same as using a supplementary lens (see Technical Appendix pages 152–155), but this time it is a very highly corrected supplementary—a camera lens used in reverse. The lens of longer focal length is fixed to the camera, and the lenses are coupled using an adaptor ring with two male threads that fit into the two filter rings. For awkward sizes you can do it yourself with a pair of Cokin thread adaptors glued flat, face to face. It is important that the two threads are not too different in diameter, or you'll get vignetting (darkening at the edges of the image). Magnification equals the focal length of the prime lens divided by the focal length of the additional lens. For example, a 50mm lens added to a 135mm telephoto gives a magnification of $135 \div 50$, or 2.7x.

When teleconverters or extension tubes are used, the light intensity on film is reduced: in effect you "lose" light. But a reversed lens is used wide open and all the functions of the prime lens, such as automatic diaphragm and TTL exposure, are retained. Ironically, an old, "unfashionable" 50mm standard lens works better than any macro lens: in terms of image brightness, the wider the aperture the better.

If you are working at ground level you can rest the set-up on a bean bag. To focus, you move the camera body, though it is sometimes easier to move the subject. This takes practice because the depth of field is very shallow.

How reversed lenses work

Most lenses are designed to perform optimally with an object larger in size than the image produced on film. By using a lens in reverse, the corrections become appropriate to close-up work, where the image size on film is as large (life size) or greater than that of the object itself. In practice, little difference in image quality is discernible until a lens is used in this way to give magnifications of about twice life size. The only disadvantage of the method is that features such as auto diaphragm and exposure meter linkages do not function when a lens is reversed.

Coupled lenses, teleconverters, and even optics such as enlarger lenses and old cine lenses work brilliantly, for the simple reason that you are using them at small apertures. This means that the image is formed from those rays closest to the lens axis where correction is best—even when using cheapish lenses.

TELECONVERTERS

When they are used close up, teleconverters act as magnification multipliers. They are great for giving that bit extra. I often use a 1.4x converter on a 90mm macro lens and have had excellent results with a Sigma 2x apo converter on the 180mm f/3.5 apo macro lens. Absolute rigidity of support and mirror lock-up are both essential to eliminate camera movement.

▶ **Crocus (*Crocus cyprius*) stamens, Troodos, Cyprus**
This photograph was an early experiment in using a reversed lens on an extension tube. There is slight flare at the center induced by the bright parts on the lens mount. In later shots these were eliminated by using a simple lens hood—a reverse lens cap with its center removed. I was delighted to find that the lens was able to resolve individual pollen grains.

CAMERA Canon F1	**SHUTTER SPEED** 1/60 sec
LENS 50mm f/3/5 macro reversed on to extension tube	**APERTURE** f/16
FILM Kodachrome 25	**LIGHTING** single flash with card reflector

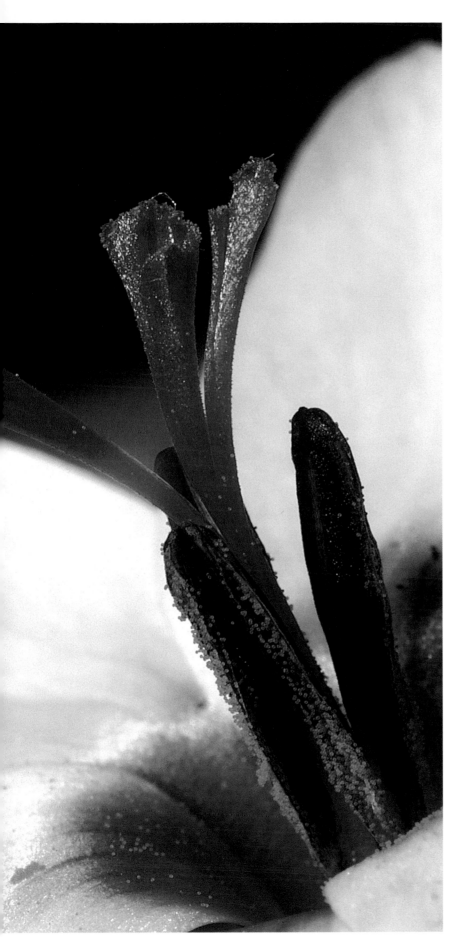

▲ **Egg of purple hairstreak butterfly (*Quercusia quercus*), Pembrokeshire, Wales**

A 24mm wide-angle was reversed on to a 180mm prime lens to give a 180 ÷ 24 = 7.5x magnification. Vignetting reduced the image to a circle at the viewfinder center, but on enlargement the result is very sharp.

CAMERA Nikon F4	**SHUTTER SPEED** ¹⁄₆₀ sec
LENS 180mm f/3.5 AF apo macro with coupled 24mm lens	**APERTURE** f/11 on 180mm lens
FILM Fujichrome Velvia	**LIGHTING** single SB23 flash used off-camera close to subject

▲ **Egg of orange tip butterfly (*Anthocaris cardamines*)**

When you need only an occasional means of getting several times life-size magnification, lens coupling is ideal. Focusing is tricky because the slightest movement sends the image out of focus. Here, the egg was on a cut stem placed in a glass beaker. The beaker was moved to focus, and the camera was held rigid in a clamp.

CAMERA Nikon F4	**SHUTTER SPEED** ¹⁄₆₀ sec
LENS 180mm f/3.5 AF apo macro with coupled 50mm lens	**APERTURE** f/11 on 180mm lens
FILM Fujichrome Velvia	**LIGHTING** single SB23 flash used off-camera close to subject

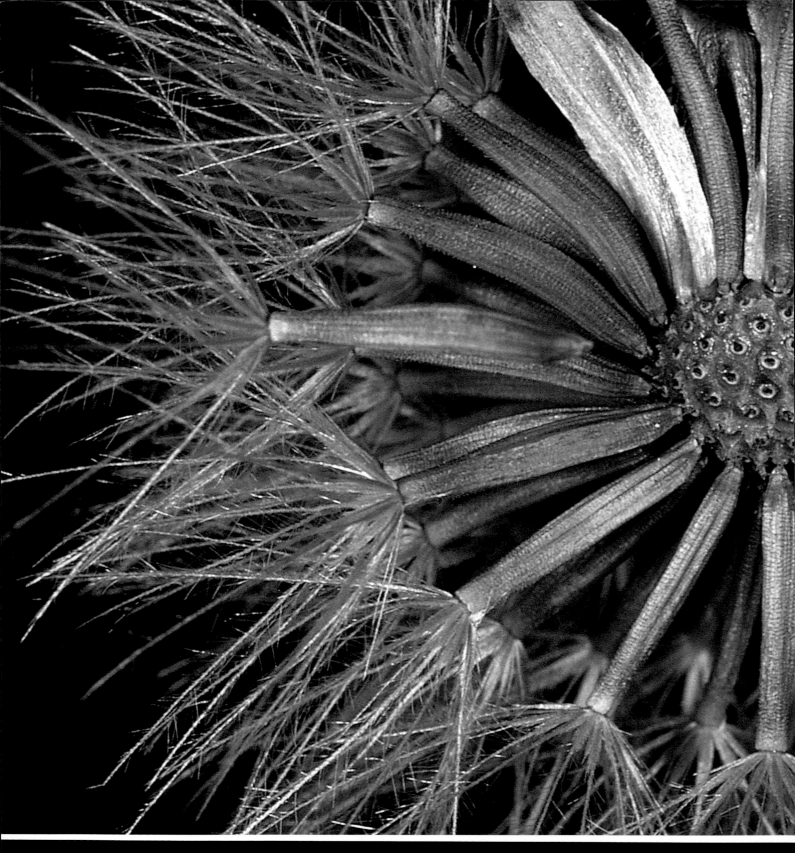

▲ **Dandelion seedhead (*Taraxacum officinale*),
Cowbridge, Wales**
Dandelion heads are designed to catch the breeze so that
the parachute seeds float away. A dandelion head taken
indoors makes a surprisingly interesting macro subject.

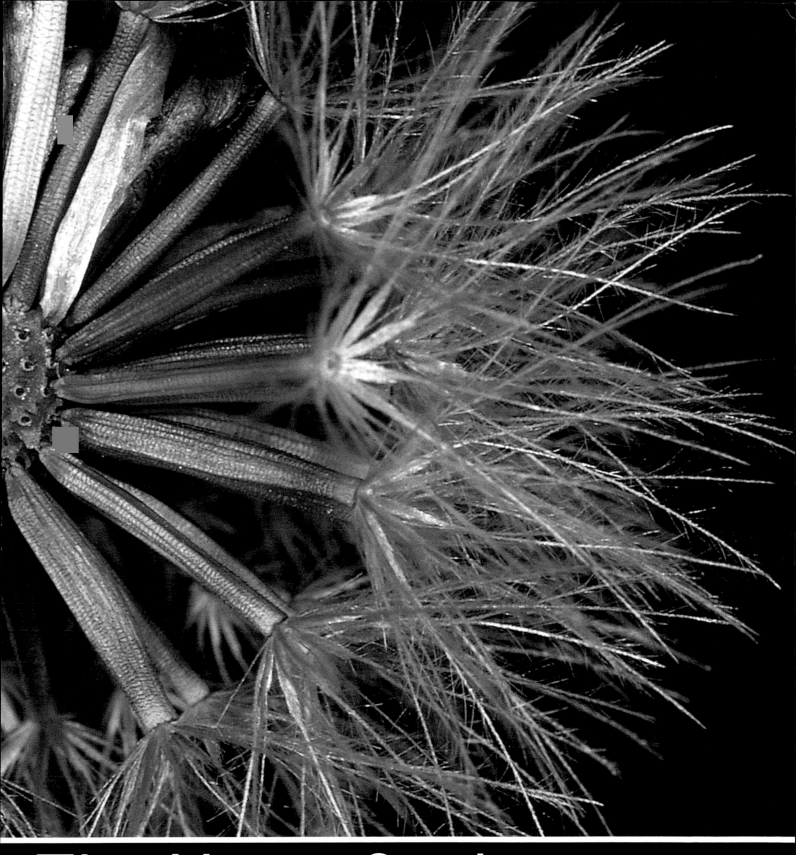

The Home Studio

The Studio and Lighting

IN THIS SECTION, the word "studio" is used in the widest possible sense—usually as a term of glorification for any collection of useful bits and pieces arranged on a conservatory table, standing on a bench in a greenhouse, or fixed to a portable workbench.

Natural light

A bright day with light cloud cover offers the perfect lighting for a plant subject set up on a greenhouse bench or a table in a conservatory. With the protection of glass, there is no breeze and no need for flash, even at greater than life-size magnification—unless your subject is agile. (While this is not normally a problem with plants, you may be attempting to include some insect life in your composition.)

On a day when the sun is bright you can achieve an effect similar to light cloud cover with a diffusing sheet held over a window. You can also experiment with reflectors positioned to throw light into the shadows and achieve the lighting balance you want.

Artificial light

In the studio, I generally use flash guns connected to the TTL system of a camera, working with a

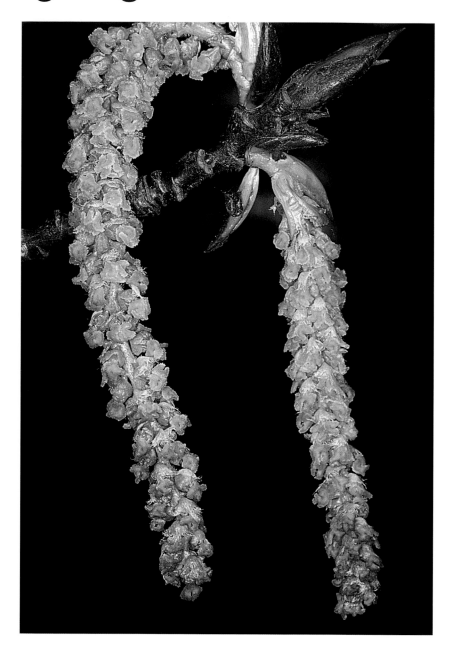

▲ **Catkins of silver birch (*Betula pendula*), Cowbridge, Wales**
For these catkins I experimented with a hand-held flash gun and with tungsten lamps, in each case measuring exposure with a digital handheld meter.

CAMERA Mamiya 645 super
LENS 80mm f/4 macro
FILM Fujichrome 64T
SHUTTER SPEED ¼ sec
APERTURE f/16

NATURAL AND TUNGSTEN LIGHT

For studio work on a relatively large scale, the output power of the lighting has to match the size of plant displays or manufactured sets. I use several flash heads, each of which also contains a tungsten modeling lamp. When working with medium-format equipment I measure exposures with an incident light flash meter placed at the subject position, and then check the effect of the lighting with a polaroid back.

With plant and flower photography, you need to monitor the condition of the plants constantly to make sure that the material does not start to wilt under artificial light. With practice you learn to work quickly to avoid this.

number of different arrangements that have been tried and tested.

With small to medium-sized subjects, ordinary desk lamps with screw-in reflector bulbs work very well. Care has to be taken not to heat up the subjects and cause wilting, but the advantage is that you can move the lamps around and keep looking through the viewfinder to see what happens—learning a great deal about lighting in the process. Some lamps with quartz-iodine bulbs also have integral heat filters.

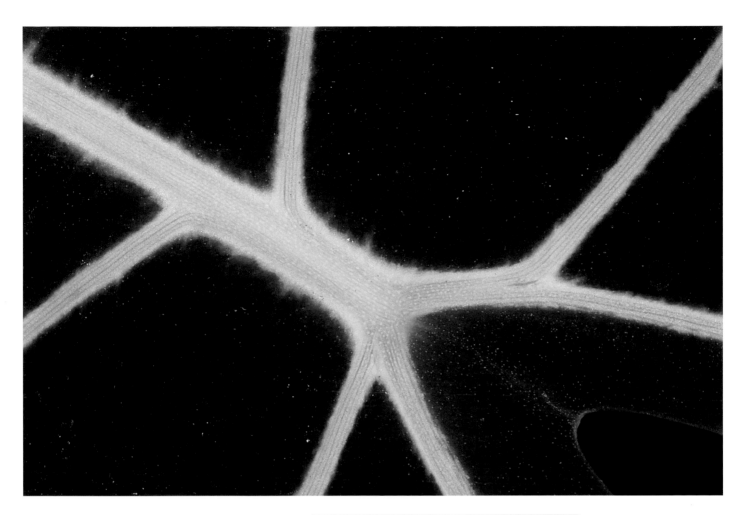

Setting up the studio

If your home studio is more than a table top and you have a dedicated work space, it saves time if some areas are devoted to particular tasks. I have a corner reserved for a homemade optical bench—a cannibalized microscope—which allows me to reach up to 12x magnification. Another small space is reserved for a light box, and close by stands the copy stand—a modified enlarger column and base (see page 128).

For photographing plants in pots, flowers in elegant vases, or single blooms against a variety of backgrounds, I use a simple set-up that usually sits on a table or workbench. A curved backdrop placed behind and under the subject gives a seamless appearance. To create a white background (see pages 136–137), a thin, back-lit translucent acrylic sheet works well.

The overhead light is a "window light": either a studio flash head or a photoflood with a large square diffuser.

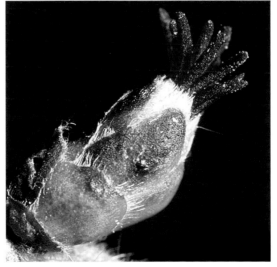

▲ Female flower of hazel (*Corylus avellana*), Cowbridge, Wales
At high magnifications, lamps need to be close to the subject. I prefer to use a desk lamp for focusing with the lens aperture wide open, then expose with flash.

CAMERA Nikon F4	**SHUTTER SPEED** $1/60$ sec
LENS Olympus 38mm f/3.5 bellows macro lens head	**APERTURE** f/11 on lens
	LIGHTING single SB23 flash
FILM Fujichrome Velvia	

▲ Leaf veins (*Colocasia* sp), Royal Botanic Gardens, Kew, England
Tungsten lamps are ideal for static subjects such as leaves—these are relatively flat, so great depth of field is not needed. These veins were photographed with the camera held in a copy stand and the subject under glass on the baseboard.

CAMERA Mamiya 645 pro TL
LENS Sigma 180mm f/3.5 AF apo macro with matched 2x converter and homemade adaptor
FILM Fujichrome 64T
SHUTTER SPEED $1/8$ sec
APERTURE f/8
LIGHTING paired tungsten lamps

Films for Artificial Light

IF YOU USE FILM that is balanced for natural light with tungsten or fluorescent lamps, the results will show strong color casts. Where the main lighting is natural but some tungsten light is also used, the warmth imparted is acceptable. Fluorescent lamps impart a greenish cast.

Tungsten film

Films balanced for tungsten light are well worth using. Fujichrome 64T does for tungsten lighting what Fujichrome Velvia did for natural light, with very fine grain, saturated colors, and excellent contrast handling. The Ektachromes are also extremely good.

Color conversion

For absolute color fidelity you should match the film and light source, but you can also use a conversion filter. The blue 80 series (80A–80D) counteracts the orange cast that tungsten light creates on daylight-balanced film. Typically, an 80A is used to balance ordinary room lighting for daylight film; an 80B for tungsten photoflood, which is less warm. A tungsten-balanced film would carry a strong blue cast used with daylight. The orange 85 series (85, 85A–C) will reduce the cast. Confusingly with these filters, 80A and 85 are the strongest, while in the 81 and 82 series (see pages 28–29) 81 and 82 are the weakest.

▷ **Mixed pulses: lentils, black-eyed beans, mung beans**
With a camera in a copy stand and paired tungsten lamps, it is easy to produce shots of subjects with limited depth of field. These pulses were the result of a raid on the kitchen.

CAMERA Mamiya 645 pro TL
LENS 80mm f/4 macro
FILM Fujichrome 64T
SHUTTER SPEED 1/8 sec
APERTURE f/11
LIGHTING paired desk lamps with reflector bulbs

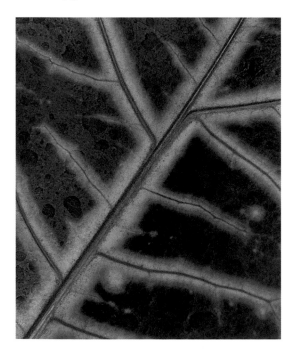

△ **Leaf veins (Colias sp)**
Daylight-balanced films can be used with tungsten light if blue filters are used—an 80B was employed here: with tungsten halogen lamps I tend to use an 80A.

CAMERA Nikon F4
LENS 105mm f/2.8 AF macro
FILM Fujichrome Provia
SHUTTER SPEED 1/8 sec
APERTURE f/11
LIGHTING paired photoflood lamps

▷ **Beaked heliconia (Heliconia rostrata), Peru**
The heliconia was held in front of black flock paper. Fuji 64T film records detail as well as its daylight-balanced counterpart.

CAMERA Nikon F4
LENS 180mm f/3.5 AF apo macro
FILM Fujichrome 64T
SHUTTER SPEED 1/8 sec
APERTURE f/16
LIGHTING paired tungsten lamps

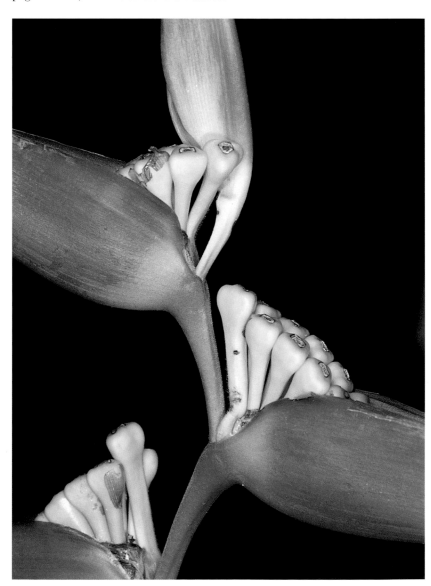

Building Rigs

Wʜᴇɴ ʏᴏᴜ ᴡᴏʀᴋ at magnifications greater than life size, vibration is a major enemy. Even when using flash, you need a firm support for the camera, a cable release, and mirror lock-up. Often, the most important accessories are adhesive tape, re-usable adhesive, wood blocks, and a series of crocodile clips and small clamps.

I find Climpex "scaffolding," supplemented with a few bits and pieces of my own, indispensible in creating rigs. Climpex, derived from laboratory scaffolding, is a series of tubes, connectors, clamps, and flexible arms. With it you can support just about anything on a tabletop. Everything fits beautifully, and it has a matte black anodized coating that stops stray reflections.

Modern microscopes focus by moving the subject, not the microscope tube, and the principle holds good for macro photography. A flower stem held in a small stand can be moved back and forth with two hands surprisingly delicately, while you look through the viewfinder.

For finer control there are focusing slides with rack and pinion or screw adjustment: they are meant for the camera but work just as well, if not better, with the subject.

The copy stand

Leaves, seeds, and pulses can all be arranged horizontally and photographed from above using a camera mounted in a copy stand. I use an old Durst enlarger stand. The camera is attached with a quick mount, and approximate focus is achieved with the original friction drive that once moved the enlarger head.

The subject can be placed on a scissors jack or a light box, or on a sheet of glass for dark ground effects (see pages 132–133).

This is the way I tend to tackle anything from about 3x to 10x magnification. For lenses, I use a ripe assortment, from Olympus macro lenses to 16mm cine lenses (used in reverse with adaptors made from filter rings and pieces of aluminum). Enlarger lenses also work very well reversed.

SUPPORTS

After years of using assorted metal rods and wooden blocks to assemble supports in the studio, I now use Climpex photo scaffolding, which can cope with any arrangement my imagination runs to.

CAMERA Nikon F4
LENS 105mm f/2.8 AF macro
FILM Fujichrome 64T
SHUTTER SPEED ¹⁄₁₅ sec
APERTURE f/8
LIGHTING tungsten

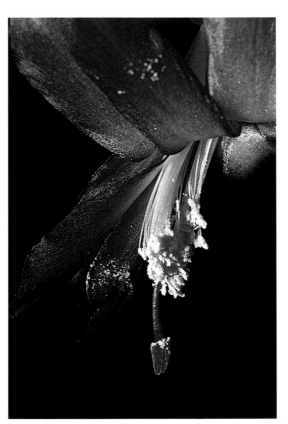

▲ **Christmas cactus (*Schlumbergera x buckleyi*)**
When setting up a corner of the home studio, I experimented both with daylight-balanced film and flash, and with tungsten-balanced film and photofloods to compare results.

CAMERA Nikon F4	**SHUTTER SPEED** ¹⁄₆₀ sec
LENS 180mm f/3.5 AF apo macro	**APERTURE** f/16
FILM Fujichrome Velvia	**LIGHTING** Nikon SB23

▶ **Christmas cactus (*Schlumbergera x buckleyi*)**
What I like about using tungsten lights is the chance to play, arranging the lamps' position and distance from the subject to get exactly the modeling I want. The lessons learned also carry over into the use of flash.

CAMERA Mamiya 645 pro TL
LENS 80mm f/4 macro
FILM Fujichrome 64T
SHUTTER SPEED ¹⁄₄ sec
APERTURE f/16
LIGHTING tungsten

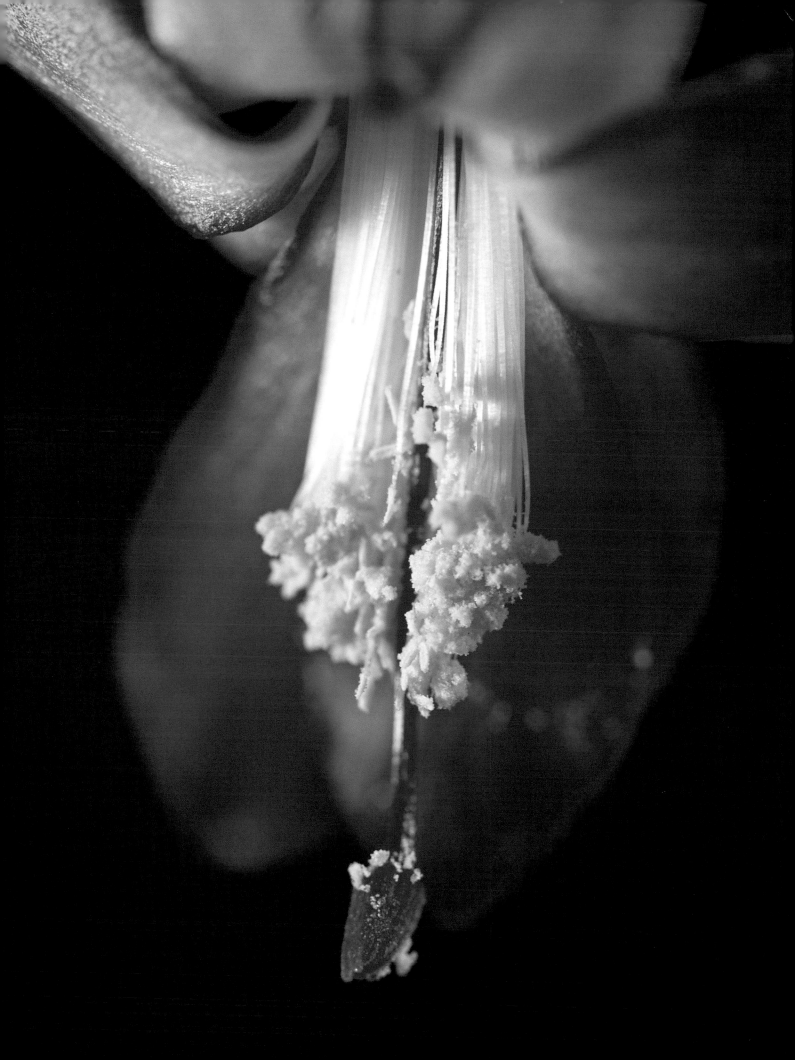

Natural Backgrounds

THERE IS OFTEN an element of economy with the truth in all areas of photography. It is not true that the camera never lies—it does, frequently. Among wildlife photographers there are ethical debates concerning the photography of animals in captivity, and about images that are created by photomontage. Problems arise when people attempt to pass these off as "natural," but if the photographer is honest about the provenance of any picture, it can be viewed on its own merits as an image.

I have long aimed to photograph plants grown in cultivation to look as natural as possible. Pots and labels are eliminated and the background is cleared of reflections from glass or those aluminum spars in greenhouses that become obvious only when the results come back from the processor. Ironically, one of the picture agencies I supply likes some shots of plants in pots to illustrate gardening books and magazines.

Creating a natural-looking background

The simplest method of showing flowers in a natural-looking setting is to make the subject and any surrounding leaves fill the frame, leaving as little room as possible for extraneous detail. However, the shape and nature of the plant may make this impossible.

I have always liked the way that out-of-focus backgrounds are created as a matter of course with close-up photography. This is a real advantage to the photographer—one of the few in a field in which you are more often faced with problems, such as slow shutter speeds, small apertures, and restricted depth of field.

Mixed vegetation, such as grasses in a range of greens and browns, makes an ideal background for a plant when it is rendered as a series of blurred, muted tones that enhance the colors of the subject. This works particularly well with macro lenses of longer focal length—90–200mm—where the subject seems to snap into focus against the softly blurred background.

When you are using flash it is essential to have the background near enough to the foreground subject to be illuminated properly. About ²/₃– 1 stop less than the foreground provides a very effective contrast. Sometimes a separate flash gun, linked as a slave, can be used to illuminate the background.

◀ **Cilician orchid (*Ophrys cilicica*), Turkey**
When I was asked to photograph this very rare Turkish orchid, collected under license as part of a propagation program, I tried to make the background as realistic as possible with a clump of grass—mixed green and dry stems— just distant enough to be lit by the flash and yet out of focus.

CAMERA Nikon F4	**SHUTTER SPEED** ¹/₆₀ sec
LENS 105mm f/2.8 AF macro	**APERTURE** f/16
FILM Fujichrome Velvia	**LIGHTING** SB21B macroflash

▼ **Frangipani (*Plumeria rubra*), Funchal, Madeira**
When I am forced to use flash in low light conditions and a black background is inevitable, I move in as tight as I can on the subject—in this case, the flowers and their leaves—to leave as little dark space as possible.

CAMERA Nikon F4
LENS 180mm f/3.5 AF apo macro
FILM Fujichrome Velvia
SHUTTER SPEED ¹/₆₀ sec
APERTURE f/16
LIGHTING twin flash

PAINTED BACKGROUNDS

Blue skies create marvelous natural backgrounds for high-contrast subjects such as roses and sunflowers. This has led some to use blue card in the studio. In practice, the results simply look as if they have been taken against blue card. Portrait photographers use custom backdrops painted with mixtures of grays and blues. These "cloudscapes," though easy on the eye, have become a sort of badge of studio portraits. It is possible to paint backdrops on card using a range of green and brown shades, and photograph with these behind a flower. But it is not easy: I know of only one person, with a rare understanding of earth and natural tones, who does this effectively.

◀ **Custard apple or sour sop (*Annona muricata*), Ribeiro Brava, Madeira** Leaves create the most natural background for fruit, whatever lighting you use. Choose a subject among vegetation that breaks up the background.

CAMERA Nikon F4
LENS 60mm f/2.8 AF macro
FILM Fujichrome Velvia
SHUTTER SPEED $^1/_{125}$ sec
APERTURE f/16
LIGHTING SB25 flash with diffuser

Dark Fields

Victorian microscopists perfected a way of depicting translucent micro-organisms as bright subjects against a dramatic dark background. The effect produces a distinct luminosity in a subject.

Dark field illumination is not difficult to create in the home studio using a very simple array of equipment, including disks of black flock paper, a sheet of glass, and wooden blocks. The light sources can be tungsten spot lamps or flash—but some form of modeling lighting is needed so that you can see the effect created in the viewfinder and move lamps to create the result you want.

Vegetable and fruit sections

Thin sections of vegetables, such as onions or peppers, and fruit, such as oranges, lemons, or kiwifruit, can be laid straight on a light box, lit from behind, and made into attractive transmitted light compositions. Even more dramatic results

▷ **Crown anemone (*Anemone coronaria*), Paphos, Cyprus**
The dark field in this case was simply a sheet of black card, and the light source was the sun—by moving the card carefully, the subject appeared back-lit against the black background.

CAMERA Nikon F4
LENS 180mm f/3.5 AF apo macro
FILM Fujichrome Provia
SHUTTER SPEED ¹/₃₀ sec
APERTURE f/16

can be obtained by lighting from the back against a dark background.

To cut thin sections requires a very sharp knife; serrated edges honed with a fine diamond lap are excellent. Practice is needed to make sure that the sections are of uniform thickness, otherwise some parts will appear darker than others when lit by transmitted light.

If you are using any form of tungsten light for focusing, slices of juicy fruit dry out quickly and take on a characteristic appearance—it is worth sacrificing a section or two when setting up and then substituting a fresh section for the final

◁ **Clock vine, (*Thunbergia mysorensis*), Oxford, UK**
The usual effect of a dark background is to provide drama—all lighting of the subject comes from the front.

CAMERA Nikon F4　　　SHUTTER SPEED ¹/₆₀ sec
LENS 105mm f/2.8 AF macro　　APERTURE f/16
FILM Fujichrome Provia　　LIGHTING SB21B macroflash

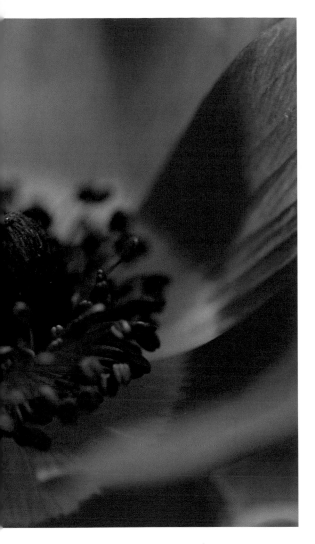

▲ Okra, ladies' fingers, gumbo, (*Abelmoschus esculeutus*)
When sectioned, okra produces intriguing shapes. These were suspended on a glass sheet above a disk of black flock paper. Lighting came from below and to the sides.

CAMERA Nikon F4	**SHUTTER SPEED** 1/125 sec
LENS Sigma 180mm f/3.5 AF macro	**APERTURE** f/16
FILM Fujichrome Velvia	**LIGHTING** twin flash guns used with TTL system

▶ Lemon (*Citrus timou*)
The lemon slice was arranged on a glass sheet held on wooden blocks above a disk of black card with two flash guns below it and about 45 degrees to the side. I experimented first with a pair of tungsten lamps to get the position.

CAMERA Nikon F4
LENS 180mm f/3.5 AF apo macro
FILM Fujichrome Velvia
SHUTTER SPEED 1/60 sec
APERTURE f/16
LIGHTING twin flash guns

photograph. The glass on which a section rests must be scrupulously clean of juice and dust, which will show up when back-lit.

The subject is held on a glass plate and raised above a disk of black flock paper—a check in the viewfinder will show whether this fills the frame. Lamps are held below the glass and to the side so that light hits the subject at about 45 degrees. To avoid light spill and spurious reflections, much of the glass plate can be covered with black card and a hole left for the subject. Experiment to see how small or how large the hole needs to be.

Still Life

To many of us, the term "still life" brings to mind those eclectic collections of objects—baskets, fruit vases, dead pheasants—beloved of both long-dead painters and friends who attend art classes. But by keeping to simple props such as attractive baskets for fruit and vegetables, or beautifully grained but rough-hewn wooden boards, you can succeed in avoiding the clichéd look. You will know if you have got it right only when others tell you.

Freshly gathered garden vegetables, soft fruits, or selection of herbs or spices form collections with a theme. Sliced and sectioned fruits and vegetables often reveal intriguing internal structure and patterns that lend themselves almost as abstract forms to the composition you are trying to create. And that is the key to still-life photography: you are in charge of selection, arrangement, and lighting.

Avoid backgrounds that are distracting by moving in close or using neutral drapes. If you are outdoors you can fill the foreground with your subject and choose an aperture that throws the natural background out of focus.

Soft, diffuse natural lighting often works well with still life, and for this, a table in a greenhouse or conservatory, on a day with light cloud cover, provides the ideal studio. If you have access to a studio lighting set-up you can be adventurous with your compositions at any time of day. A useful kit includes a main light (with or without an umbrella for diffuse light), fill-in, and a "key" light for a degree of back lighting that will pick out fine hairs on stems or define the rims of fruit.

Other people's efforts, or nature itself, may inadvertently provide just the scene you need for still life: formal flower arrangements, window boxes, groups of garden implements, fallen fruit, and leaves. You, the photographer, have to be ready to see the compositions that present themselves and grasp the opportunities.

▲ Seeds of curry spices
To prevent too much mixing of the seeds, a small card frame was initially used, then a little stirring with a finger created the degree of chaos required. The camera was mounted overhead in a copy stand and the selection changed and moved until a particular pattern looked right—framing was achieved by adjusting the magnification.

CAMERA Nikon F4	**SHUTTER SPEED** ¹/₁₂₅ sec
LENS Sigma 180mm f/3.5 AF apo macro	**APERTURE** f/16
FILM Fujichrome Velvia	**LIGHTING** twin flash guns used with TTL system

▶ Gerberas
Florists sell these deservedly popular flowers from South Africa in a wide range of colors. The job was to depict this range, and the flowers were cut from their stems and arranged beneath the camera on a card on the board of a copy stand. The whole thing was done outdoors, with light, wispy clouds giving ideal illumination.

CAMERA Mamiya 645 super
LENS f/4 macro
FILM Fujichrome Velvia
SHUTTER SPEED ¹/₃₀ sec
APERTURE f/16

◀ **Orchid nursery, New Jersey, USA**
On an April visit I saw this display of *Phalaenopsis* orchids in Professor Carlos Fighetti's greenhouse. There was no need to arrange pots, for the vast array of orchids made their own statement about the richness and range of color and form created by the breeder.

CAMERA Nikon F4
LENS Nikkor 24mm f/2.8 AF
FILM Fujichrome Velvia
SHUTTER SPEED 1/30 sec
APERTURE f/8

▼ **Fruits of autumn, Italy**
(*Photo Lois Ferguson*)
The initial selection of fruits, both cultivated and wild—the acorns of a Vallonia oak with their prickly cups—was made to evoke the richness of fall in the Salento Peninsula. The flowers were added for contrast, with the artist's eye for detail.

CAMERA Nikon F60
LENS Sigma 24mm f/2.8 AF
FILM Fujichrome Velvia
SHUTTER SPEED 1/30 sec
APERTURE f/11

▲ **Windowsill, Provence, France**
Rural France abounds with nooks and crannies where nature and inanimate objects seem to wait patiently for your camera. Here, a back street in a tiny walled village revealed this windowsill arrangement—pure chance.

CAMERA Nikon F801 **SHUTTER SPEED** 1/30 sec
LENS Sigma 24mm f/2.8 AF **APERTURE** f/8
FILM Fujichrome Velvia **FILTER** polarizer

Soft Focus and White Backgrounds

Flowers and plants are often depicted in magazines and advertisement shots in soft focus against a white background.

To create a white background, you can stand the subject in front of a sheet of white card or paper. However, this will affect exposure, and more often than not, the background will end up looking distinctly gray. I have occasionally photographed flowers against the white of a hazy summer sky, though twigs and stems in the background can create strange effects as light spills around their edges.

In the studio, a flat light box (for leaves, petals, and flat, daisy-like flowers) or a curved sheet of white, translucent acrylic will generate a suitable white, though you must be careful to balance the color temperature of the light behind the opalescent surface with the film you use.

Soft focus can be achieved either in-camera or post-production (see pages 108–109). Most people who come to plant photography from a plant background think the effect is overdone as a creative tool. But art editors seem to feel the opposite, and if you want to sell your work in these markets, the moral is obvious.

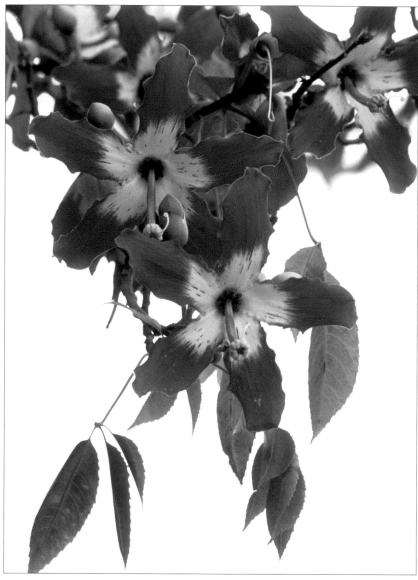

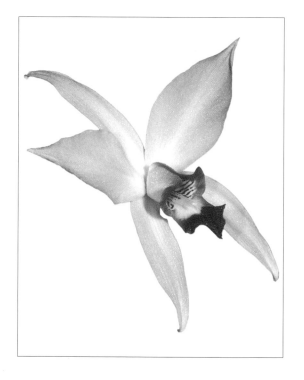

◁ *Laelia anceps*, **Royal Botanic Gardens, Kew, England**
White card does not appear pure white on film—a back-lit acrylic sheet or light box is better. Even so, this orchid had to be "selected," the selection inverted, and the background filled with pure white (see pages 148–149).

CAMERA Nikon F4
LENS 105mm f/2.8 AF macro
FILM Fujichrome Velvia
SHUTTER SPEED ¹/₆₀ sec
APERTURE f/16
LIGHTING SB21B macroflash

△ **Floss silk tree (*Chorisia speciosa*), Funchal, Madeira**
By exposing for the flowers, the cloud behind was grossly overexposed. This gave a white background except for a few twigs where light spill created odd blue shadows at the edges, removed in Photoshop for reproduction.

CAMERA Nikon F4
LENS 180mm f/3.5 AF apo macro
FILM Fujichrome Velvia
SHUTTER SPEED ¹/₃₀ sec
APERTURE f/11

▷ **Red tulip with stamens**
Soft focus works well with white backgrounds—specialist "defocusing" lenses or soft filters can be used. The time-honored method of smearing petroleum jelly thinly on glass and leaving a clear central spot was used here.

CAMERA Nikon F4
LENS 180mm f/3.5 AF apo macro plus 2x converter
FILM Fujichrome Velvia
SHUTTER SPEED ¹/₆₀ sec
APERTURE f/16
LIGHTING SB21B macroflash

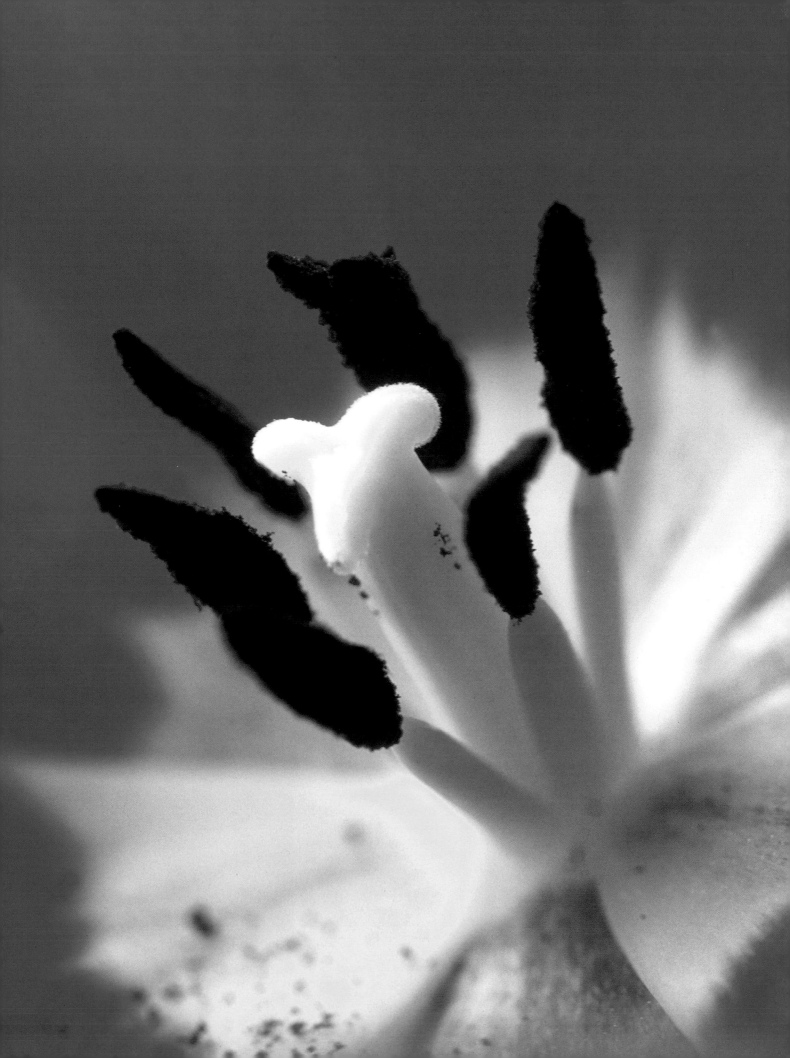

Black Backgrounds

THERE IS NO DOUBT that a black background is dramatic and makes colors set against it appear more vibrant. However, black backgrounds in plant and flower photography are a matter both of personal taste and of fashion. At times everyone seems to hate them, but then, at other times, they become popular and you can find new markets for material that has been languishing at the back of the filing cabinet.

Dark backgrounds occur when you use flash illumination if the backdrop is too far from the main subject to be illuminated by the flash gun. This can be remedied by having the background— or something to break up the background—close enough to the foreground subject to be lit by the flash (see pages 130–131). Alternatively, you can use a shutter speed slow enough to give exposure to the background.

If you actually want to create a black background, then you can rely on flash: arrange the background far behind the subject, and use a small aperture and a synchronization speed of ¹⁄₂₅₀ sec,

which many 35mm cameras permit as a matter of course. Alternatively, you can use a black backdrop. Black card can be surprisingly reflective and may appear distinctly gray when flash is used. You can create your own board by spraying with matte black paint, but again this can appear gray on film. I can recommend Humbrol enamel matte black as the mattest and blackest paint I have yet found, but I find it more useful for spraying the insides of homemade lens hoods and adaptors.

Black fabric is less reflective than either paint or card. Photographing objects in a hotel room, for example, I have even resorted to using a black T-shirt—fortunately, a standard item in my wardrobe—but the best materials for black backdrops are black flock paper or jet black velvet. However, both of these are likely to pick up dust and tiny bits of hair and fluff and these will stand out as blemishes on film when they are lit by flash. You can avoid this by giving the surface a good brushing with a velvet or suede brush before setting up the shot.

▶ **Glory bush (*Tibouchina* sp), Ribeira Brava, Madeira**
To get the darkest possible background when using flash out of doors, avoid any vegetation close to the plant and use the highest flash synchronization speed with a slow film. In this way, any background will be several stops under-exposed and will appear black on film.

CAMERA Nikon F4
LENS Sigma 180mm f/3.5 AF apo macro
FILM Fujichrome Velvia
SHUTTER SPEED ¹⁄₂₅₀ sec
APERTURE f/16
LIGHTING SB21B macroflash

◀ ***Fuchsia boliviana*, Los Angeles, USA**
With strong colors, a black background creates very dramatic results.

CAMERA Nikon F4
LENS 105mm f/2.8 AF macro
FILM Fujichrome Provia
SHUTTER SPEED ¹⁄₆₀ sec
APERTURE f/16
LIGHTING SB21B macroflash

▶ ***Bougainvillea spectabilis*, Funchal, Madeira**
The best "black" I know for backgrounds is black flock paper. Most card has a slight shine that makes it appear gray in a photograph.

CAMERA Nikon F4
LENS 105mm f/2.8 AF macro
FILM Fujichrome Velvia
SHUTTER SPEED ¹⁄₆₀ sec
APERTURE f/16
LIGHTING SB21B macroflash

▲ **Alpine flowers, Dolomites, Italy**
Image manipulation is not obvious here—which is how most
of us want it to work. The original transparency was badly
scratched, dust-flecked, and had a color cast, and all these
blemishes were corrected in Photoshop.
(corrected by Lois Ferguson)

Image Manipulation

Scanning and Printing

Dɪɢɪᴛᴀʟ ꜰɪʟᴇꜱ ᴄᴀɴ ʙᴇ ᴘʀᴏᴅᴜᴄᴇᴅ directly using digital cameras or by scanning transparencies and negatives. Flatbed scanners will produce scans of negatives and transparencies that are extremely useful for producing sample layouts. High resolution comes at a price to match, and a dedicated slide/negative scanner is the best option for 35mm users wanting to produce prints up to $11^{3/4}$ x $16^{1/2}$in (A3) size.

At the scanning stage you can adjust the size of the output file to suit your purposes. I use a Nikon Coolscan, which scans at 2400dpi and produces up to 26MB files.

Color correction

If you always use the same films and have a standard processor, you will find that comparatively little correction needs to be made to most transparencies; negatives require even less. Scanners function better with E6 emulsions than with Kodachromes, in which the film layer structure is different and dyes are created during development. I have evolved a basic "recipe" for Kodachromes that involves adding red and yellow, and which creates a starting point from which fine-tuning can be carried out to suit an individual transparency.

Note that with color adjustments made after scanning you can lose pixels: if you adjust the color before the scan, that information is retained in the scan.

The color space

With a scanner, monitor, and printer there is vast room for variation between what you see on screen and in print. Color spaces allow you to work with a range of colors electronically consistent in all the elements in the chain. Monitors have to be calibrated—this can either be done commercially or using the Adobe Gamma Utility. Photoshop also comes with Monitor (ICC) profiles ready programed, which can be used when needed.

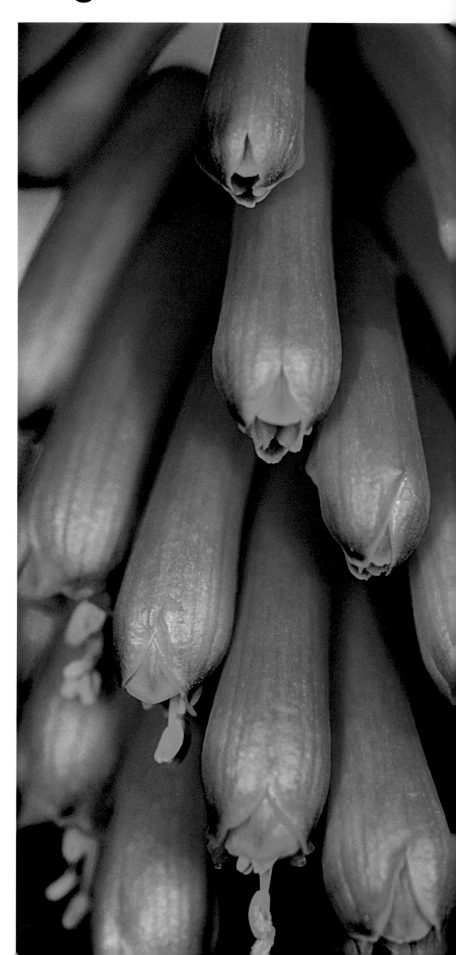

◄ Red-hot poker (*Veltheimia capensis*), National Botanic Garden of Wales

I make most corrections at the scan stage, but this works only if you have taken time to calibrate monitor, scanner, and printer and work in a chosen color space such as RGB or Photoshop's own.

CAMERA Nikon F4
LENS 180mm f/3.5 AF apo macro
FILM Fujichrome Velvia
SHUTTER SPEED ¹/₆₀ sec
APERTURE f/11

► Glory-of-the-snow (*Chionodoxia lucillae*), Oxford, England

The transparency is scanned directly into Photoshop—with any slight color correction perfomed in LEVELS. The file is stored on CD. Cropping and setting the resolution and final print size follows, but before printing I always use FILTER>UNSHARP MASK to restore any lost "bite."

CAMERA Nikon F4
LENS 105mm f/2.8 AF macro
FILM Fujichrome Provia
SHUTTER SPEED ¹/₆₀ sec
APERTURE f/16
LIGHTING SB 21B macroflash

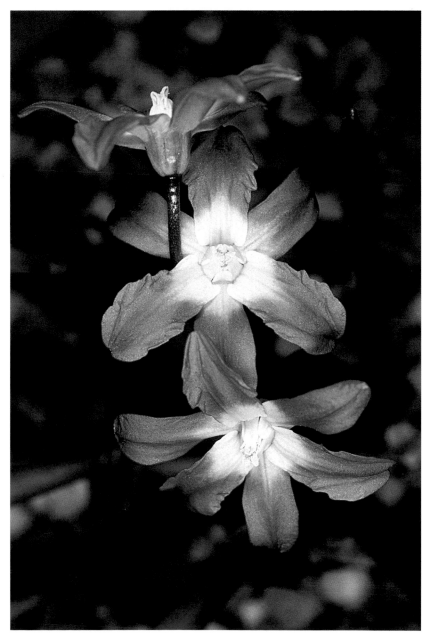

Photoshop Basics

Adobe Photoshop, with its immediacy of response, allows far more control than wet chemistry ever did. Once you have learned the basics you may find that it becomes extremely addictive. Much of what you do involves four functions on the menu bar—Image, Layer, Select, Filter—and the tool panel.

In most cases you will only want to make small changes to color and contrast. This is done via Image > Adjust, where you find three categories of actions: contrast range and color balance, general color alteration, and image orientation. These include Levels, Auto Levels, Curves, Color Balance, and Brightness/Contrast. Initially, I found it useful to use brightness and contrast and finish with adjustment of color balance. But much greater control is possible through Levels (and Curves) commands. Auto Levels is a good starting point, making the lightest gray pixel white and the darkest gray pixel black: the colors lie between those limits.

Levels allows medium color tones to be lightened or darkened by choosing separate red, green, and blue channels, and moving the sliders on the histogram. It looks confusing at first. Moving the left-hand point to the end of the histogram sets the darkest pixels as black. If the darkest pixels are at level 7 (the left-hand input box), this becomes the zero point.

Moving the right-hand point to the other end makes the lightest pixels white. The middle arrow —the Gamma point—adjusts mid-tones (dark-

⊿ Leaf: original image
The veins of this variegated leaf show strong contrasting colors, which clearly illustrate the results of using some of the options in a photo-manipulation program.

CAMERA Nikon F4
LENS 105mm f/2.8 AF macro
FILM Fujichrome Velvia
SHUTTER SPEED ¹⁄₆₀ sec
APERTURE f/16
LIGHTING SB21B macroflash

⊿ Leaf: Invert
The command Invert in the Image dialogue box (Image > Adjust > Invert) provides a way of replacing white pixels with black and each color with its complementary tone, giving a kind of negative effect.

⊿ Leaf: Posterize
Posterize (Image > Adjust > Posterize) achieves an effect much like the wet-chemistry result of partly re-exposing a print through the development process. In this case, you have much more control and can set a "degree" of posterization.

Butterwort (*Pinguicula caudata*), origin Mexico, Oxford, England

A simple image of a flower against a plain background is a good subject for experimentation after producing a digital file.

CAMERA Nikon F4	**FILM** Fujichrome Velvia
LENS 180mm f/3.5 AF apo macro	**SHUTTER SPEED** ¹/₃₀ sec
	APERTURE f/16

Butterwort: Invert

The INVERT command was used first (IMAGE > ADJUST > INVERT) to produce a lightened background and reversed highlights and shadows.

Butterwort: Equalize

Next, EQUALIZE was applied (IMAGE > ADJUST > EQUALIZE). Like many options within Photoshop, it is only for occasional use on the "let's have a look" basis.

ening to the left, lightening to the right). The histogram depicts the number of pixels at each of 256 levels of brightness (0–255) in a 24-bit image. In practice, most of the time you just look at the image and see what happens, adjusting until it looks right.

CURVES allows even finer control, but it takes a lot more practice to do anything with this command that you can't achieve with LEVELS.

VARIATIONS, which you'll find in the fourth block of the drop-down menu, helps when use of LEVELS has subdued colors. IMAGE > ADJUST > VARIATIONS opens another window that presents a series of preview images, from which you can choose a change in contrast or tone.

Monochrome Backgrounds

COLOR DATA CAN BE REMOVED from a digital file in Photoshop in a number of ways to leave a monochrome original, and prints of high quality and excellent tonal range can be produced (with or without toning) in this way. You can even convert parts of an image to monochrome, by making a selection and then pasting it back into a new layer, where it can be adjusted without affecting the rest of the image. Or, if you invert the selection, you can create a monochrome background while preserving the colored subject in a different layer.

Toning

First you need to produce the grayscale image. One method is to use IMAGE > MODE > GRAYSCALE; check the GRAYSCALE box to remove color, then employ IMAGE > MODE > RGB. Now open HUES AND COLORS (IMAGE > ADJUST > HUE/SATURATION) and check the COLORIZE box. The sliders can be adjusted to set the tone, the extent to which the grays are tinted, and the lightness or darkness of the final image. You can imitate sepia, platinum, and other forms of toning.

More subtle toning can be generated using duotones and tritones. Using IMAGE > MODE > GRAYSCALE, select the DUOTONE option. A choice of DUOTONE, TRITONE, and so on, allows one or more colors (specified as Pantone colors) to be mixed with black for the grayscale images—you are in control of the degree of tinting. There are presets that can be used to generate effects such as sepia and platinum.

Channels

Using SELECT > COLOR RANGE offers an alternative way of creating a grayscale image. You can check the red, green, and blue, or magenta, yellow, and cyan boxes and see what graytones exist in each channel. Channels can be made to act in much the same way that color filters work with black and white: depth of tone is intensified by using a filter of a complementary color to the

▲ **Mother-in-law's seat (*Echinocactus grusonii*)**
Agfa Scala film was used to capture the initial monochrome image.

CAMERA Nikon F4
LENS 180mm f/3.5 AF apo macro
FILM Agfa Scala
SHUTTER SPEED 1/250 sec
APERTURE f/11

▲ **Mother-in-law's seat: platinum toned**
Although the image is monochrome, it was scanned as a file in RGB color mode, which makes it easy to "tone." Use IMAGE > ADJUST > HUE/SATURATION and check the COLORIZE box. By adjusting the HUE and SATURATION sliders, you can achieve a pretty good representation of any toning process you like.

◀ **Mother-in-law's seat: sepia toned**
Another method of toning is to convert to grayscale and then convert back to Duotone mode (IMAGE > MODE > DUOTONE). You can choose DUOTONE or TRITONE and specify particular Pantone colors for a preselected effect.

△ ▷ Deudrobium orchid (*Deudrobium phalanopsis*) In this case, the GREEN channel—as green is the complementary color to magenta—held the most detail. The resulting image was printed as a monochrome print.

CAMERA Nikon F4
LENS 105mm f/2.8 AF macro
FILM Fujichrome Velvia
SHUTTER SPEED 1/60 sec
APERTURE f/16
LIGHTING SB21B macroflash

◁ △ Corsican pine (*Pinus nigra* ssp *laricio*) The first task was to select the trunks. SELECT > INVERSE was used to select and clear the background. A graduated fill was created and used in the background.

CAMERA Nikon F4
LENS 24mm f/2.8 AF wide-angle
FILM Agfa Scala
SHUTTER SPEED 1/125 sec
APERTURE f/11

subject, such as green for a magenta flower. The same effect is produced when you select the green channel with an image of a magenta flower such as the orchid in the illustration. You can then save a channel separately (using FILE > SAVE AS) and work on it.

Ink sets are available for some photorealistic printers in which six-color ink is replaced by six degrees of black: this generates excellent graytone prints directly.

Layers

Selections can be placed in layers, which act like acetate sheets arranged one above the other. Each layer is then unaffected by changes made to the rest of the image. You can alter the sequence of the layers, using some as masks.

The opacity of a layer can be changed to allow more or less of the layers below to show through in a montage. Any selection placed on a layer can be moved around using the hand tool.

An adjustment layer allows you to preview changes to color and tone without the need to adjust individual layers. It sits on top of the other layers and acts as a filter.

Creating layers uses up a great deal of RAM in a computer, and you cannot have too much RAM available. When running Photoshop, I close all other programs and use a minimum set of Mac extensions.

If you have created a montage and want to preserve separate layers, you must store the files in Photoshop format. To save in any other format—such as a TIFF, for example—the layers must be "flattened" before saving.

History palette

The history palette (WINDOW > SHOW HISTORY) allows you to retrace your actions without having to remember to save a file at each step—this is a tremendous improvement on earlier versions of Photoshop. However, when a file is saved and closed, then re-opened later, its history is not stored, so you will need to take "snapshots" of particular states as you go along if you will want to revert to them.

Selection: White Backgrounds

THE SUCCESS OF SO MUCH in Photoshop depends on making a selection: isolating an element accurately with a ring of "marching ants." There are several ways to do this: MARQUEE tools select shaped areas for cropping (ellipse, rectangle) or pixels in a single column or row (column, row). The MAGIC WAND selects areas of continuous color, and is useful for subjects that are to be lifted from plain backgrounds. The magnetic LASSO is particularly useful and quick. PEN tools are used to create paths.

If working with Photoshop becomes a part of your life, you will find that using a graphics tablet rather than a mouse makes it much easier to perform selections.

No selection is perfect—especially when made with a mouse. So, to add an area to your selection Shift–drag (using the LASSO or MARQUEE tool) or Shift–click (using the MAGIC WAND), either inside or outside the selection; to remove an area with these tools use Option–drag and Option–click respectively.

Cloning

The CLONING or RUBBER STAMP tool is indispensible for correcting blemishes. In general terms it can be made to pick up pixels from an image (Option–click after selecting the tool and then click on ALIGNED in the OPTIONS palette). You can deposit the pixels elsewhere in the image with a click of the mouse or by dragging. If you have two image files open you can Option–click on one image and clone the pixels you pick up into the other one.

◀ **Magic Wand selection** The initial selection of the flower was made using the MAGIC WAND. The selection was improved by moving the "marching ants" boundary to add areas with Shift–drag (LASSO or MARQUEE tool) or Shift–click (MAGIC WAND) inside or outside the selection, and to remove areas with Option–drag and Option–click respectively.

▶ **Violet limodore (Limodorum abortivum)** At first sight, it would seem easy to separate the flower from its dark background. In practice, you always have to add or subtract from a selection to get the best you can manage.

CAMERA Nikon F4
LENS 105mm f/2.8 AF macro
FILM Fujichrome Velvia
SHUTTER SPEED 1/60 sec
APERTURE f/16
LIGHTING SB21B macroflash

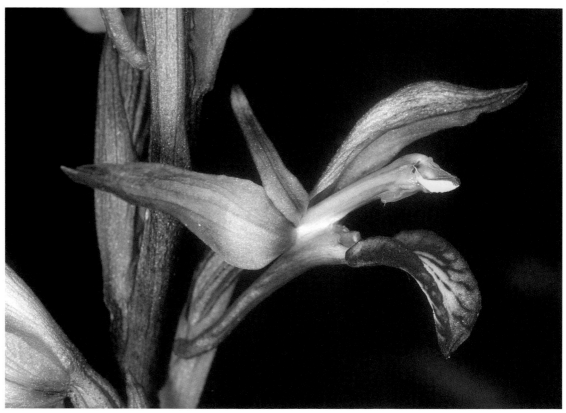

◀ **Magnetic Lasso selection**
The selection was made using the MAGNETIC LASSO and lightly "feathered" to soften the edges. The selection was extended to include some of the lighter flower parts, which had been missed.

Magnetic Lasso Options

Feather: 2 pixels ☑ Anti-alias

Lasso Width: 10 pixels

Frequency: 57 Edge Contrast: 20

Stylus: ☐ Pressure

▲ **Blue iris**
The image was obtained using natural light and slight overexposure to emphasize the subject's "softness."

CAMERA Nikon F4
LENS 105mm f/2.8 AF macro
FILM Fujichrome Velvia
SHUTTER SPEED 1/30 sec
APERTURE f/16

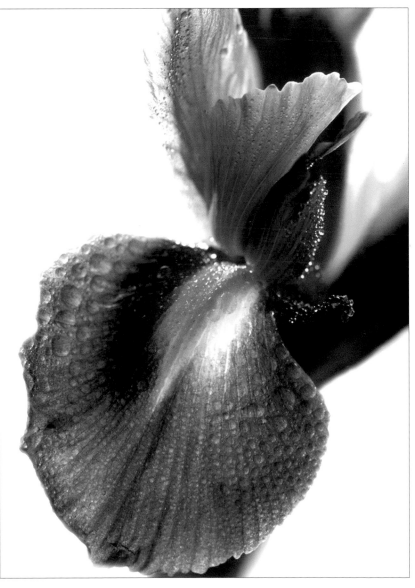

▲ **Blue iris: detail**
During examination of the original selection for any spots and blemishes needing correction, an enlarged portion was saved as a separate image.

▷ **Blue iris: white background**
Using the SELECT > INVERSE command, the background was selected and then filled with "pure" white: this has the value 255 (on a scale of 0–255, giving 256 values) for red, green, and blue.

Filters and Color Manipulation

A WIDE RANGE OF FILTERS is included within Photoshop, and any number are available as add-ons. Two categories quickly become indispensible to the photographer: BLUR and SHARPEN.

By making a selection and inverting, the background is selected. This can be pasted into another layer and a GAUSSIAN BLUR applied to create an out-of-focus background and accentuate subject sharpness. A GAUSSIAN BLUR can also be applied to a selection duplicated into a layer. By adjusting the transparency, you can then control the softening of the image by letting the original sharp object show through.

Despite its name, UNSHARP MASK (FILTER > SHARPEN > UNSHARP MASK) actually sharpens images. It is the most useful filter of all, applied after all other tasks have been completed. It ingeniously counters the softening caused by scanning by increasing edge sharpness. You can set the Amount (not too much, or edges become jagged—I use from 120 to 160 percent). RADIUS sets the number of pixels away from the subject's

▲ ▶ *Lyonothamnus asplenifolius* leaves
The image began as a monochrome picture. It was scanned and preserved in RGB mode. The FIND EDGES command was then employed (FILTER > STYLIZE > FIND EDGES). With strong, graphic images this can be used to produce an etched line effect with some artificial coloring. The effect seems to work particularly well with leaves.

CAMERA Nikon F4
LENS 60mm f/2.8 AF macro
FILM Fujichrome Provia
SHUTTER SPEED 1/60 sec
APERTURE f/16
LIGHTING SB21B macroflash

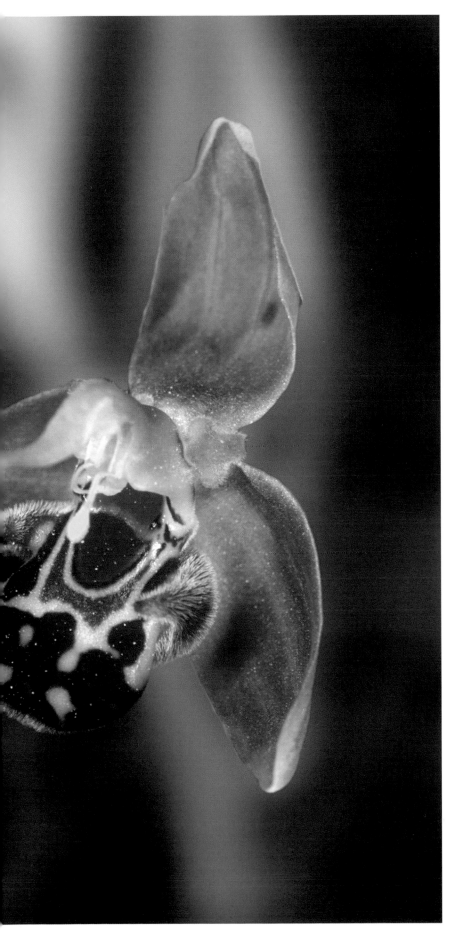

Bee orchid (*Ophrys apifera*), Kenfig, Wales
The orchid flower was shot against a background of stems and leaves.

CAMERA Nikon F4
LENS 60mm f/2.8 AF macro
FILM Fujichrome Provia
SHUTTER SPEED ¹/₆₀ sec
APERTURE f/16
LIGHTING SB 21B macroflash

Bee orchid: Gaussian Blur
The flower was carefully selected with the PEN tool. SELECT > INVERSE selected the background and the GAUSSIAN BLUR filter was applied (FILTER > BLUR > GAUSSIAN BLUR). The effect is like changing depth of field.

edge where contrast will be increased (I use 1–1.5). THRESHOLD dictates the contrast difference that must exist between adjacent pixels before sharpening is applied.

An analogy is the way in which detail is revealed on a subject's surface by side lighting, which creates tiny shadows (see pages 26–27). You may find it prudent to save images before applying the final UNSHARP MASK—if at a later stage you need to make changes after saving, this cannot be undone.

I seldom use "artistic" effects, but I like FIND EDGES (FILTERS > STYLIZE > FIND EDGES), which creates an image reminiscent of those on lith film. I often start with a monochrome image, convert to RGB, tone it, and then apply the filter on a hit-and-miss basis until I get a result I like.

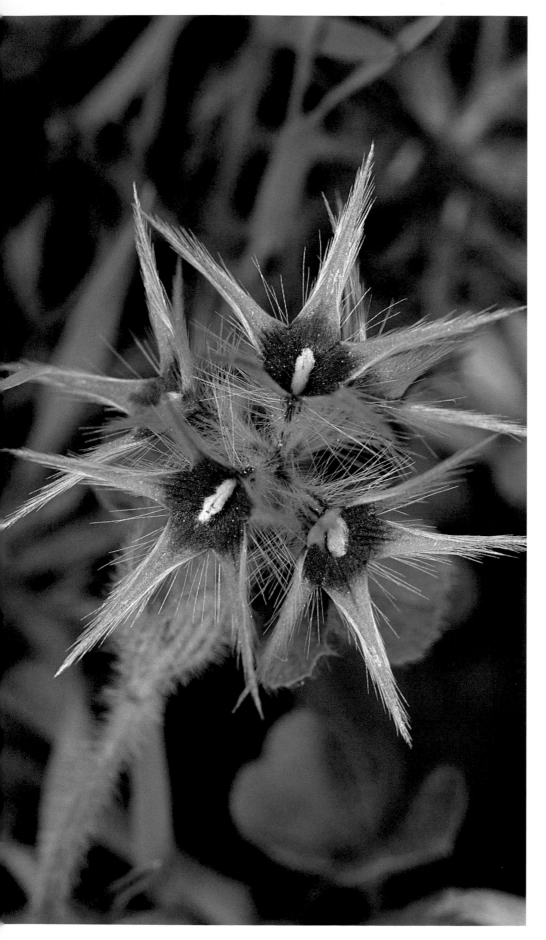

Technical Appendix

Supplementary lenses

The simplest way to try close-up photography is to add supplementary lenses or "diopters" to the front of a lens (they screw into the filter thread). These do not allow you to focus on infinity, but they do give better close focusing. The camera's metering system is unaffected, and no light is lost, as it is with extension tubes. For good results it is important to use small apertures, such as f/8 and smaller—to avoid the softening that such lenses produce unless you use light rays close to the lens axis. Nikon and some other manufact-urers produce two-element diopters that produce excellent results but are correspondingly more expensive.

Extension tubes

An extension tube separates lens from camera body to produce a magnified image on film. Disadvantages are light loss and having to fit together a set of tubes in differing combinations to produce a range of magnifications. Although TTL metering is retained, features such as autofocus are lost in all but the most expensive tubes. However, a single extension tube of, say, 25mm can be very useful in producing an extra degree of magnification from a macro lens, or from a telephoto with a close-focus facility.

Macro lenses

Most manufacturers produce a range of macro lenses. These are also excellent general-purpose lenses, as you pay handsomely for a high level of correction.

◀ Star Clover *(Trifolium stellatum)*, Olympia, Greece

Most modern macro lenses focus to 1:1 (life size) as standard, without recourse to extension tubes. Older lenses were optimized for one magnification (about 1:10), but many now have a floating element system that maintains lens corrections throughout the focus range. Autofocus is of limited use and can be a nuisance, because the slightest movement of camera or subject causes the lens to "hunt."

Your choice of lens lies between the "standard" focal length of 50–60mm, the "portrait" lens of 90–105mm. and the increasingly popular 180–200mm lenses. Think first about the kind of subjects you will wish to photograph.

Focal length 50–60mm
With lenses of this focal length, the front element is recessed and the lens front is very close to the subject at 1:1. They work well with macroflash units. At 1:1 magnification the flash tubes are close to the subject, so relief is good (light comes in at an angle of about 35 degrees to the lens axis).

Focal length 90–105mm
Lenses in this range are often recommended for insect photography. While manual-focus macro lenses retained their marked focal length at all magnifications, modern AF macro lenses focus by moving internal elements, and the focal length decreases as you move closer to the subject. At 1:1, the Nikkor AF 105mm f/2.8 has a focal length of around 79mm; the focal length of the Tamron 90mm AF SP f/2.8 is even less.

Focal length 180–200mm
The focal length I currently favor is 180mm. With this, backgrounds are rendered as a soft blur and the effect is to make the subject snap in and out of focus.

You can be a yard or more away from a lively butterfly and not worry it by your presence as it feeds. Such macro lenses usually have internal focusing; they also possess a tripod collar, which is essential. Most macroflash outfits do not have sufficient power to cope with the lens/subject distance, so you have to assemble your own flash set-up.

Reversed lenses
Most lenses are designed to perform optimally when the object is larger than the image—this affects the angles that light rays make with a lens. Many modern lenses have special moving groups that give close-focus corrections.

When a lens is reversed, in practice, you see little difference until the lens is used to give magnifications of about twice life size. After that, differences are noticeable and reversing improves matters a lot. This is the method suggested by Nikon, for example, when obtaining high magnifications using bellows and their reversed 28mm or 24mm wide-angle lenses.

When lenses are reversed, features such as auto diaphragm and exposure meter linkages are lost. For some makes you can buy rather cumbersome adaptors such as "Z" rings, which allow you to use a twin cable release to operate the shutter and lens diaphragm. Novoflex makes an adaptor for Canon that preserves much of the electronic linkage, but the price is high.

Roll film for macro work
To get the full advantage of the larger area of film, you need the subject to occupy the same proportion of the screen, but this means higher magnification and thus a reduction in depth of field. This is not a problem with flat subjects such as leaf surfaces.

Many 35mm macro lenses have far greater covering power than is needed for 35mm format, and I have used Nikon, Sigma, and Novoflex lens heads to cover 6 x 4.5cm format.

For example, my Sigma 180mm f/3.5 apo macro can be fitted to my Mamiya super pro TL—using a homemade adaptor—to give from about 0.1x to 1.25x magnification. Metering is possible in stop-down mode, and the TTL flash system works perfectly, since the meter cell is in the body of the camera.

One adaptor consists of a Mamiya body cap with the center sawed out, glued to a cheap Nikon-fit extension tube.

A more versatile version (though a more expensive one) can be made from a Mamiya reversing ring fitted, via a 59–52mm stepping ring, to a Nikon BR-6 ring: this allows automatic diaphragm retention with a double cable release. The set-up is very sharp and useful in the studio, but it is cumbersome and needs to be well supported.

Sharpness and depth of field
Closing down the diaphragm restricts light rays passing through a lens to those near the axis. As well as the lens being better corrected near the axis, this procedure increases depth of field.

An image is, in theory, made up of points. A circle of $\frac{1}{850}$in (0.03mm) or less (the blur circle, or circle of least confusion) appears as a sharp point to the eye, so there is some latitude in the position of the film plane. As the light moves further in front of or behind the film plane, it spreads out, and the distance over which it stays within the limits of the blur circle is the depth of focus.

At the subject, a slight movement either side of the plane of sharp focus (within the depth of field) will also produce a circle of $\frac{1}{850}$in (0.03mm) or less on film.

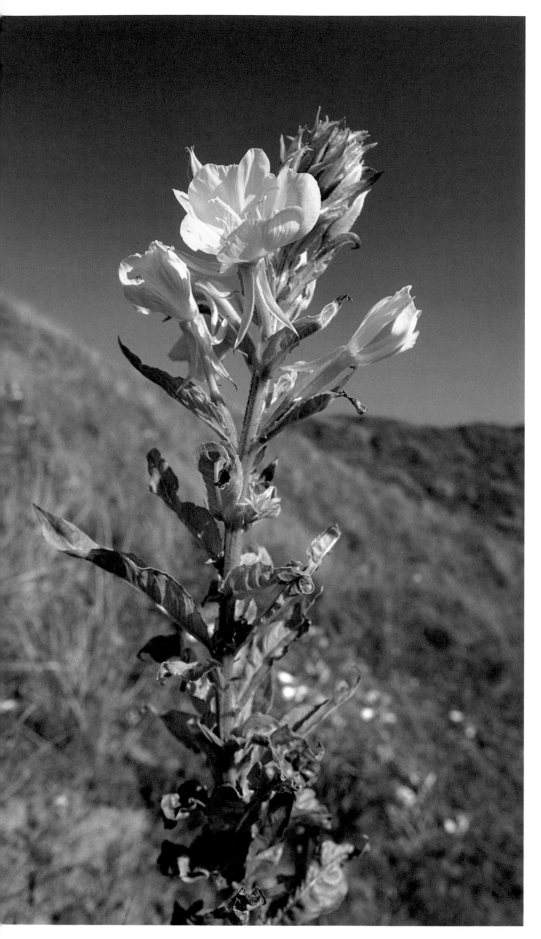

Filters

Color filters

On gray days and when the sky is bright but "white," the 81 series of warming filters is useful. These filters can also be used to accentuate already "warm" light such as sunsets. They are coded as 81, 81A, 81B, 81C, 81D, 81E, and 81F, in order of increasing strength. A correspondingly cool cast can be created with the 82 series: numbered 82, 82A, 82B, and 82C.

The blue 80 series of filters counteract the orange cast that tungsten light creates on daylight-balanced film. The codes are 80A, 80B, 80C, and 80D. Typically 80A is used to balance ordinary room lighting for daylight film; 80B is recommended for tungsten photoflood, which is less warm. Tungsten-balanced film would carry a strong blue cast if used in daylight, due to its higher color temperature. The 85 series of orange filters (85, 85A, 85B, and 85C) will reduce this cast. The numbering of all these filters is confusing—80A and 85 are the strongest, whereas in the 81 and 82 series the 81 and 82 filters are the weakest.

Light waves, like microwaves, radio waves, ultraviolet, and infrared, are transverse electromagnetic waves. This means that they have an electric field that vibrates in all directions perpendicular to the direction of travel. A polarizer is like a grid, whose bars allow through only the light vibrating in a particular direction. The scattering that produces the blue sky, and the reflection of light from a non-metallic surface, produces a preferred direction for this electric field.

◀ Large Flowered Evening Primrose (*Oenethera erythrosepala*), Kenfig, Wales

A polarizer can be rotated to cut out this light or allow it through. It can be used to enhance the blue of the sky or the intensity of leaf color by cutting surface reflection. It can also cut the surface reflections from water, making the surface transparent, allowing under-water plants to be shot clearly. With water, the greatest degree of polarization occurs for rays at about 54 degrees to the vertical (the Brewster angle).

Manual focus cameras can be used with both linear and so-called circular polarizers. The latter are designed for autofocus systems and incorporate a 1/4-wave filter with a linear polarizer, which changes the phase of the light and allows the autofocus system to function.

Camera movements

Often with a floral scene in a viewfinder, parts at the top are further away than the subject towards the bottom. You can close down the aperture to get the greatest depth of field and focus at the hyperfocal distance to maximize what appears in focus (see pages 64–65).

With large-format field cameras you can also move the back or lens panels in a series of tilts and shifts to get both near and distant objects in focus. A detailed discussion of this facility is beyond the scope of this book but several lenses are available in 35mm format, notably those made by Canon, which allow these movements to be employed.

Several manufacturers of roll film cameras make "shift" lenses that, while intended for architecture, will work with plants. Hasselblad makes two bodies that allow complex movements.

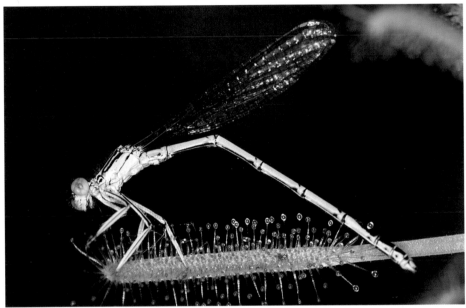

▶ Top: Death's Head Hawkmoth larva (*Acherontia atropos*), San Miguel, Azores. Centre: Damselfly trapped by Sundew (*Drosera intermedia*), Hampshire, UK. Bottom: Slime mould (*Mucilago crustacea*), Wales

Index

Acknowledgements

Many people have, over the years, encouraged and helped foster my interest in and love of plants of all sorts. In this current project I owe a huge debt of gratitude to Lois Ferguson, my partner, whose own unashamed love of the world around her and whose eyes for the shape and form inherent in nature have also opened mine. Several of the pictures included in this book are hers, and I have been able to draw extensively on her artistic skills with image manipulation, and rely on her encouraging comments on my own ideas.

My undying gratitude goes to Miss Betty Hughes—one of those special teachers who patiently encouraged my interests, to the late Anthony Huxley who made my first book in 1983 possible, and to those many people who have attended courses, workshops and accompanied me on tours. Their responses to my enthusiasm have made me feel it is all worthwhile.

Stalwart friends have been of incalculable value through the last few years and my thanks go to Robert Mash and Peter Parks who share my obsessions, to my brother Peter A. Davies, to Clive and Di Rainbow, John Roberts, Steve and Kate Benbow of Photolibrary Wales, and to my children Hannah and Rhodri, who have always provided a critical but positive audience—preferring a Dad who was a happy but impecunious writer to his being a frustrated pedagogue.

To those who have lent technical and practical support I offer my gratitude: Deirdre Harrison of Climpex miniature studio scaffolding, Mark Langley of Mamiya, Graham Armitage of Sigma UK, Dr Philip Cribb at the Royal Botanical Gardens, Kew, Professor Charles Stirton and the staff of the National Botanic Garden Wales and to the Royal Horticultural Society at Wisley. Special thanks go to Paul and Joey Sims of Colourbox Technique for their consistently superb processing since I moved to Oxford and to Peter Williams at Colab Cardiff.

And last, but by no means least, my appreciation and grateful thanks go to the team at Collins & Brown: to Sarah Hoggett who commissioned the book, Emma Baxter who edited it and patiently humored a pedantic and would-be perfectionist author, Roger Bristow who oversaw the project, Roger Daniels who worked unremittingly on the design, and to Beverly Jollands for her skills in tweaking my prose and gently goading me where necessary.

Contact Paul Harcourt Davies—picture gallery and sales, photographic and wildlife tours at:
www.hiddenworlds.co.uk